D1407106

# STEVE McQUEEN WILLIAM CLAXTON photographs

Foreword and Commentary by William Claxton

Dedicated to Neile and Chad and to the memories of Terry and Steve.

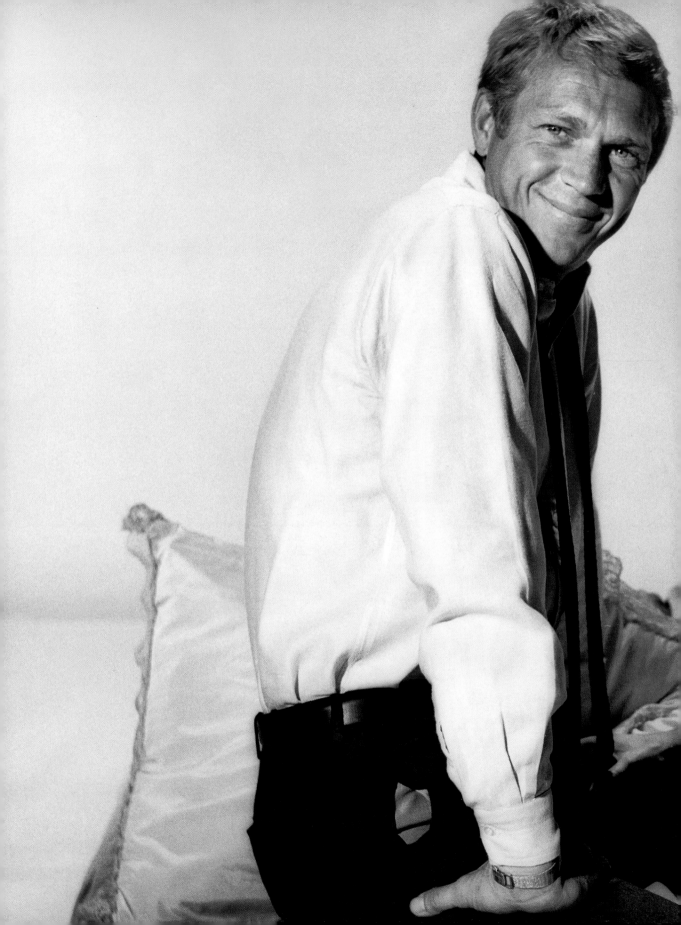

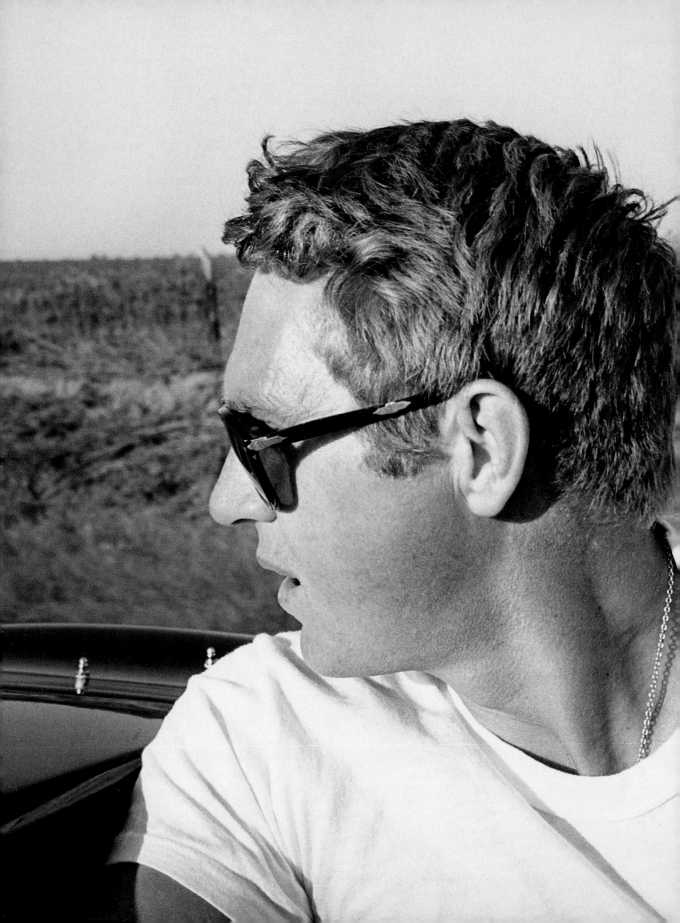

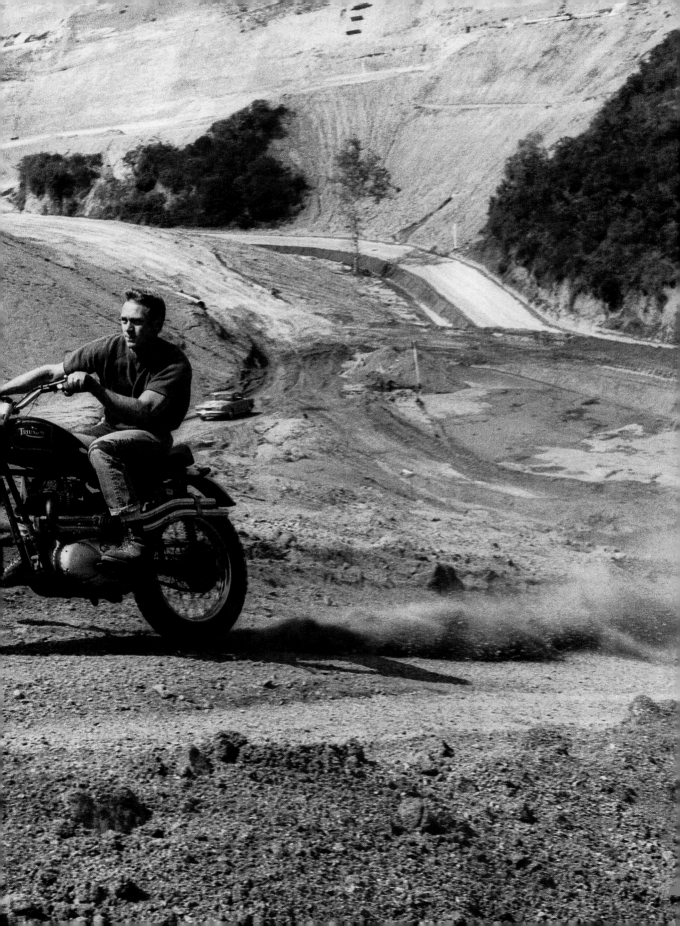

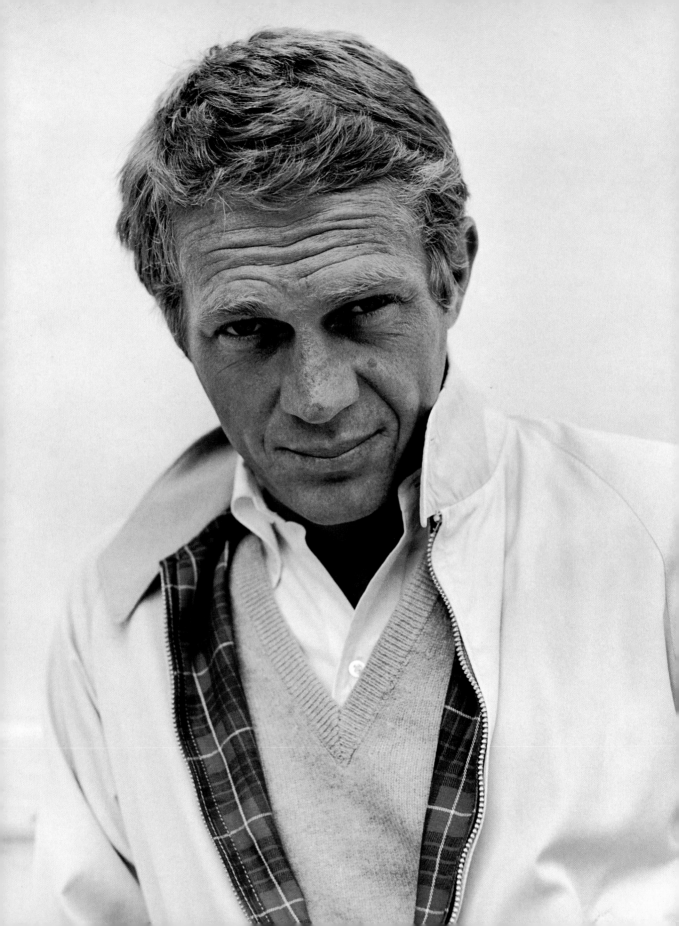

# STEVE McQUEEN
## WILLIAM CLAXTON
### photographs

- 7/04 -

Olly,

Soon you'll be photographing
legends like this!

hope you enjoy,

Mabs

## TASCHEN

KÖLN LONDON LOS ANGELES MADRID PARIS TOKYO

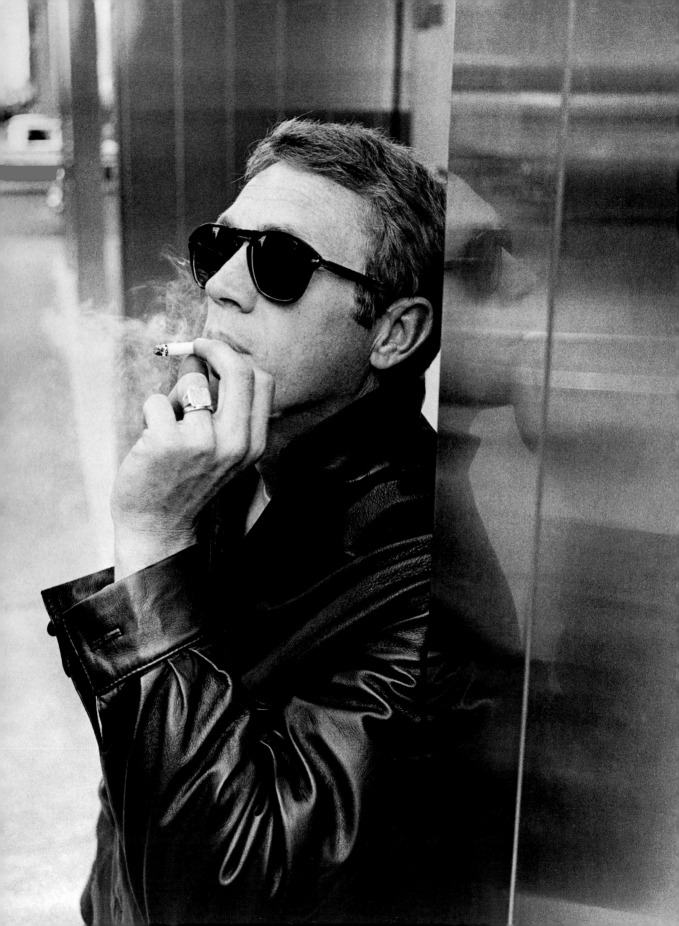

# FOREWORD

Motion pictures and film actors have always been an important part of my life. Every day I can recall a movie or a scene from a movie that has had an influence on my behavior or my point of view. As a young moviegoer, I never realized that one day I would meet and, what's more, photograph many of these film stars.

It all began when I was a little boy. My sister, Colleen, and I would be dropped off at our local movie theater early Saturday afternoons and be left there until late that night. The movie theater became a metaphor for babysitter. Sometimes our older brother would grudgingly accompany us, but he wouldn't sit with us. He wasn't about to be seen babysitting in front of his friends. It wasn't uncommon for many of the parents in our neighborhood to leave their children in the safe haven of this little local cinema. We all felt perfectly safe. But, of course, that was the late 1930s and early 1940s. It was a much safer and trusting time. The theater owner always kept an eye on us as well as all of the other kids who frequented his establishment. His name was appropriately Monty Friend and his movie house was the Montrose Theater. It was a place of sheer joy for us.

We would sit through the double features, a comedy, a cartoon, *The March of Time*, and the coming attractions several times. Our nourishment came from Hershey bars and popcorn. At some point in the early evening, Monty Friend would call to us quietly in the dark theater to let us know that our parents had come to pick us up and were waiting in the family car out front.

It wasn't easy for me to leave the movie house. The 40 x 40 foot images that appeared on the screen became the other people in my life. The giant faces of the film actors would become the other members of my family. Sometimes the movies would reflect the beautiful side, sometimes the frightening side, and sometimes even the boring side of my celluloid, extended family. For example, Cary Grant, Dick Powell, Jimmy Stewart, Gary Cooper, and Clark Gable were the buddies I wanted to have on my side when I grew up. As for the beautiful Irene Dunne and Norma Shearer, and Jean Arthur, I could count on them for their warm and friendly personalities. My all-time favorite was Myrna Loy. Beautiful, smart, witty, and with a unique voice, she could do no wrong, especially if she was paired with William Powell, Spencer Tracy, or Clark Gable. Lana Turner, Hedy Lamarr, Ava Gardner, and Lena Horne offered unbelievable glamour, almost too good to be true. On the other side, Joan Crawford and Bette Davis absolutely frightened me. I could count on Bob Hope, Jack Benny and Rochester, Gracie Allen and Zasu Pitts to make me laugh. Greer Garson and Walter Pidgeon were my parents, or the kind of parents I wished my real-life parents would be like.

I was completely convinced that when Judy Garland and Mickey Rooney would "rent a barn and stage a musical" I could do the same thing in my backyard. What a great idea. Fred Astaire and Ginger Rogers provided the best in black and white screen entertainment in those wonderful RKO musicals. Great tunes sung in a black, white, and silver setting, very art deco. Those sets were the ultimate nightclubs to me, with silver and white palm trees, big winding staircases, and penthouses overlooking the skyscrapers. *Gunga Din*, *The G-Men*, gangsters, and car chases offered my kind of excitement.

The tough guys I admired most were Humphrey Bogart, Richard Widmark, Edward G. Robinson, and James Cagney. I always liked the guys with strong and unusual faces, yet sensitive personalities, like Victor McLaglen, John Garfield, or John Hodiak, and later Aldo Ray, James Coburn, and Jean-Paul Belmondo.

As the years went by with the knowledge of having seen hundreds of films, we became very selective in our choices and favorite movies from the various studios: RKO and MGM would always provide quality musicals. After all, MGM had Van Johnson, June Allyson, Judy Garland, Ann Miller, Gene Kelly, and Frank Sinatra.

In my teen years the hip thing to do if you were a movie buff was to find out which theaters had sneak previews. We found that Pasadena and Glendale were the favorite testing venues for the major studios. Through our detective work, we would find the right theater and arrive early, and get really excited as the theater became dark. You could hear the hustle and bustle of some big star finding his or her way with the producers to their cordoned-off seats in the back of the theater. The logo of the studio would appear on the screen. If it was MGM or Paramount, we would cheer. If it was Warner Brothers, RKO, or Twentieth Century Fox, we felt that there was a real chance of the movie being pretty darn good. But if the Monogram or Republic Pictures logo appeared, we would give out with a quiet groan. Some of our pals would even get up and leave. After the screening, the opinion cards would be passed out in the lobby. We would mark ours diligently … who was good, who was bad, was the story good, and so on.

When I met a young actress named Peggy Moffitt (and later married her), we quickly found that we shared this strong interest in movies. She knew as much as I did about films as a fan and frequently much more. After all, her father, Jack Moffitt, was a noted screenwriter and film critic, and Peggy was a drama student who had been in thirteen films as a teenager. In fact, growing up in Hollywood made her a bona fide "movie brat". She had been privy to many private screenings at the actual studios. So, between the two of us, there existed a vast amount of strong likes and dislikes when it came to movies. We both had definite feelings in regard to actors, directors, set designers, cinematography, costume designers, film scores, and stories.

Shortly after we were married, we came home one night to our little photography studio/home in the Hollywood Hills, and I turned on our small black and white television set. On the screen were horses with cowboys in a chase sequence.

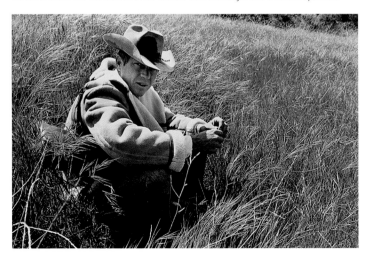

"Yuk!" I thought to myself. Westerns never appealed to either of us unless it was something special like *High Noon*, *Shane*, *Stagecoach*, or *The Ox-Bow Incident*. Suddenly, a close-up of a face appeared on the tiny screen. An unusual face. This cowboy was totally different. In just one close-up this guy could express six or seven different and sometimes contradictory emotions and seemingly insightful thoughts. In a split second I knew that we were dealing with a strong and different kind of cowboy hero. He was interesting, unusual, appealing, and sensitive all at the same time. He was rugged, decidedly different, and yet unconventionally handsome. He was Steve McQueen. And the TV show was *Wanted: Dead or Alive*. In the feature films that followed, such as *Never So Few*, *Hell Is for Heroes*, and *The War Lover*, it was McQueen that grabbed your attention. Then, in 1963, *The Great Escape* was about to open and word was out that McQueen's performance was sensational.

Once again, a larger-than-life face was about to enter our lives.

By the early 1960s, I had become well-known for my jazz photography and was a successful photojournalist frequently assigned by big publications like *LIFE* magazine to cover movie productions at the major film studios. On one such assignment I was to meet and photograph Natalie Wood. I reported to Stage 4 at Paramount Studios to meet with the producer Alan Pakula, the director Robert Mulligan, and the picture's stars Natalie Wood and Steve McQueen. The title of the film was Love with the Proper Stranger. In the center of the big empty sound stage seated around a table was this group discussing everything from wardrobe to every aspect of early production problems.

I shook hands politely with Natalie Wood and got my first, live close-up of her beautiful face. Her dark brown, friendly eyes met with mine and I knew that we would be friends. I then turned to meet her leading man, McQueen. He didn't offer his hand; he just stared at me with his intense steel blue eyes. (Later he would say to me, "Clax, I really zapped you with my look, didn't I?") His look was chilling. I felt that he knew everything about me in a split second. I thought, "Oh shit, what have I got myself into with this guy?" He was both seductive and threatening. Time would prove that my hunches, instincts, whatever you want to call them, were right about this unusual actor. He was street-smart, animal-like, non-intellectual, and hip. In fact, he brought new meaning to the word hip: he was super-hip.

This book covers just a few years of my relationship with Steve. After making *The Cincinnati Kid*, Steve went to Hong Kong to work on *The Sand Pebbles*, and Peggy and I went off to Europe to work on our own careers. In the passing years, Steve and I rarely spoke. We both had moved on with our lives. From what I have since read and heard, Steve was into cocaine and that did not help his relationships. By that time, however, he was such a big star that only his family and friends had to bear the brunt of his changed personality.

In those few short years that I worked and played with Steve, we had a lot of fun, and I feel that I'm a very fortunate man for having known Steve McQueen, who was an American original.

**William Claxton, Los Angeles, 2004**

# VORWORT

Filme und Schauspieler spielen eine wichtige Rolle in meinem Leben. Tagtäglich fallen mir Filme oder Szenen aus Filmen ein, die mich und meine Einstellung geprägt haben. Als heranwachsender Kinofan hätte ich mir nie träumen lassen, dass ich viele meiner Leinwandstars eines Tages kennen lernen und obendrein fotografieren würde.

Es begann, als ich ein kleiner Junge war. Jeden Samstagnachmittag schickten mich meine Eltern mit meiner Schwester Colleen ins Kino unserer kleinen Stadt. Das Kino wurde eine Metapher für den Babysitter. Manchmal begleitete uns zähneknirschend unser älterer Bruder. Er setzte sich nie neben uns, denn in Anwesenheit seiner Freunde empfand er es als unter seiner Würde, auf uns aufzupassen. Damals war es nichts Ungewöhnliches, dass Eltern ihre Kinder der Obhut dieses kleinen Kinos anvertrauten. Wir fühlten uns dort sicher und geborgen. Allerdings war das Ende der dreißiger, Anfang der vierziger Jahre, als die Welt noch in Ordnung war. Der Kinobesitzer hatte immer ein Auge auf uns und seine anderen kleinen Stammgäste. Er trug den sinnigen Namen Monty Friend, sein Kino hieß Montrose Theater. Für uns war es ein Ort ungetrübter Freude.

Wir blieben bis zum Abend, so dass wir das gesamte Programm mit zwei Hauptfilmen mehrmals sahen, zuerst eine Komödie, dann einen Zeichentrickfilm, anschließend die Dokumentarfilmserie *The March of Time* und die Vorschau. Wir ernährten uns von Hershey-Riegeln und Popcorn. Irgendwann holte uns Monty Friend dann leise aus dem dunklen Saal und brachte uns zu unseren Eltern, die draußen vor dem Kino im Auto warteten.

Es fiel mir jedes Mal sehr schwer, das Kino zu verlassen. Die etwa 12 x 12 Meter großen Bilder auf der Leinwand waren meine Freunde geworden, die gigantischen Gesichter der Schauspieler gehörten für mich zur Familie. In den Filmen erlebte ich bald die schöne, bald die Furcht erregende und manchmal auch die langweilige Seite meiner Leinwandhelden. Cary Grant, Dick Powell, Jimmy Stewart, Gary Cooper und Clark Gable zum Beispiel waren meine besten Kumpel. Ich sonnte mich in der warmherzigen Freundlichkeit der Schönheiten Irene Dunne, Norma Shearer und Jean Arthur. Doch meine ungekrönte Königin war Myrna Loy. Bildschön, intelligent, witzig und von der Natur mit einer einzigartigen Stimme ausgestattet, konnte sie einfach nichts falsch machen, insbesondere wenn sie an der Seite von William Powell, Spencer Tracy oder Clark Gable spielte. Für den nötigen Glamour sorgten die Diven Lana Turner, Hedy Lamarr, Ava Gardner und Lena Horne. Joan Crawford und Bette Davis hingegen machten mir Angst. Bob Hope, Jack Benny und Rochester, Gracie Allen und Zasu Pitts waren immer für einen Lacher gut. Greer Garson und Walter Pidgeon kürte ich zu meinen Ersatzeltern, Eltern, wie ich sie mir im echten Leben gewünscht hätte.

Ich war davon überzeugt, es Judy Garland und Mickey Rooney gleichtun zu können, die „eine Scheune mieteten und dort eine Show auf die Bühne brachten" – das musste bei uns zu Hause auch möglich sein. Eine großartige Idee. Fred Astaire und Ginger Rogers zauberten mit ihren wunderbaren RKO-Musicals Glanzlichter des Schwarzweißfilms auf die Leinwand. Unvergessliche Melodien, gesungen vor einem Bühnenbild in Schwarz, Weiß und Silber, ganz im Art-déco-Stil. So stellte ich mir den ultimativen Nachtclub vor, mit silberfarbenen und weißen Palmen, breiten geschwungenen Treppen und Penthäusern mit Blick über die Wolkenkratzer.

Filme wie *Aufstand in Sidi Hakin* und *Der FBI-Agent*, Gangster und wilde Verfolgungsjagden waren ganz nach meinem Geschmack.

Die harten Burschen, die ich am meisten bewunderte, waren Humphrey Bogart, Richard Widmark, Edward G. Robinson und James Cagney. Ich hatte immer ein Faible für Männer mit einem ausdrucksstarken, markanten Gesicht und weichem Herz, wie Victor McLaglen, John Garfield oder John Hodiak und später Aldo Ray, James Coburn und Jean-Paul Belmondo.

Im Laufe der Jahre und nach Hunderten von Filmen hatten wir aus unserem Hobby eine Wissenschaft gemacht. Die Studios RKO und MGM zum Beispiel produzierten die besten Musicals. Immerhin hatte MGM Van Johnson, June Allyson, Judy Garland, Ann Miller, Gene Kelly und Frank Sinatra unter Vertrag.

Als Teenager und Filmfreak war es zu meiner Zeit ein regelrechter Sport, die Kinos ausfindig zu machen, in denen die Sneak Previews stattfanden. Wir entdeckten, dass die bevorzugten Orte für den Testlauf der großen Studios Pasadena und Glendale waren. Mit detektivischem Geschick spürten wir das richtige Kino auf. Meist waren wir unter den ersten Gästen. Wenn dann die Lichter ausgingen, hielt es uns vor Aufregung kaum auf den Plätzen. Man konnte das Geraschel der Stars hören, wie sie sich mit den Produzenten zu den abgesperrten Sitzen im hinteren Teil des Saals vortasteten. Das Logo des Studios erschien auf der Leinwand. War es das von MGM oder Paramount, jubelten wir innerlich. War es das von Warner Brothers, RKO oder Twentieth Century Fox, standen die Chancen nicht schlecht, dass wir einen verdammt guten Film zu sehen bekommen würden. Wenn jedoch das Logo von Monogram oder Republic Pictures erschien, stöhnten wir leise auf. Einige von uns standen dann sogar auf und gingen. Nach der Vorführung wurden in der Eingangshalle Bewertungskarten verteilt, die wir eifrig ausfüllten … wer war gut, wer schlecht, war die Story gut und so weiter.

Als ich eine junge Schauspielerin namens Peggy Moffitt kennen lernte (die später meine Frau werden sollte), entdeckten wir rasch unsere gemeinsame Liebe zum Film. Sie wusste mindestens genauso viel über Filme wie ich. Schließlich war ihr Vater Jack Moffitt ein bekannter Drehbuchautor und Filmkritiker; außerdem besuchte sie die Schauspielschule und hatte als Teenager in 13 Filmen mitgewirkt. Dass sie in Hollywood aufgewachsen war, machte sie zu einer waschechten „Filmgöre". Oft schleuste sie uns zu privaten Vorabvorführungen in die Studios ein. In unseren leidenschaftlichen cineastischen Vorlieben und Abneigungen stimmten wir stets überein. Beide hatten wir feste Meinungen über Schauspieler, Regisseure, Ausstatter, die Filmkunst, Kostüme, Filmmusik und Plots.

Kurz nach der Hochzeit kamen wir eines Abends in unser bescheidenes Fotostudio/ Zuhause in den Hügeln von Hollywood zurück und ich schaltete den kleinen Schwarzweißfernseher ein. Cowboys galoppierten in einer stürmischen Verfolgungsjagd über die Mattscheibe. „Gähn", dachte ich. Western waren nicht unser Ding, bis auf wenige Ausnahmen wie *Zwölf Uhr mittags*, *Mein großer Freund Shane*, *Ringo – Höllenfahrt nach Santa Fé* oder *Ritt zum Ox-Bow*. Plötzlich tauchte auf dem Bildschirm die Nahaufnahme eines Gesichts auf. Ein ungewöhnliches Gesicht. Dieser Cowboy war völlig anders. In nur einem Close-up konnte der Mann sechs oder sieben verschiedene, zum Teil widersprüchliche Gefühle und scheinbar tiefgründige Gedanken ausdrücken. Ich wusste sofort, wir hatten es hier mit einem starken, einem neuen Typ Cowboy zu tun. Er war interessant, charismatisch, attraktiv und empfindsam zugleich. Er hatte ein markiges und doch auf unkonventionelle Art gut aussehendes Gesicht. Sein Name war Steve McQueen und die Westernserie

hieß *Der Kopfgeldjäger*. In den folgenden Spielfilmen, darunter *Wenn das Blut kocht*, *Die ins Gras beißen* und *Verliebt in den Krieg*, wurde McQueen zum heimlichen Hauptdarsteller. 1963 gelang ihm dann mit seiner sensationellen schauspielerischen Leistung in *Gesprengte Ketten* der endgültige Durchbruch.

Erneut sollte ein überlebensgroßes Gesicht in unser Leben treten.

In den frühen sechziger Jahren hatte ich mir mit meinen Jazzfotografien einen Namen gemacht und berichtete nun regelmäßig als Fotojournalist für renommierte Zeitschriften wie das *LIFE Magazine* über Filmproduktionen der großen Studios. Bei einem dieser Termine sollte ich Natalie Wood fotografieren. Ich begab mich zu Bühne 4 der Paramount Studios, wo ich den Produzenten Alan Pakula, den Regisseur Robert Mulligan und die beiden Hauptdarsteller Natalie Wood und Steve McQueen treffen sollte. Der Titel des Films war *Verliebt in einen Fremden*. Die vier saßen an einem Tisch, der mitten in dem riesigen leeren Tonstudio stand, und diskutierten jede Kleinigkeit, von der Garderobe bis zu den anderen üblichen Anfangs-problemen einer Produktion.

Ich gab Natalie Wood höflich die Hand und machte meine erste Nahaufnahme ihres ausdrucksvollen Gesichts. Ihre dunkelbraunen, freundlichen Augen begeg-neten meinen und ich wusste, wir würden Freunde werden. Dann wandte ich mich ihrem Filmpartner zu, McQueen. Anstatt mir seine Hand zu reichen, musterte er mich mit seinen durchdringenden stahlblauen Augen. (Später sagte er zu mir: „Clax, dieser Blick hat dich umgehauen, nicht wahr?") Sein Blick konnte einem Angst einjagen. Ich hatte das Gefühl, als hätte er mich auf der Stelle durchschaut. Ich dachte: „Scheiße, was hab' ich mir mit diesem Kerl eingebrockt?" Er war charmant und gleichzeitig bedrohlich. Die Zeit sollte zeigen, dass ich mit meinem Instinkt, meinem Gefühl gegenüber diesem außergewöhnlichen Schauspieler richtig lag. Er war clever, animalisch, nicht intellektuell und hip. Ja durch ihn gewann das Wörtchen hip eine neue Bedeutung: Er war superhip.

Dieses Buch spiegelt eine Zeit, in der Steve und ich uns nahe standen. Nach *Cincinnati Kid* führten ihn die Dreharbeiten für *Kanonenboot am Yangtse-Kiang* nach Hongkong, und Peggy und ich gingen aus beruflichen Gründen nach Europa. In den folgenden Jahren hatten wir kaum Kontakt. Unser Leben verlief in unterschiedlichen Bahnen. Offenbar hatte Steve angefangen, Kokain zu nehmen, was für seine Freundschaften nicht gerade förderlich war. Aber damals war er schon so berühmt, dass nur seine Familie und Freunde unter seiner veränderten Persönlichkeit zu leiden hatten.

In den wenigen Jahren unserer gemeinsamen Arbeit hatten wir eine Menge Spaß und ich schätze mich sehr glücklich, Steve McQueen gekannt zu haben, ein amerikanisches Original.

William Claxton, Los Angeles, 2004

# AVANT-PROPOS

Le cinéma et les acteurs ont toujours occupé une place importante dans ma vie. Il n'est pas un jour sans que je me souvienne d'un film ou d'une scène qui a influencé mon comportement ou ma vision des choses. Cinéphile depuis mon plus jeune âge, je ne pensais pas qu'un jour, je rencontrerais et même photographierais nombre de ces vedettes de cinéma.

Tout a commencé quand j'étais petit garçon. Nos parents nous déposaient, ma sœur Colleen et moi, devant le cinéma de quartier tous les samedis après-midis et nous y restions jusque tard dans la soirée. La salle de cinéma est vite devenue notre « seconde maman ». Parfois, notre grand frère nous accompagnait à contrecœur, mais il ne s'asseyait jamais avec nous : pas question pour lui d'être surpris par ses amis en train de faire du baby-sitting ! De nombreux parents dans le voisinage avaient pris l'habitude de confier leurs enfants à la sphère protectrice de ce petit cinéma de quartier. Nous nous sentions tous en parfaite sécurité. Évidemment, c'était à la fin des années 1930 et au début des années 1940, à une époque caractérisée par une atmosphère empreinte d'insouciance et de sécurité. Le propriétaire du cinéma gardait toujours un œil sur nous, ainsi que sur tous les autres enfants qui fréquentaient son établissement. Il s'appelait Monty Friend et son cinéma était le Montrose Theater. Pour nous, c'était un endroit de pur bonheur.

Nous regardions des longs métrages, des comédies, des dessins animés, les actualités et les prochaines sorties plusieurs fois de suite, tout en nous régalant de barres céréalières et de pop-corn. Puis, en début de soirée, Monty Friend nous appelait discrètement dans l'obscurité de la salle pour nous dire que nos parents étaient là et qu'ils nous attendaient dehors dans la voiture.

J'avais peine à quitter le cinéma. Les personnages qui apparaissaient sur les images projetées sur l'écran ont envahi ma vie. Les visages géants des acteurs sont devenus de nouveaux membres de ma famille. Les films reflétaient tantôt le côté agréable, tantôt le côté effrayant, et parfois même le côté ennuyeux de ma grande famille en celluloïd. Ainsi, Cary Grant, Dick Powell, Jimmy Stewart, Gary Cooper et Clark Gable étaient les copains que je voulais avoir à mes côtés en grandissant. Quant aux belles Irene Dunne, Norma Shearer et Jean Arthur, je comptais sur elles pour m'apporter chaleur et affection. Mon actrice favorite était Myrna Loy. Belle, élégante, intelligente, dotée d'une voix unique, elle était incapable de faire le mal, surtout quand elle jouait aux côtés de William Powell, Spencer Tracy ou Clark Gable. Lana Turner, Hedy Lamarr, Ava Gardner et Lena Horne avaient un charme incroyable, presque irréel. D'un autre côté, Joan Crawford et Bette Davis me terrifiaient. Bob Hope, Jack Benny et Rochester, Gracie Allen et Zasu Pitts me faisaient rire. Greer Garson et Walter Pidgeon étaient mes parents, ou plutôt le genre de parents que j'aurais voulu avoir dans la vraie vie.

J'étais persuadé, comme Judy Garland et Mickey Rooney qui décident de « louer une grange et d'y monter une comédie musicale » dans *Place aux rythmes* (*Babes in Arms*, 1939), que je pouvais en faire autant dans mon arrière-cour. Quelle idée ! Fred Astaire et Ginger Rogers, dans leurs grandes comédies musicales de la RKO, étaient les rois du divertissement en noir et blanc. De grands airs chantés dans un décor très art déco entièrement fait de noir, de blanc et d'argent. Pour moi, ces décors étaient le meilleur des night-clubs, avec leurs palmiers blanc et argent, leurs grands escaliers en colimaçon et leurs superbes appartements offrant une vue imprenable

sur les gratte-ciel. *Gunga Din*, les G-Men, les gangsters et les courses-poursuites en voiture : autant de choses qui provoquaient mon exaltation.

Les acteurs que j'admirais le plus pour leurs rôles de durs étaient Humphrey Bogart, Richard Widmark, Edward G. Robinson et James Cagney. J'ai toujours apprécié les hommes aux visages forts et peu communs, dotés malgré tout de personnalités sensibles comme Victor McLaglen, John Garfield ou John Hodiak, et plus tard, Aldo Ray, James Coburn et Jean-Paul Belmondo.

Au fil des années et après avoir vu des centaines de films, nous sommes devenus de plus en plus sélectifs dans nos choix et dans nos films favoris produits par les différents studios : la RKO et la MGM, sans nul doute, produiraient toujours des comédies musicales de qualité. Après tout, la MGM avait Van Johnson, June Allyson, Judy Garland, Ann Miller, Gene Kelly et Frank Sinatra.

Quand j'étais adolescent, le must pour les mordus de cinéma, c'était de repérer les salles qui proposaient des avant-premières. Pasadena et Glendale étaient les deux localités privilégiées des grands studios pour lancer de nouveaux films. Après avoir joué les détectives, nous finissions par trouver le bon cinéma, nous y arrivions tôt et notre excitation était à son comble quand les lumières s'éteignaient. On pouvait entendre le remue-ménage provoqué par l'arrivée de quelque grande star, accompagnée des producteurs, essayant de se frayer un passage jusqu'à leurs places réservées au fond de la salle. Le logo du studio apparaissait sur l'écran. Si c'était celui de la MGM ou de la Paramount, nous applaudissions. Si c'était celui de la Warner Brothers, de la RKO ou de la Twentieth Century Fox, nous savions que le film avait de grandes chances d'être sacrément bon. En revanche, si le logo de la Monogram ou de la Republic Pictures apparaissait, nous émettions un léger grognement. Certains de nos camarades n'hésitaient pas à se lever et à quitter la salle. Après la projection, les cartes d'opinion circulaient dans le hall. Nous y inscrivions nos commentaires avec application : qui avait bien joué, qui avait mal joué, l'histoire était-elle bonne, etc.

Un jour, j'ai rencontré une jeune actrice du nom de Peggy Moffitt (que j'ai épousée par la suite), et nous nous sommes vite rendu compte que nous partagions la même passion pour le cinéma. En tant que cinéphile, elle en savait autant que moi sur les films, et souvent bien plus encore. Après tout, son père, Jack Moffitt, était un scénariste et critique de cinéma reconnu, elle-même était étudiante en art dramatique et avait déjà tourné dans treize films étant adolescente. En réalité, le fait qu'elle avait grandi à Hollywood avait fait d'elle une véritable petite actrice en herbe. Elle avait assisté à de nombreuses projections privées dans les studios. Si bien qu'entre elle et moi, il y avait quantité d'accords et de désaccords quand nous en venions à parler de cinéma. Nous avions tous les deux des opinions très tranchées sur les acteurs, les réalisateurs, les décorateurs, le septième art, les costumiers, les musiques et les intrigues.

Un soir, peu de temps après notre mariage, nous sommes rentrés chez nous dans notre petite maison/studio de photo sur la colline de Hollywood, et j'ai allumé le poste de télévision en noir et blanc. Sur l'écran, on pouvait voir des cow-boys sur des chevaux dans une scène de poursuite. « Beurk ! », me suis-je dit. Les westerns ne nous avaient jamais attirés, à l'exception d'incontournables chefs-d'œuvre comme *Le Train sifflera trois fois*, *L'Homme des vallées perdues*, *La Chevauchée fantastique* ou *L'Étrange Incident*. Soudain, un visage en gros plan est apparu sur notre petit écran.

Un visage peu commun. Ce cow-boy était totalement différent. En un seul gros plan, cet homme pouvait susciter six ou sept émotions distinctes, voire contradictoires, et

pénétrait littéralement votre esprit. En un instant, j'ai compris que nous avions affaire à un nouveau type de héros, fort et hors du commun.

Il était à la fois intéressant, insolite, attirant et sensible. Il était rude, résolument différent et, malgré tout, extraordinairement beau. C'était Steve McQueen. Et la série télé s'appelait *Au nom de la loi*. Par la suite, dans des longs métrages comme *La Proie des vautours*, *L'Enfer est pour les héros* et *L'Homme qui aimait la guerre*, c'est toujours Steve McQueen qui attirait l'attention. Puis, en 1963, le film *La Grande Évasion* n'était pas encore sorti que le bruit courait déjà que Steve McQueen y jouait un rôle sensationnel.

Une fois encore, un visage géant était sur le point d'entrer dans nos vies.

Au début des années 1960, j'étais connu pour mes photographies de jazz et j'exerçais la profession de journaliste-photographe avec succès, travaillant souvent pour de grands magazines comme *Life* pour lesquels je couvrais les productions des grands studios. Pour l'un de ces reportages, je devais rencontrer et photographier Natalie Wood. Je me suis présenté sur le plateau 4 des studios de la Paramount afin d'y rencontrer le producteur Alan Pakula, le réalisateur Robert Mulligan et les têtes d'affiche Natalie Wood et Steve McQueen. Le titre du film était *Une certaine rencontre*. Au centre de l'immense plateau de tournage vide, tous étaient assis autour d'une table en train de discuter de tout, des costumes au moindre petit problème de production.

J'ai serré poliment la main de Natalie Wood dont je voyais le beau visage d'aussi près pour la première fois. Ses doux yeux marron foncé ont rencontré les miens et j'ai tout de suite su que nous serions amis. Je me suis alors retourné pour saluer son partenaire, Steve McQueen. Il ne m'a pas tendu la main ; il m'a juste dévisagé avec ses yeux bleu acier. (Plus tard, il m'a dit : « Clax, je t'ai vraiment scié avec mon regard, n'est-ce pas ? ») Il avait un regard à vous glacer le sang. J'ai eu l'impression qu'il savait tout de moi en une fraction de seconde. Je me suis dit : « Et merde, qu'est-ce que je fais donc avec ce type ? » Il était à la fois séduisant et menaçant. Le temps m'a prouvé que mes pressentiments, mes intuitions ou que sais-je encore, ne m'avaient pas trompé sur cet acteur hors du commun. C'était un homme de la rue, un « animal », jouant sur les émotions et branché. En fait, c'est super-branché qu'il faudrait dire.

Le présent ouvrage ne couvre que quelques années de mes relations avec Steve McQueen. Après *Le Kid de Cincinnati*, il est parti à Hong-Kong pour tourner *La Canonnière du Yang Tsé*, pendant que Peggy et moi avons gagné l'Europe pour y poursuivre nos propres carrières. Pendant ces années, Steve McQueen et moi nous sommes rarement parlé. Nos vies ont pris des chemins différents. J'ai lu et entendu depuis qu'il avait sombré dans la cocaïne et que cela avait nui à ses relations. Mais c'était alors une si grande star que seuls les membres de sa famille et ses amis ont eu à subir les conséquences des altérations de sa personnalité.

Pendant ces quelques courtes années au cours desquelles Steve McQueen et moi avons travaillé et joué ensemble, nous nous sommes beaucoup amusés, et je crois que j'ai beaucoup de chance d'avoir connu Steve McQueen, un Américain à part entière.

**William Claxton, Los Angeles, 2004**

Steve returns to New York as a movie star. He had lived in New York City before as a struggling young actor. Although he had worked on the stage in *A Hat Full of Rain*, it wasn't until he went to Hollywood that he became a known talent. New York City, 1962.

Steve kehrt als Filmstar nach New York zurück. Jahre zuvor hatte er sich dort als Nachwuchsschauspieler durchgeschlagen. Trotz seines frühen Bühnenauftritts in dem Broadwaystück *A Hat Full of Rain* wurde er erst in Hollywood als großes Talent gefeiert.
New York City 1962.

Quand il revient à New York, Steve est une star de cinéma. Il avait vécu dans cette ville auparavant, mais c'était alors un jeune acteur qui avait du mal à joindre les deux bouts. Il était déjà monté sur les planches dans une pièce intitulée *A Hat Full of Rain*, mais son talent n'a vraiment été reconnu qu'après son arrivée à Hollywood. New York, 1962.

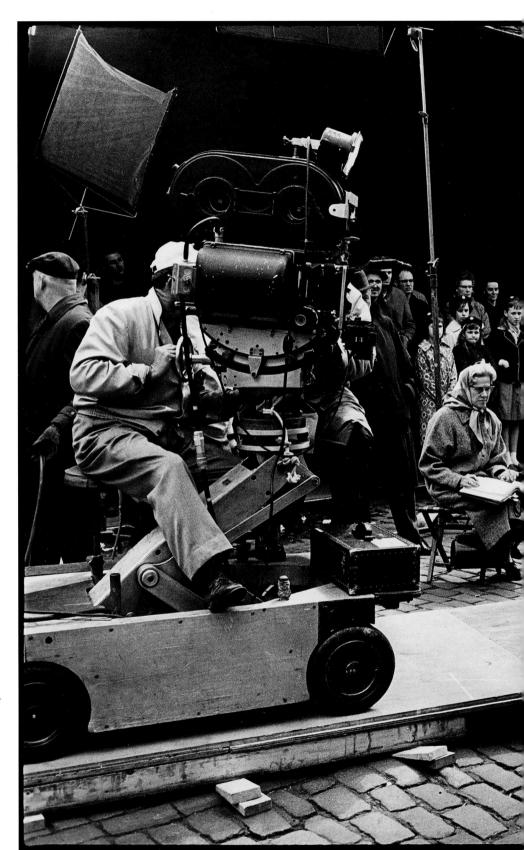

At work in the early
morning hours on the
Lower West Side of
Manhattan for a scene
from *Love with the
Proper Stranger*.
New York City, 1962.

Dreharbeiten in den
frühen Morgenstunden
auf der Lower West
Side, Manhattan, für
eine Szene aus *Verliebt
in einen Fremden*.
New York City 1962.

Sur le tournage d'*Une
certaine rencontre*,
aux premières heures
de la journée dans le
Lower West Side de
Manhattan. New York,
1962.

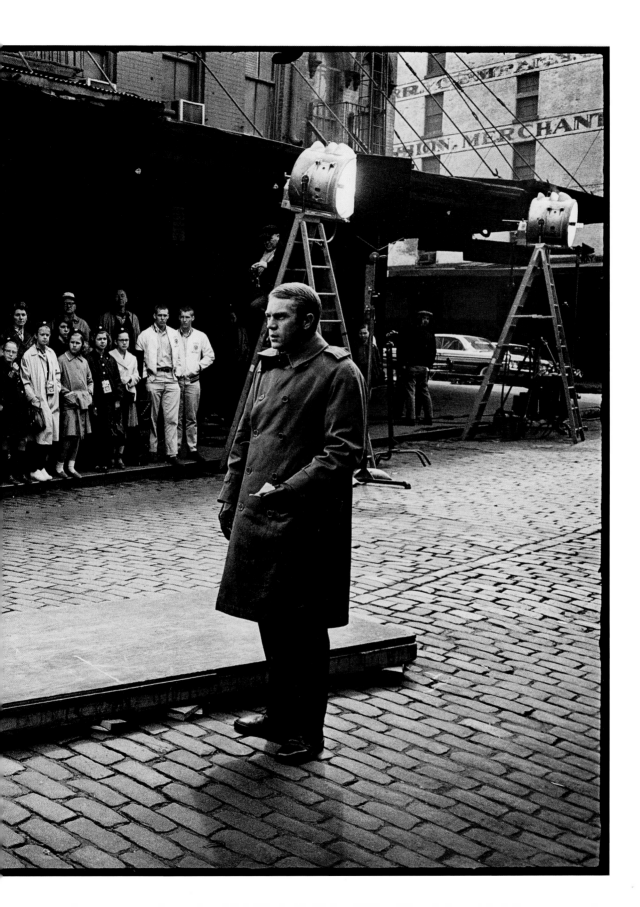

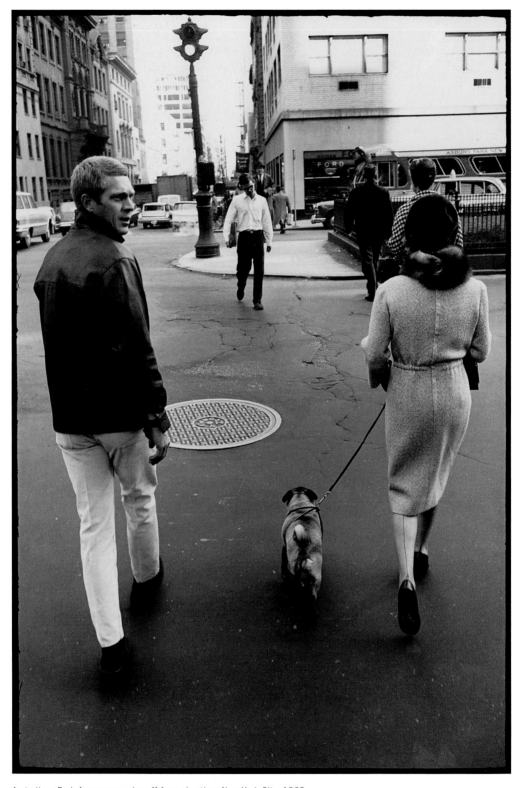

A stroll up Park Avenue on a day off from shooting. New York City, 1962.
Spaziergang auf der Park Avenue an einem drehfreien Tag. New York City 1962.
Promenade dans Park Avenue entre deux journées de tournage. New York, 1962.

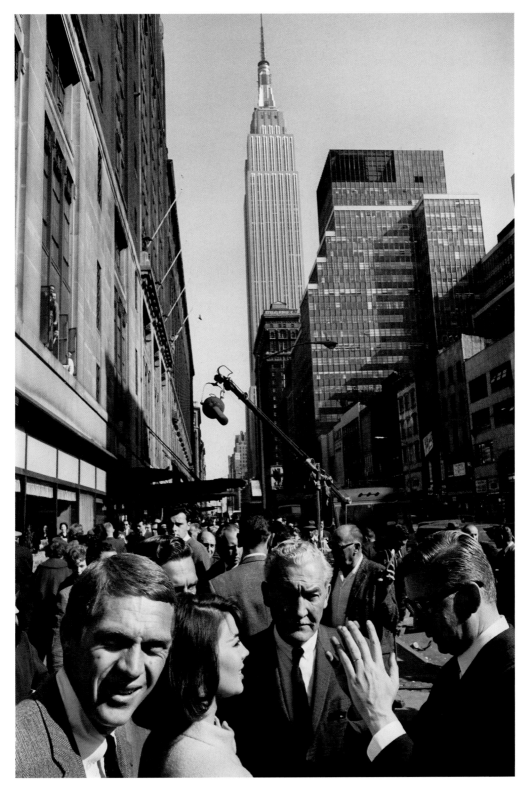

A section of Manhattan's Thirty-Fourth Street was blocked off so that director Robert Mulligan could work with Steve and Natalie Wood for the production *Love with the Proper Stranger*. New York City, 1962.

Ein Abschnitt der 34. Straße in Manhattan wurde abgesperrt, damit Regisseur Robert Mulligan mit Steve und Natalie Wood für *Verliebt in einen Fremden* drehen konnte. New York City 1962.

Une partie de la 34e Rue dans Manhattan a été barrée afin que le réalisateur Robert Mulligan puisse travailler avec Steve et Natalie Wood pour le film *Une certaine rencontre*. New York, 1962.

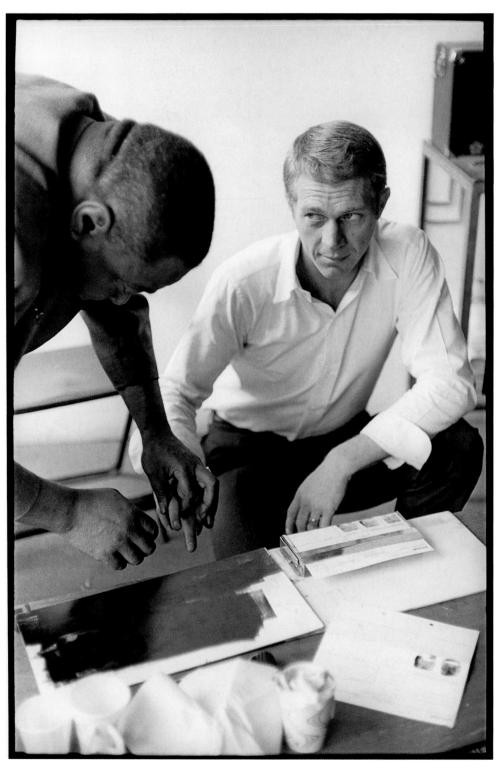

A New York City policeman fingerprints Steve. He played a musician in *Love with the Proper Stranger* and, in accordance with a very old ruling, in order to perform in a nightclub in that city, he had first to obtain a cabaret license. 1962.

Ein New Yorker Polizeibeamter nimmt Steves Fingerabdrücke für seine Rolle als Musiker in *Verliebt in einen Fremden*. Ein uraltes Gesetz verlangte von Musikern eine „Kabarett-Lizenz", um in einem New Yorker Nachtclub auftreten zu dürfen. 1962.

Un policier new-yorkais relève l'empreinte digitale de Steve pour le rôle qu'il joue dans *Une certaine rencontre*. En vertu d'une loi très ancienne, Steve a dû obtenir une « licence de cabaret » pour pouvoir jouer dans un night-club de New York. 1962.

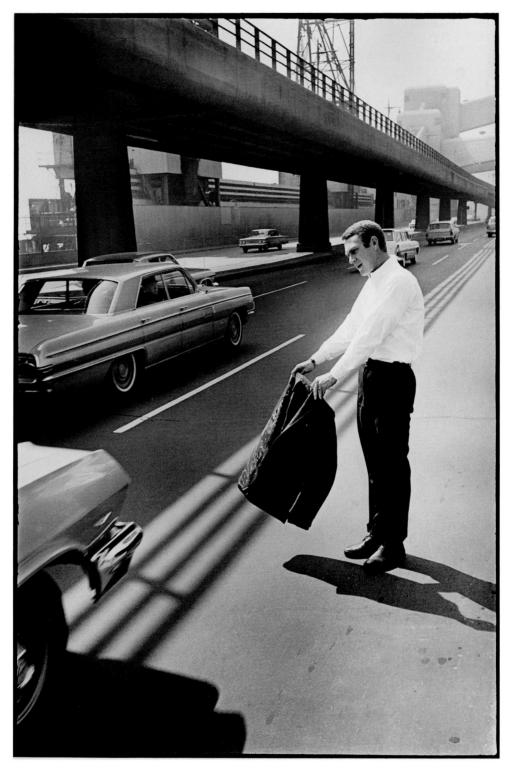

Steve plays matador on the East Side Drive. New York City, 1962.
Steve spielt Matador am East Side Drive. New York City 1962.
Steve joue au matador sur l'East Side Drive. New York, 1962.

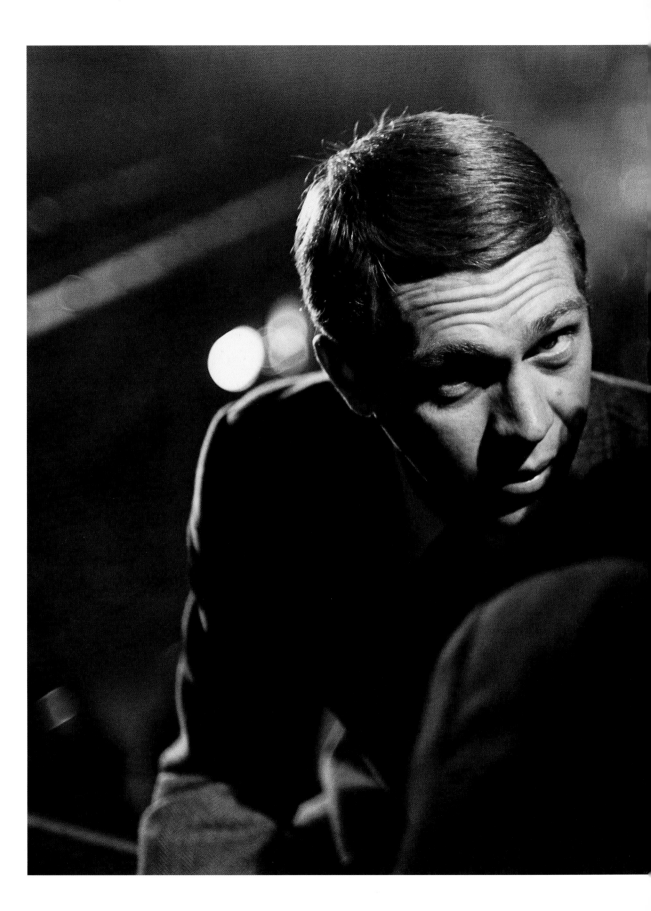

Steve tells Mulligan of a problem and does not want to be overheard. There were times when Steve had such a mistrust of people that it bordered on paranoia, perhaps as a result of growing up without a father and with an alcoholic mother. Hollywood, 1962.

Steve bespricht mit Mulligan ein Problem und will dabei nicht belauscht werden. Zeitweilig hegte Steve anderen Menschen gegenüber ein so tiefes Misstrauen, dass es an Paranoia grenzte – womöglich eine Folge seiner vaterlosen Kindheit mit einer alkoholkranken Mutter. Hollywood 1962.

Steve confie un problème à Mulligan et ne veut être entendu de personne d'autre. Par moments, Steve se méfiait tellement des gens que cela confinait à la paranoïa. Peut-être parce qu'il a grandi sans père et avec une mère alcoolique. Hollywood, 1962.

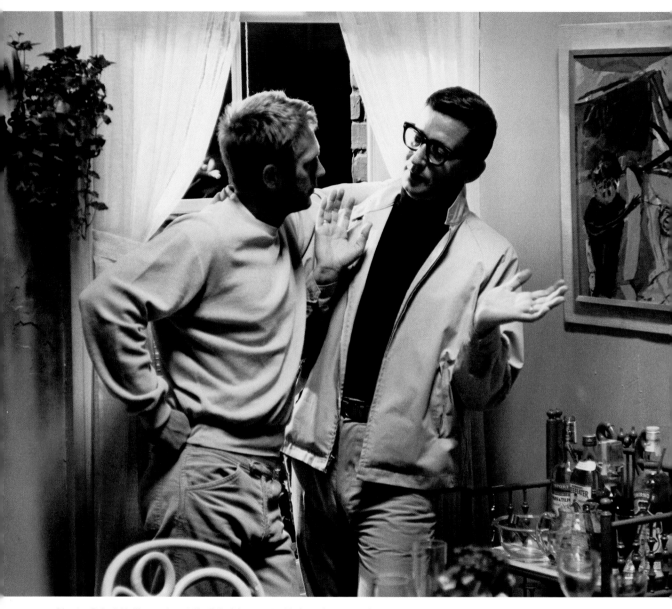

Director Robert Mulligan acts out the Edie Adams part with Steve in a scene from
*Love with the Proper Stranger*. Hollywood, 1962.

Regisseur Robert Mulligan übernimmt den Part von Edie Adams in einer Szene mit Steve
aus *Verliebt in einen Fremden*. Hollywood 1962.

Le réalisateur Robert Mulligan montre à Steve le rôle d'Edie Adams dans *Une certaine
rencontre*. Hollywood, 1962.

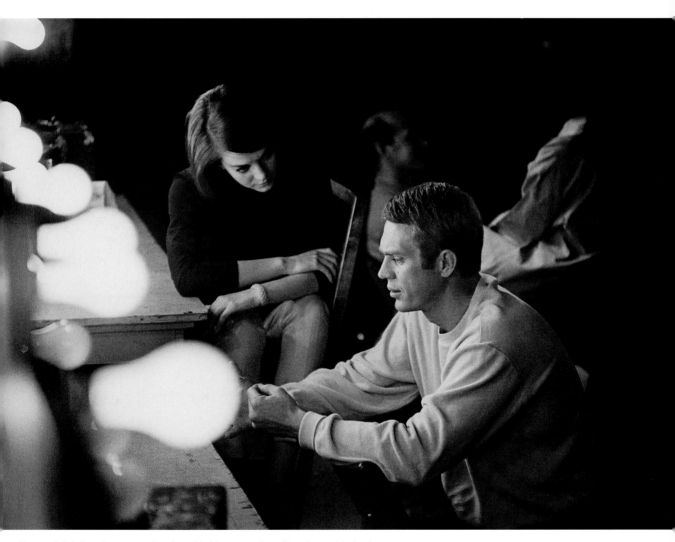

Steve and Natalie got on very well and confided in one another often when not in front of the movie camera. Hollywood, 1962.

Auch wenn Steve und Natalie nicht vor der Filmkamera standen, verstanden sie sich ausgezeichnet und vertrauten einander oft ihre Sorgen an. Hollywood 1962.

Steve et Natalie s'entendaient très bien et se confiaient souvent l'un à l'autre hors du champ de la caméra. Hollywood, 1962.

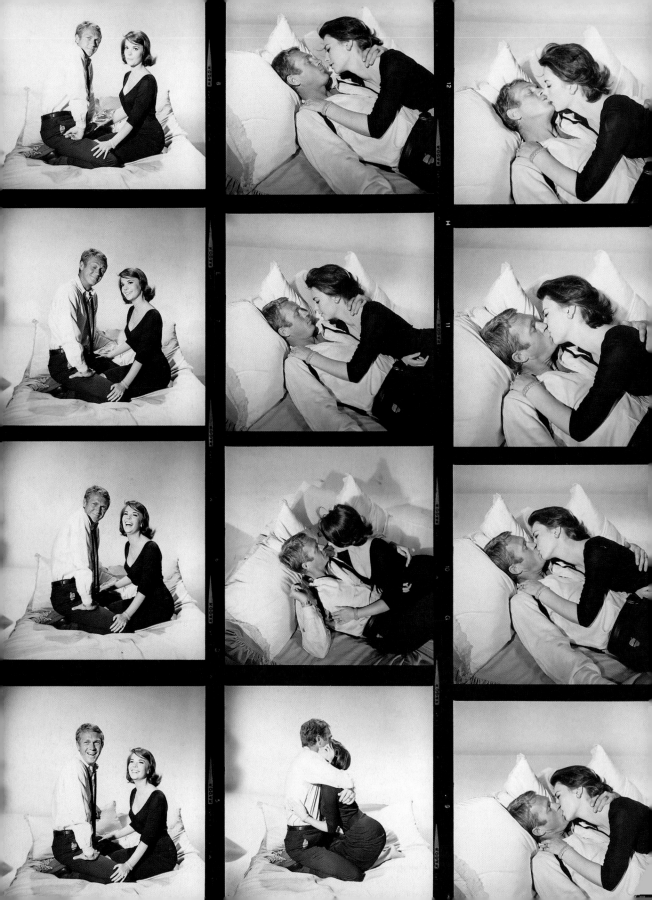

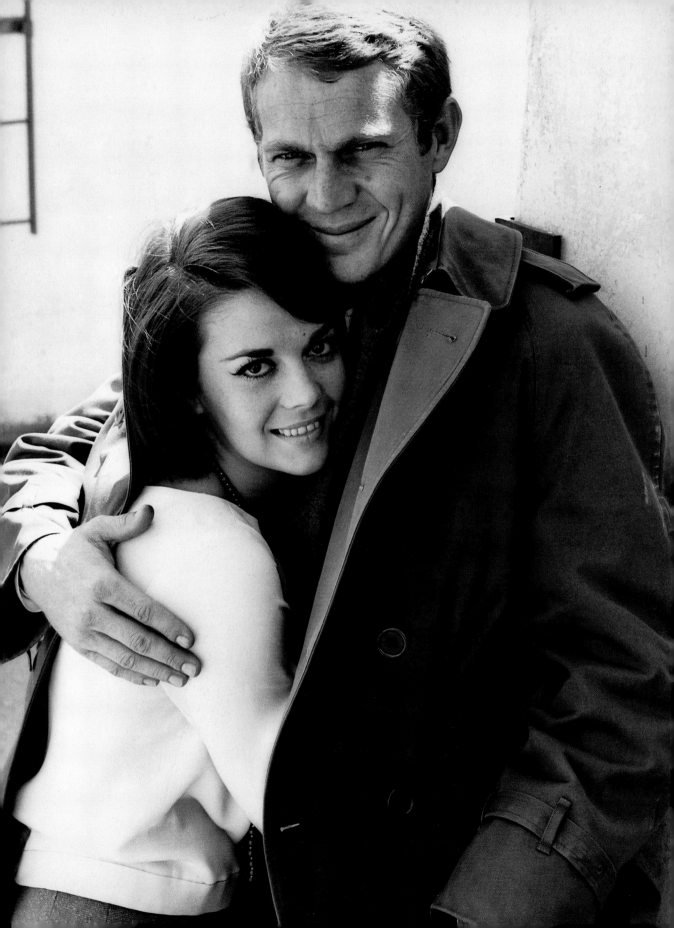

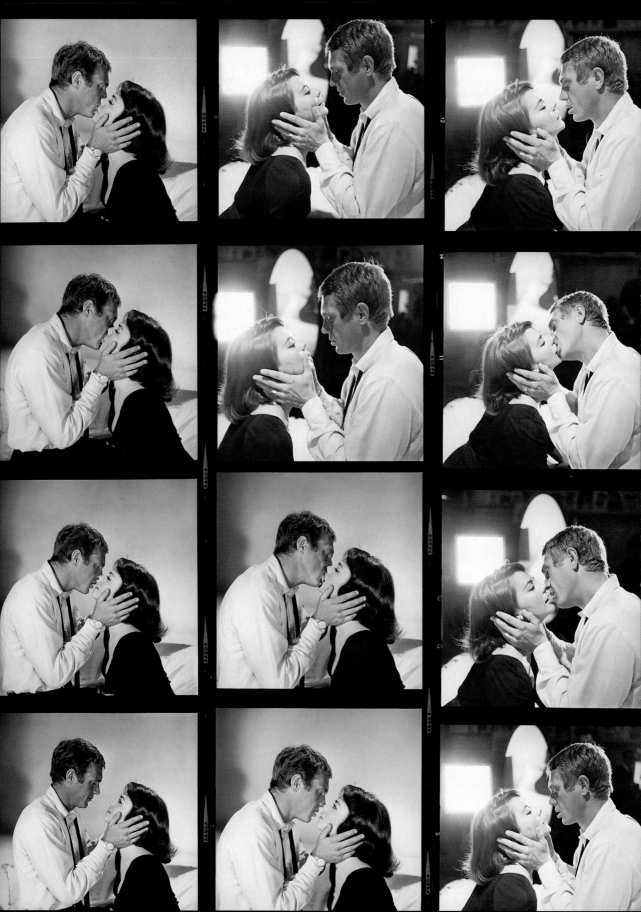

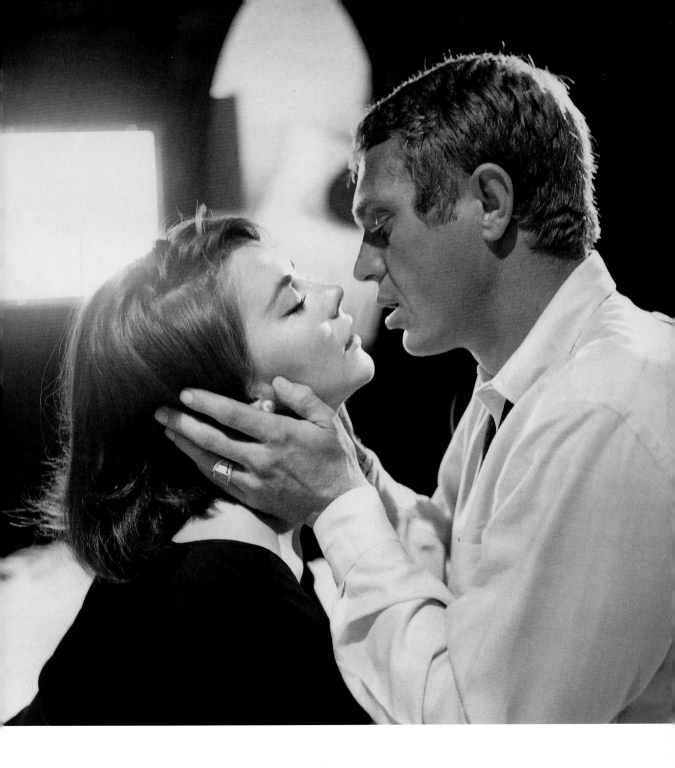

We shot these publicity photos at Paramount Studios to illustrate the advertisements for *Love with the Proper Stranger*. Hollywood, 1962.

Diese Fotoaufnahmen entstanden in den Paramount Studios als Bildmaterial für die Werbekampagne zu *Verliebt in einen Fremden*. Hollywood 1962.

Ces photographies ont été prises dans les studios de la Paramount pour la promotion du film *Une certaine rencontre*. Hollywood, 1962.

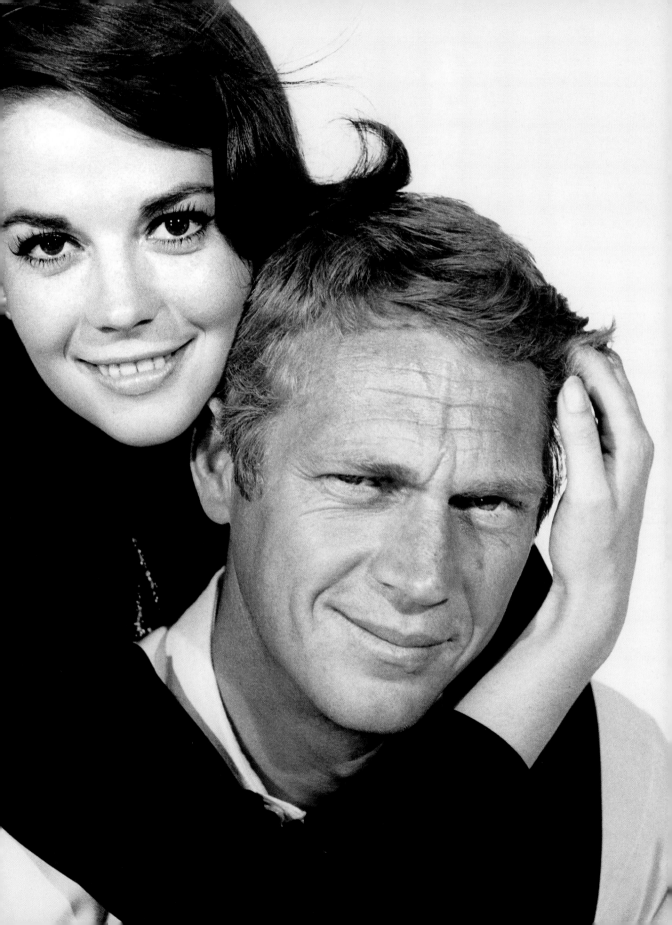

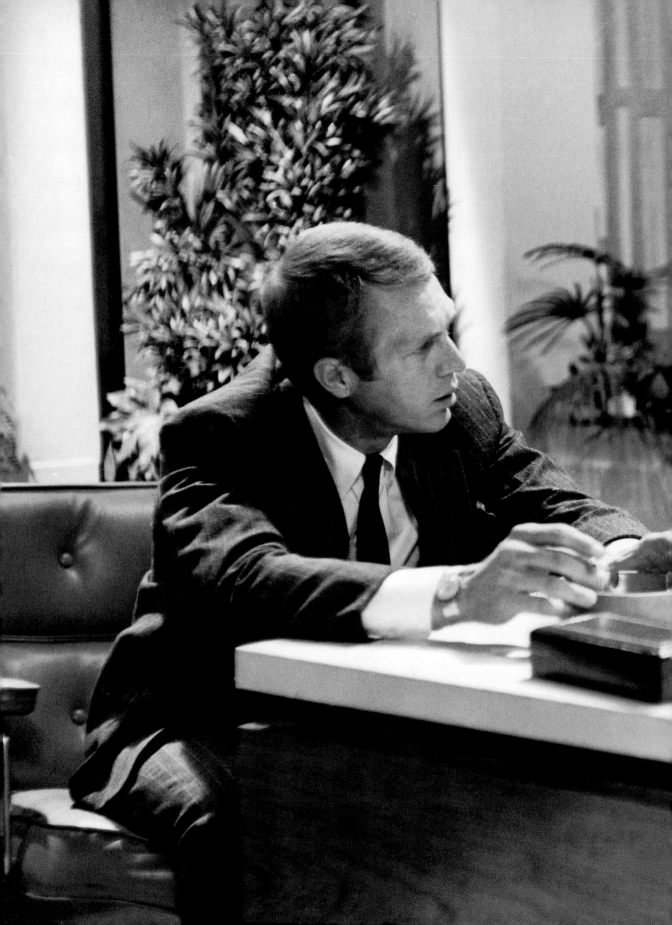

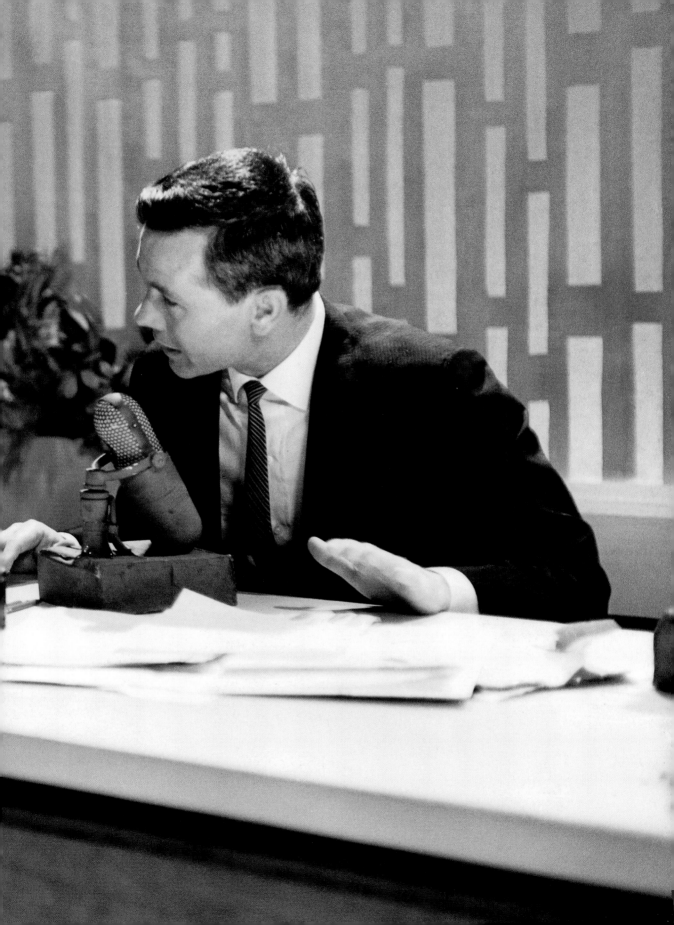

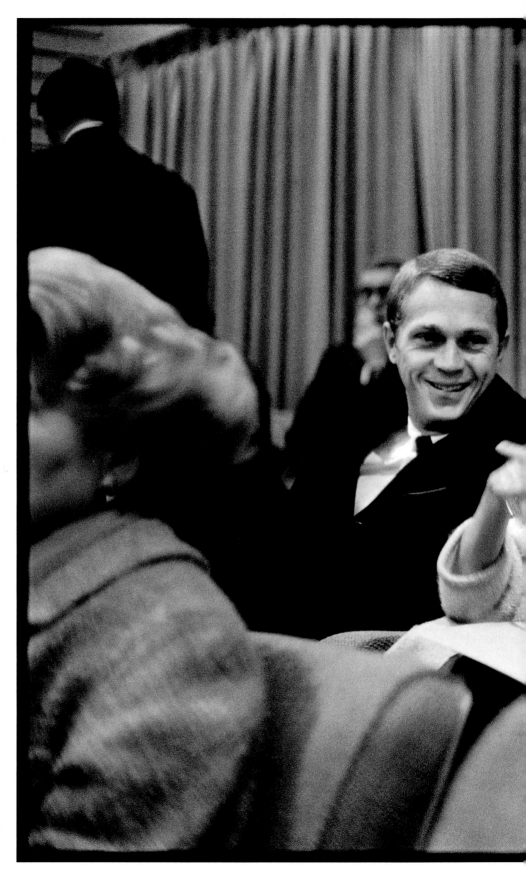

Steve and his wife
Neile sit with Hedda
Hopper at a screening
of *The Great Escape*.

Steve und seine Frau
Neile zusammen mit
Hedda Hopper bei
einer Vorführung von
*Gesprengte Ketten*.

Steve et son épouse
Neile encadrant
Hedda Hopper lors
d'une projection de
*La Grande Évasion*.

Pages 38–39:
*The Tonight Show
Starring Johnny Carson*.
New York City, 1964.

Seite 38–39:
Steve in Johnny
Carsons *Tonight Show*.
New York City 1964.

Pages 38–39:
Extrait de l'émission
*The Tonight Show
Starring Johnny Carson*.
New York, 1964.

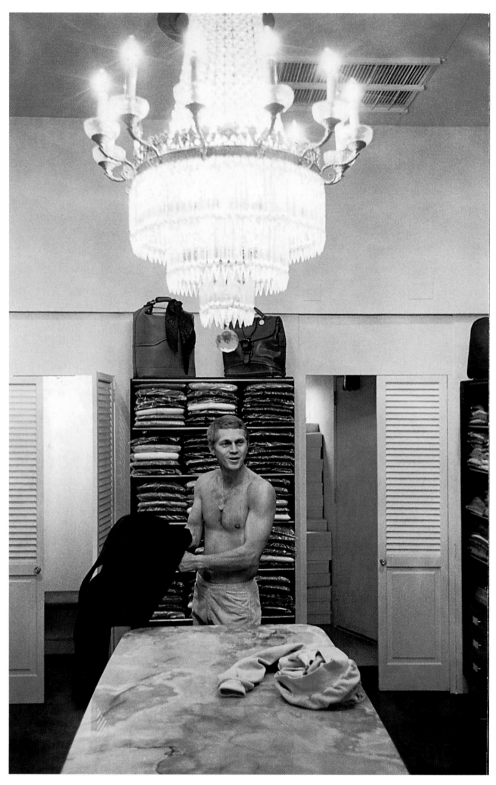

Battaglia men's store on Fifth Avenue. New York City, 1962.
Der Herrenausstatter Battaglia auf der Fifth Avenue. New York City 1962.
Dans la boutique pour hommes Battaglia, sur la 5e Avenue. New York, 1962.

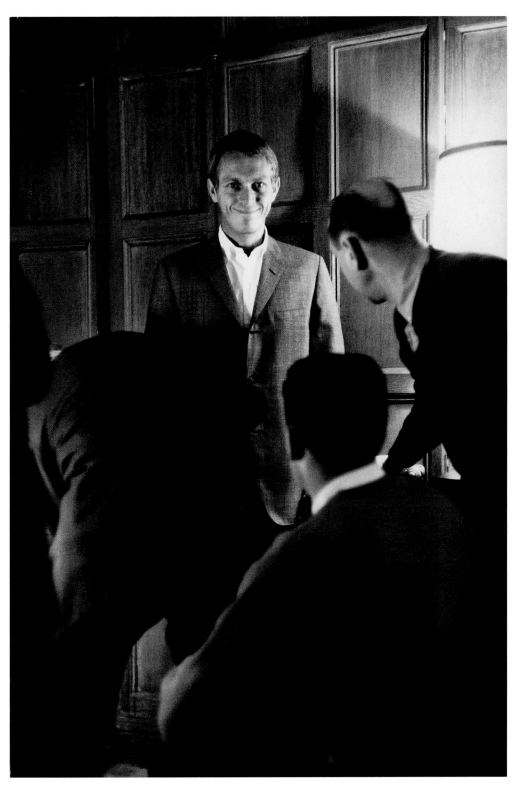

Wardrobe fitting. New York City, 1962.
Anprobe. New York City 1962.
Séance d'essayage. New York, 1962.

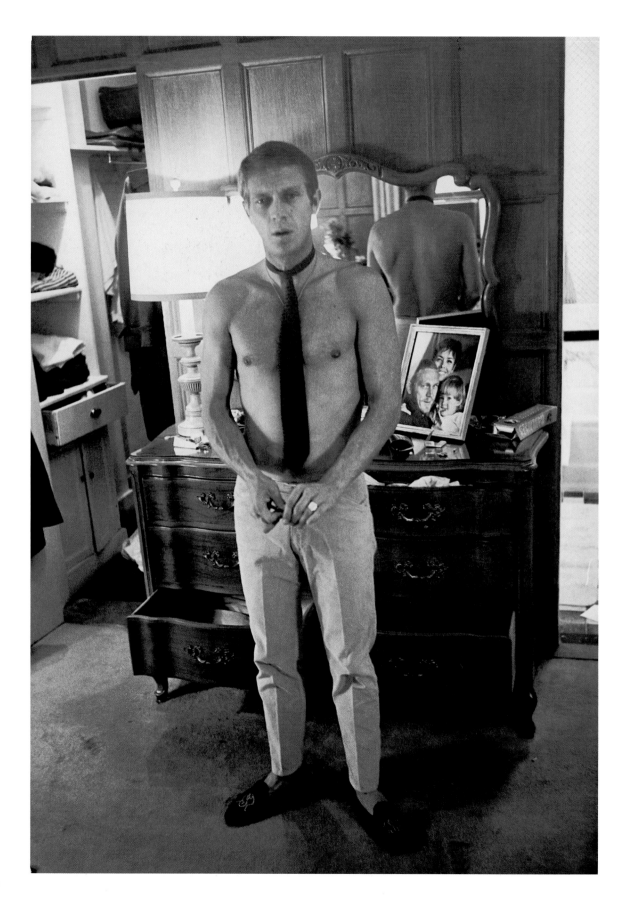

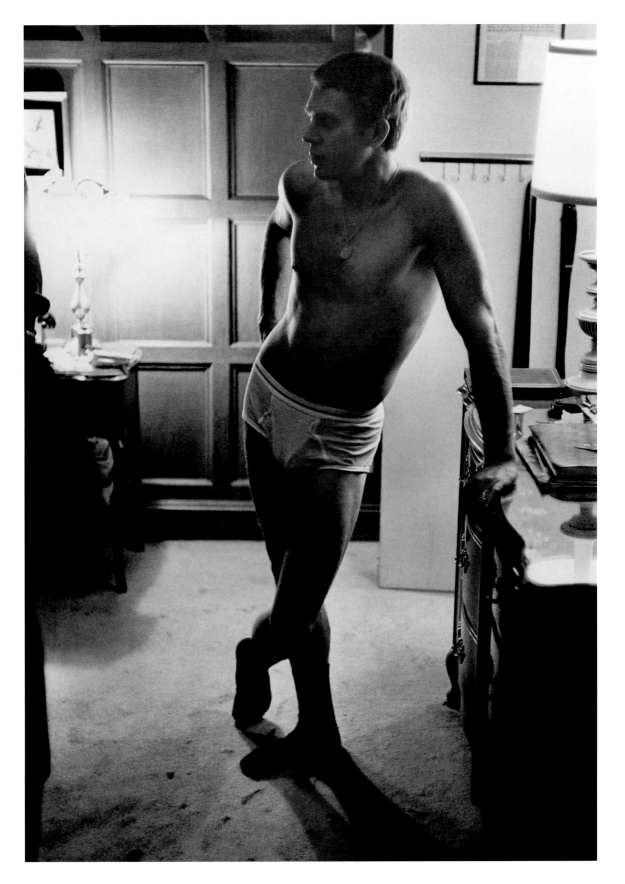

Steve relaxing and clowning around in his suite at the Sherry-Netherlands Hotel. At one point that evening, while basking in this luxurious hotel, Steve remarked to me that only a few years ago he had lived six blocks from there in a cold-water flat with three other guys. "Man, I was starving – I did everything and anything to survive." New York City, 1962.

Steve ganz entspannt und albern in seiner Suite im Sherry Netherlands Hotel. Irgendwann an diesem Abend, an dem wir es uns in dem Luxushotel gut gehen ließen, erzählte mir Steve, dass er nur wenige Jahre zuvor sechs Blocks entfernt mit drei anderen Jungs in einer Bude ohne heißes Wasser gehaust hatte. „Mann, ich war am Verhungern – ich machte so ziemlich alles, um zu überleben." New York City 1962.

Steve se détend en faisant le clown dans sa suite au Sherry Netherlands Hotel. Ce soir-là, alors qu'il se la coulait douce dans cet hôtel de luxe, Steve m'a confié que, seulement quelques années plus tôt, il avait habité à six pâtés d'immeubles de là, dans un appartement sans eau chaude, avec trois autres camarades. « Et je peux te dire que je mourais de faim. J'ai vraiment fait tout et n'importe quoi pour survivre. » New York, 1962.

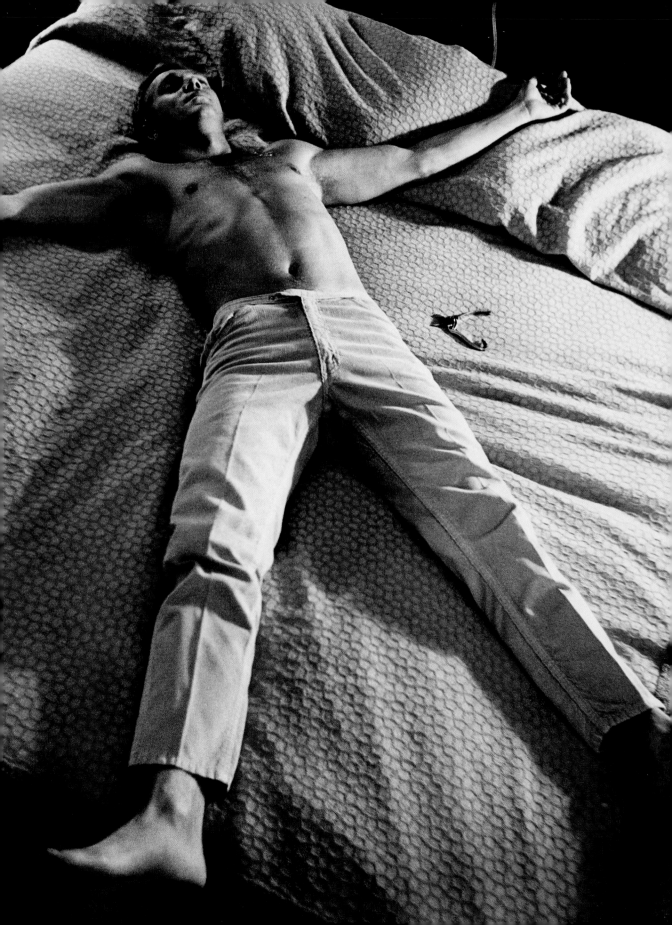

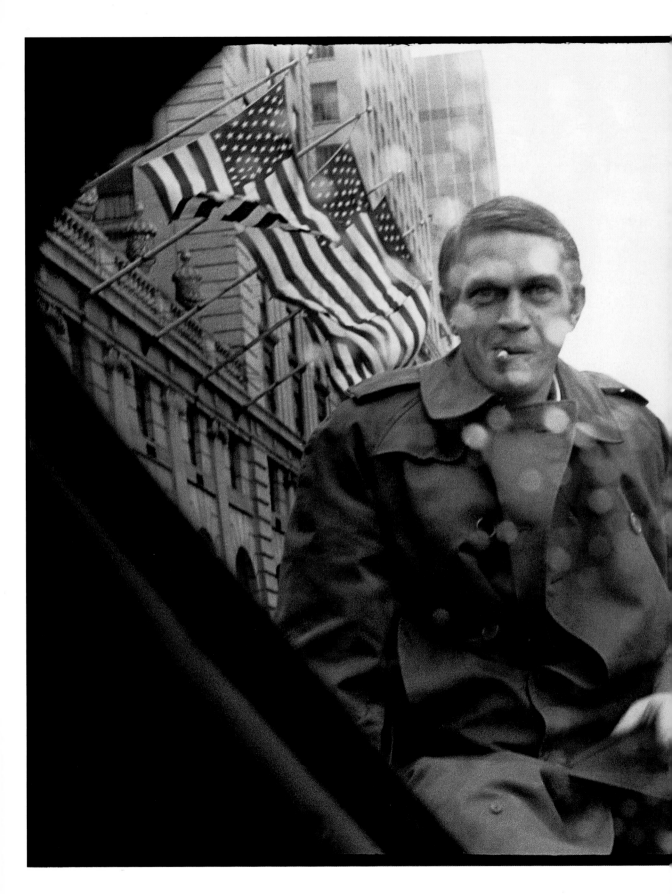

Steve jumps from one limousine to another in a derring-do performance during a rain shower on Fifth Avenue. Just having a little fun. New York City, 1962.

Während eines Regenschauers auf der Fifth Avenue wagt Steve den tollkühnen Sprung von einer Limousine in die andere. Ein kleiner Spaß am Rande. New York City 1962.

Alors qu'il pleut sur la 5e Avenue, Steve saute allègrement d'une limousine à l'autre. Il faut bien s'amuser un peu. New York, 1962.

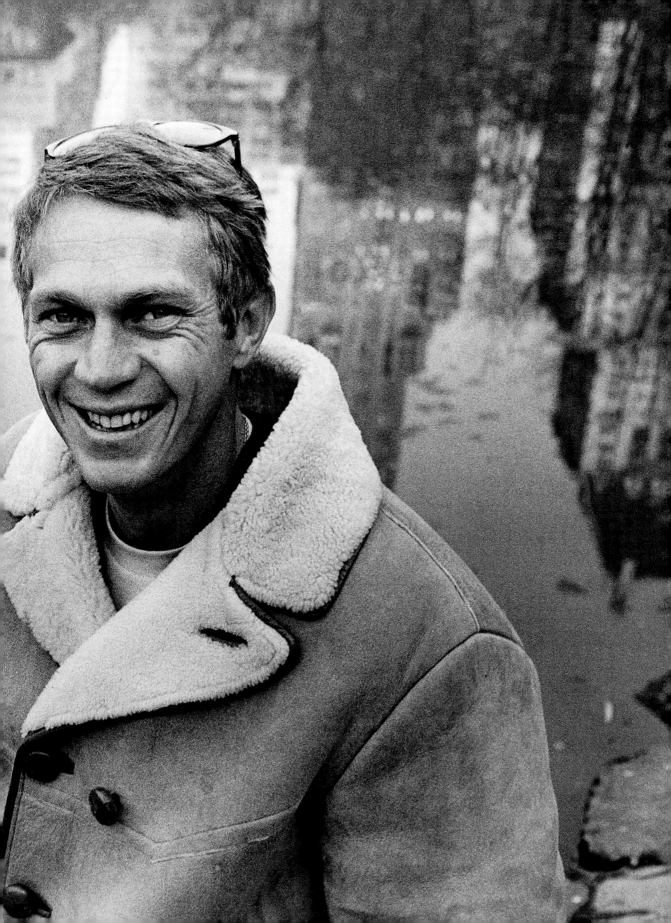

Screening the previous day's "rushes" or "dailies" of *Love with the Proper Stranger*. Left to right: producer Alan Pakula, visitor and choreographer Jerome Robbins, director Robert Mulligan, Natalie Wood, editor Aaron Stell, and McQueen. Robbins and Natalie had become close friends after working together on *West Side Story*. New York City, 1962.

Vorführung der tags zuvor entstandenen Filmsequenzen zu *Verliebt in einen Fremden*. Von links nach rechts: Produzent Alan Pakula, der Choreograph Jerome Robbins als Gast, Regisseur Robert Mulligan, Natalie Wood, der Cutter Aaron Stell und McQueen. Nach ihrer Zusammenarbeit für die *West Side Story* waren Robbins und Natalie enge Freunde geworden. New York City 1962.

Pendant la projection des rushes d'*Une certaine rencontre* tournés la veille. De gauche à droite : le producteur Alan Pakula, le chorégraphe en visite Jerome Robbins, le réalisateur Robert Mulligan, Natalie Wood, le monteur Aaron Stell et Steve McQueen. Jerome et Natalie étaient devenus bons amis après avoir travaillé ensemble sur *West Side Story*. New York, 1962.

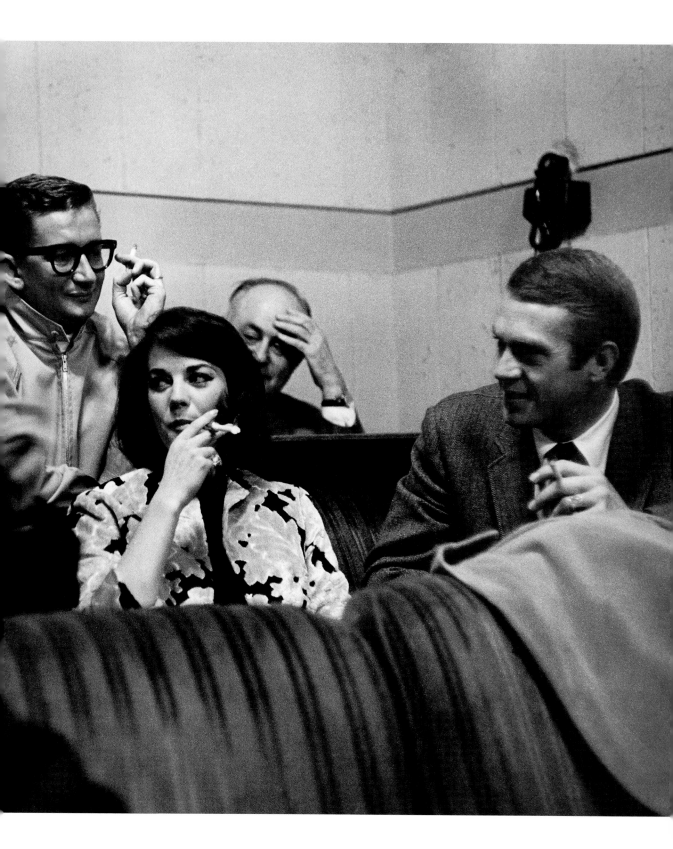

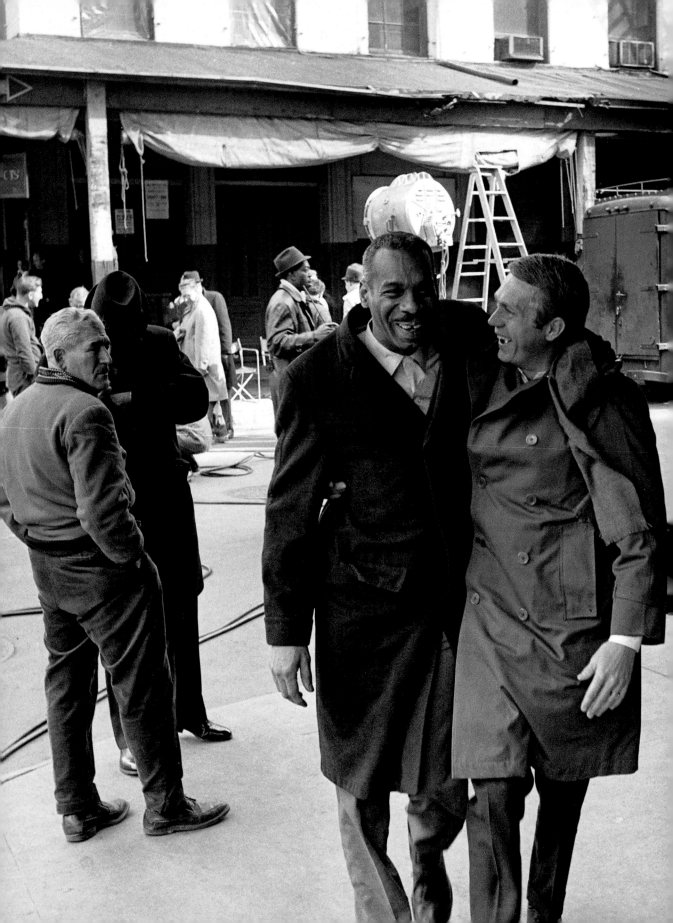

While on location in Mahattan's Lower West Side, Steve is visited by George Downs, one of his pals from his early struggling actor days in the city. I never saw Steve so happy to see someone. He became very emotional upon seeing George and brought him over to meet his assistant Sid Kaiser. The more I learned about Steve and his never having known his father, the more I understood his behavior and camaraderie with other men. New York City, 1962.

Während der Dreharbeiten auf Manhattans Lower West Side bekommt Steve Besuch von George Downs, einem seiner Kumpel aus den bitteren Tagen als Jungschauspieler in New York. Selten habe ich Steve so glücklich gesehen. Er war ganz gerührt von dem Wiedersehen mit George und bestand darauf, ihn seinem Assistenten Sid Kaiser vorzustellen. Je mehr ich über Steve und seine vaterlose Kindheit erfuhr, desto besser verstand ich sein Verhalten und seine kameradschaftliche Art gegenüber anderen Männern. New York City 1962.

Alors qu'il tourne dans le Lower West Side de Manhattan, Steve reçoit la visite de George Downs, l'un de ses camarades à l'époque où il était encore tout jeune acteur. Je n'ai jamais vu Steve aussi heureux. La visite de George l'a rempli d'émotion et il a accompagné son ami pour lui présenter son assistant Sid Kaiser. Plus j'en apprenais sur Steve et sa vie passée sans avoir connu son père, plus je comprenais son comportement et son esprit de camaraderie masculine. New York, 1962.

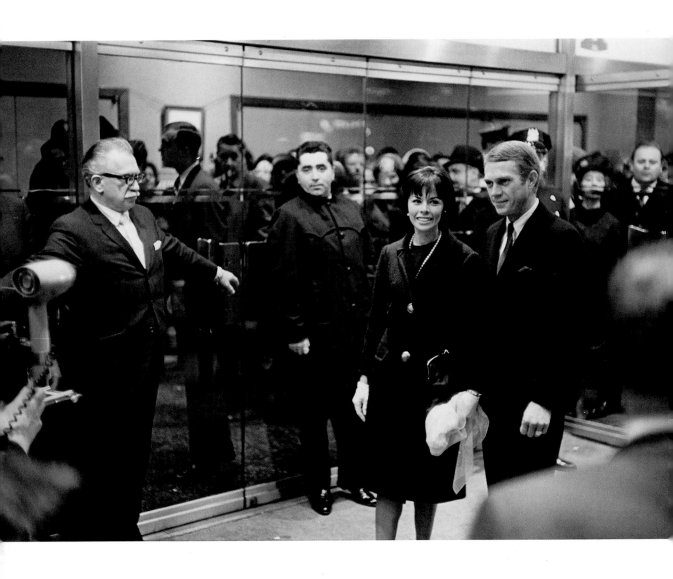

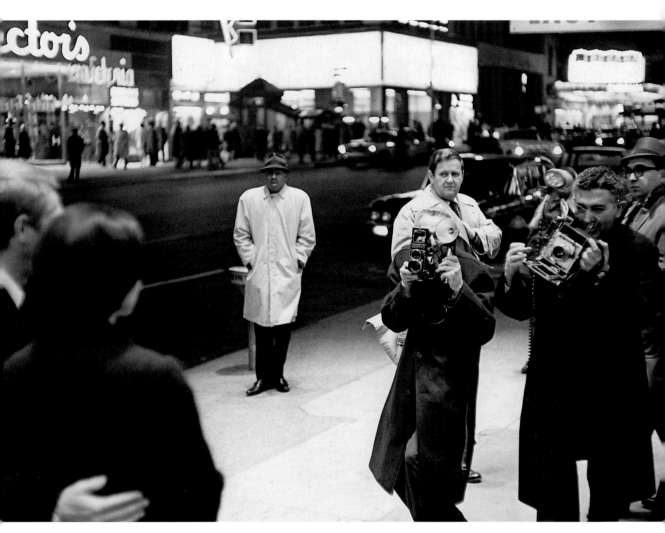

Several nights later, as Steve and Neile leave the theater after the premiere of *The Great Escape*, George appears on the sidewalk to greet them. New York City, 1962.

Einige Tage später steht George, als Steve und Neile nach der Premiere von *Gesprengte Ketten* das Kino verlassen, überraschend auf dem Bürgersteig, um sie in Empfang zu nehmen. New York City 1962.

Plusieurs jours plus tard, alors que Steve et Neile quittent le cinéma après la première de *La Grande Évasion*, George les attend sur le trottoir pour les saluer. New York, 1962.

In his hotel suite after a screening of *The Great Escape*, my wife Peggy Moffitt turned to Steve and said, "You know, Steve, you have a choice that very few actors ever get: you could become a great actor or you can be a movie star." Her remark stopped Steve in his tracks. He looked at her in amazement, turned to me and said, "Man, your ol' lady is really something else!" New York City, 1962.

Meine Frau Peggy Moffitt sagte nach einer Vorführung von *Gesprengte Ketten* in seiner Hotelsuite zu Steve: „Weißt du, Steve, du hast eine Chance, die sich nur ganz wenigen Schauspielern bietet: Du kannst wählen, ob du ein großartiger Schauspieler werden oder ein Film-star sein willst." Steve hielt in der Bewegung inne. Er schaute sie erstaunt an und sagte dann zu mir: „Mann, deine bessere Hälfte ist 'ne Wucht!" New York City 1962.

Dans la suite de Steve, après une projection de *La Grande Évasion*, mon épouse Peggy Moffitt se tourne vers lui et lui dit : « Tu sais, Steve, tu es un des rares acteurs à pouvoir choisir entre devenir un grand acteur ou être une star de cinéma. » Sa remarque l'a stoppé net. Steve a regardé mon épouse avec stupeur, il s'est tourné vers moi et il m'a dit : « Mon vieux, ta patronne n'est vraiment pas comme les autres ! » New York, 1962.

It was about 4 AM, pitch black, on a Sunday morning. The phone rang. I tossed the covers aside and reached across the bed over Peggy, picking up the phone on the second or third ring.

"Hello." I recognized McQueen's voice.

"Hey Clax ...," said a hushed but urgent voice, " ... Steve. Hey, what's happenin', you wanna go with us? I'm meetin' Bud and Don and some of the other cats up in Palmdale at Du-par's. We're headin' out to Mojave, cross-country bike race. We'll have breakfast there." His voice got seductive, "Eggs over easy, bacon, hashbrowns, hot coffee. It'll be a blast. Watch the sun come up over the desert. Smoke a little. You know, get next to nature. Can you dig it?"

"Yeah, uh ... let me wake up a little, okay?" Steve continued nonstop: "We'll chase some jackrabbits across the desert. Do some wheelies in the sand, hot, sweaty. We'll have a ball." Pause. "Yeah, I know your ol' lady's gonna be pissed. So's mine. Hey, we gotta make it. 'Bout noon, when it's too hot, we'll take off and head to a funky little Mexican place I know near Pearblossom. Guacamole, refried beans and some brews. Okay? See ya in about thirty minutes, my place."

"Yeah, okay," yawn, "but give me a little more time."

Steve interrupts: "Clax, don't forget to bring your ax. You'll get some great shots."

I hang up the phone. Peggy rolls over and in a slightly sarcastic tone says: "Let me guess; must be Steve. Wants you to go out with the 'guys.' Right? Well ... okay. See you about dinner time ... if I'm lucky."

I kissed her goodbye.

Los Angeles, August 1963.

Es war etwa vier Uhr früh an einem Sonntagmorgen und stockdunkel. Das Telefon läutete. Ich warf die Decke zur Seite, langte quer über das Bett und Peggy hinweg nach dem Telefon und nahm beim zweiten oder dritten Klingeln ab.

„Hallo." Ich erkannte McQueen.

„Hey, Clax ...", erklang eine gedämpfte, aber drängende Stimme, „... hier ist Steve. Hey, wie sieht's aus, kommst du mit? Ich treff' mich mit Bud und Don und ein paar von den anderen Jungs oben in Palmdale im Du-par's. Wir fahren in die Mojave-Wüste, zu einem Cross-Country-Motorradrennen. Wir wollen dort frühstücken." Seine Stimme wurde verführerisch: „Spiegeleier, Speck, Bratkartoffeln, heißer Kaffee. Das wird 'ne Party. Zusehen, wie die Sonne über der Wüste aufgeht. Was rauchen. Weißt schon, eins werden mit der Natur. Alles klar?"

„Hmm, ja ... lass mich erst mal wach werden, okay?"

Steve redete ununterbrochen weiter: „Wir treiben ein paar Hasen durch die Wüste. Drehen ein paar heiße, schweißtreibende Runden im Sand. Wir werden einen Mordsspaß haben." Pause. „Ich weiß, deine Alte wird stinksauer sein. Meine auch. Hey, wir müssen das bringen. Gegen Mittag, wenn es zu heiß wird, fahren wir weiter zu einem abgefahrenen mexikanischen Schuppen in der Nähe von Pearblossom. Guacamole, Bohnenmus und ein paar Bier. Okay? Wir sehn uns in etwa einer halben Stunde bei mir."

„Okay", gähne ich, „aber lass mir etwas mehr Zeit."

Steve unterbricht: „Clax, und denk an deine ‚Ax'. Du wirst tolle Aufnahmen bekommen." Ich legte den Hörer auf. Peggy wälzte sich herum und sagte in einem leicht sarkastischen Ton: „Lass mich raten, bestimmt Steve. Will, dass du mit den Jungs rausfährst. Stimmt's? Tja ... okay. Dann seh' ich dich also zum Abendessen ... wenn ich Glück hab'."

Ich küsste sie zum Abschied.

Los Angeles, August 1963.

Il doit être quatre heures du matin. Il fait nuit noire. On est dimanche matin. Tout à coup, le téléphone sonne. Je rejette les couvertures et passe mon bras au-dessus de Peggy pour attraper le téléphone, et je décroche à la deuxième ou troisième sonnerie.

« Allô ? Je reconnais la voix de Steve.

– Salut, Clax ..., dit une voix étouffée, mais pressée, ... c'est Steve. Eh, dis, tu veux venir avec nous ? Je vais retrouver Bud et Don et quelques autres à Palmdale, au Du-par's. On s'en va dans le désert Mojave pour faire une course de motocross. On prendra le petit déjeuner là-bas. » Sa voix devient séduisante : « Œufs au bacon, pommes de terre sautées, café chaud : ça va être la fête ! Un lever de soleil sur le désert, une cigarette, se rapprocher de la nature, tu vois le genre. Alors, ça te dit ?

– Euh, ouais ... laisse-moi me réveiller un peu, tu veux ? »

Steve continue : « On va chasser le lièvre dans le désert. Et faire du rodéo dans le sable. Il va faire chaud, on va transpirer un bon coup. On va s'éclater. » Il marque une pause. « Bon, je sais que la patronne ne va pas apprécier. La mienne non plus. Mais il faut qu'on le fasse. Vers midi, quand il fera trop chaud, on partira et on ira dans un super restaurant mexicain que je connais près de Pearblossom. Guacamole, haricots frits et quelques bons verres. D'accord ? Alors, dans une demi-heure, chez moi.

– Bon, d'accord, dis-je en bâillant, mais laisse-moi un peu de temps. »

Steve m'interrompt : « Clax, n'oublie pas d'apporter ton Ax. Tu vas pouvoir t'éclater avec. »

Je raccroche. Peggy se retourne et me dit d'un ton légèrement moqueur : « Laisse-moi deviner : c'était Steve, hein ? Il veut que tu partes avec ses potes, n'est-ce pas ? Eh bien, vas-y ... Et à ce soir pour le dîner ... avec un peu de chance. »

J'ai embrassé ma femme, je lui ai dit au revoir et je suis parti.

Los Angeles, août 1963.

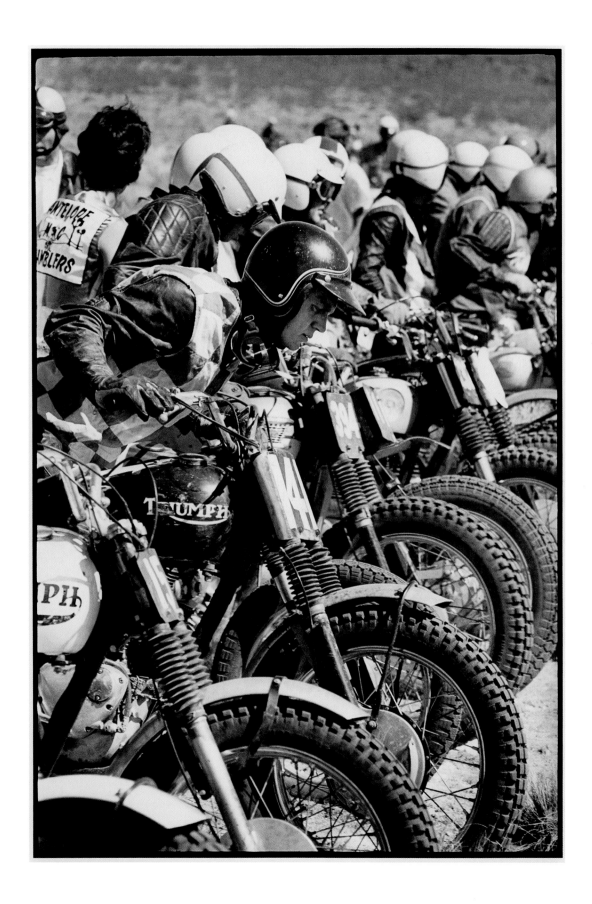

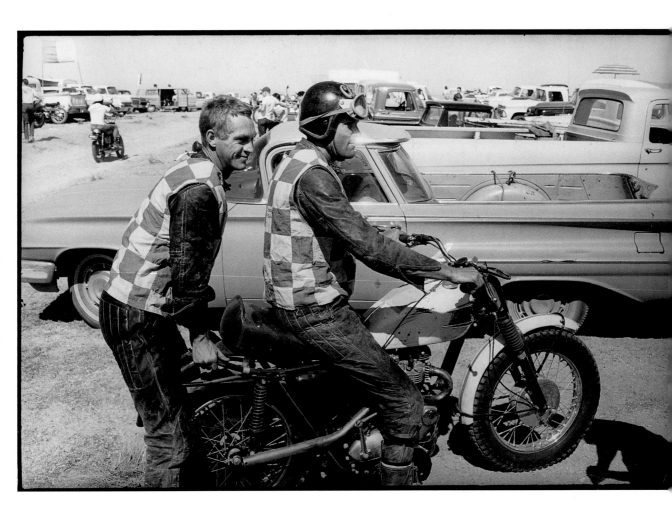

Page 61: The starting line for one of many races Steve was to ride with his pal Bud Ekins, the stuntman who performed all of Steve's dangerous riding scenes in *The Great Escape*. Mojave Desert, 1963.

Seite 61: Vor dem Start zu einem von vielen Rennen, die Steve mit seinem Freund Bud Ekins fuhr, dem Stuntman, der ihn bei sämtlichen gefährlichen Fahrszenen in *Gesprengte Ketten* doubelte. Mojave-Wüste 1963.

Page 61 : Avant l'une des nombreuses courses que Steve a disputées avec son ami Bud Ekins, le cascadeur qui l'a doublé dans toutes les scènes dangereuses de *La Grande Évasion*. Désert Mojave, 1963.

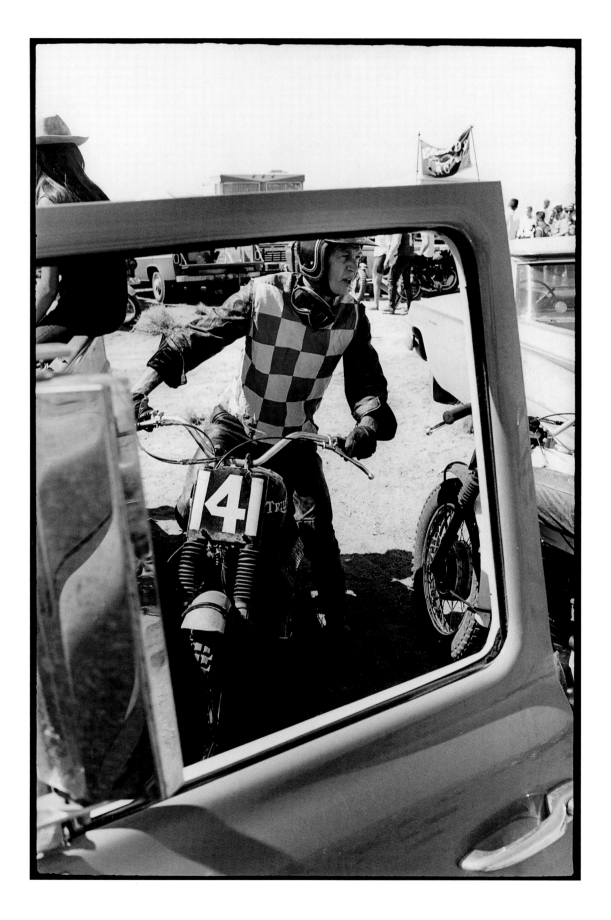

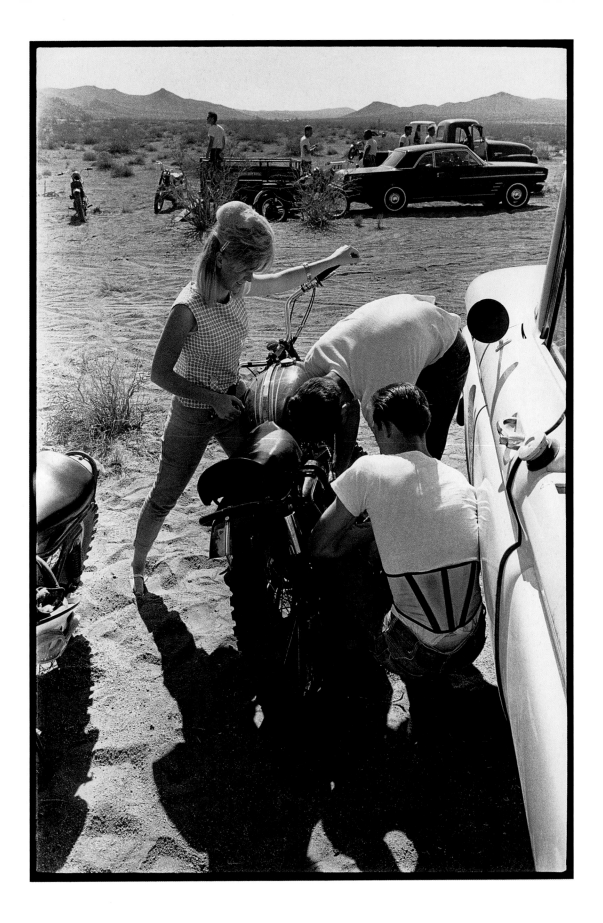

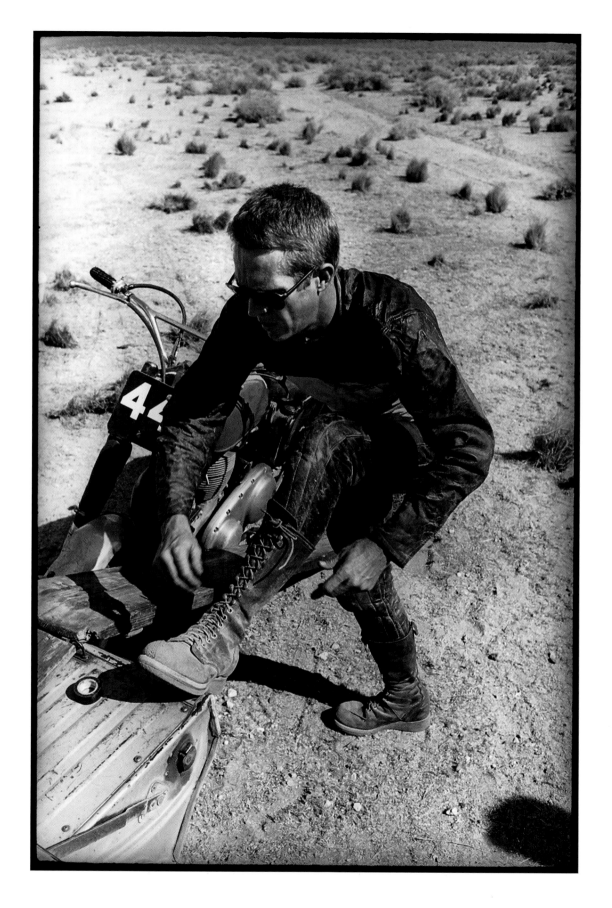

Steve takes off in a blaze of smoke and sand in the first race of the day. Mojave Desert, 1963.

In einer Wolke aus Rauch und Sand startet Steve das erste Rennen des Tages. Mojave-Wüste 1963.

Première course de la journée : Steve démarre dans un nuage de fumée et de sable. Désert Mojave, 1963.

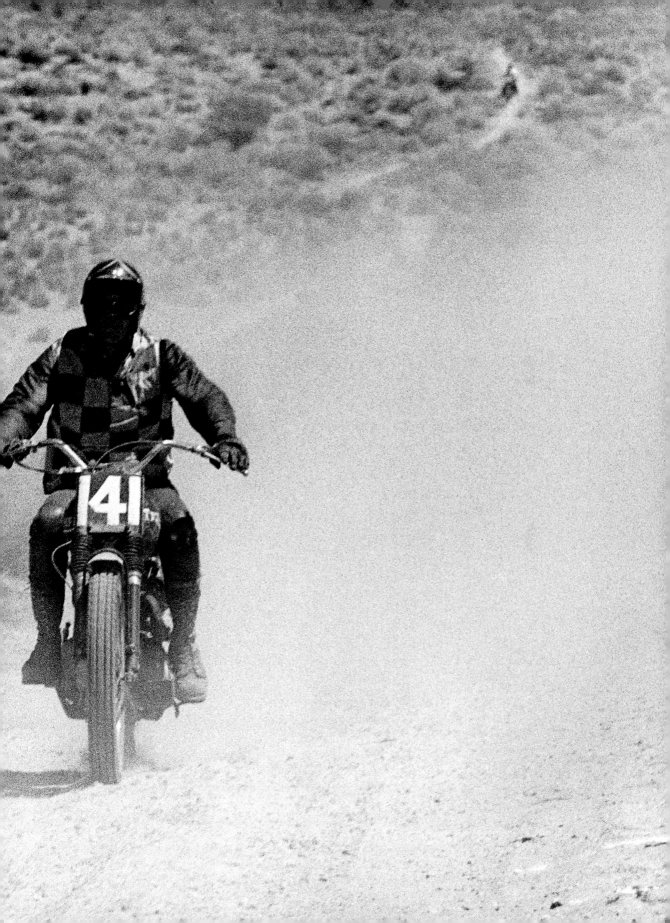

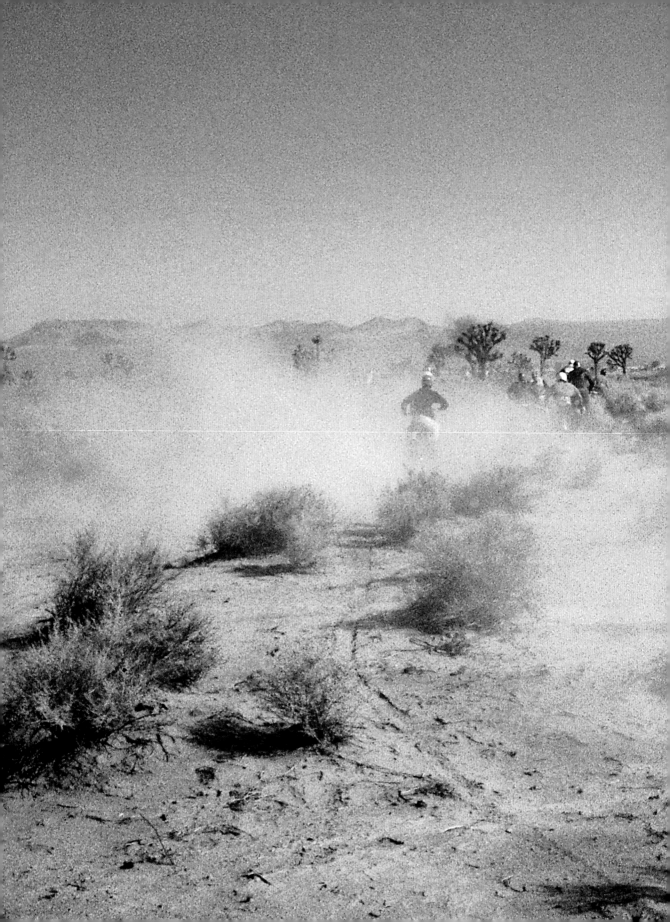

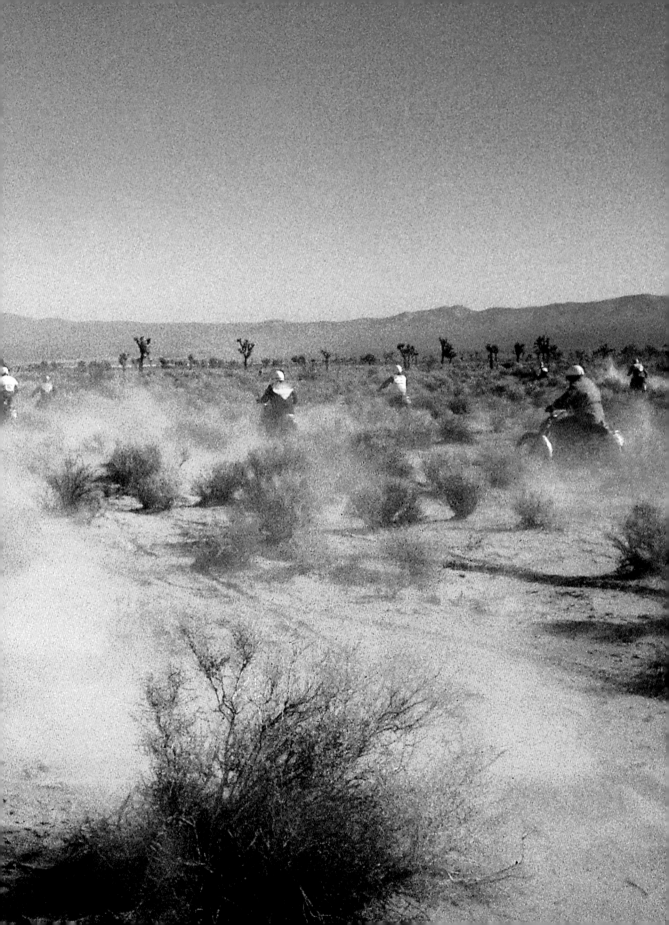

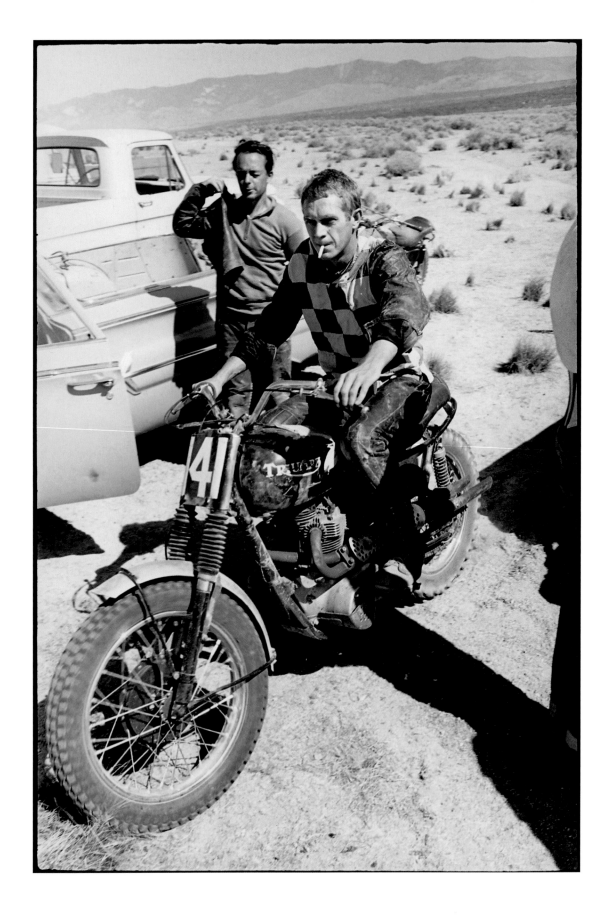

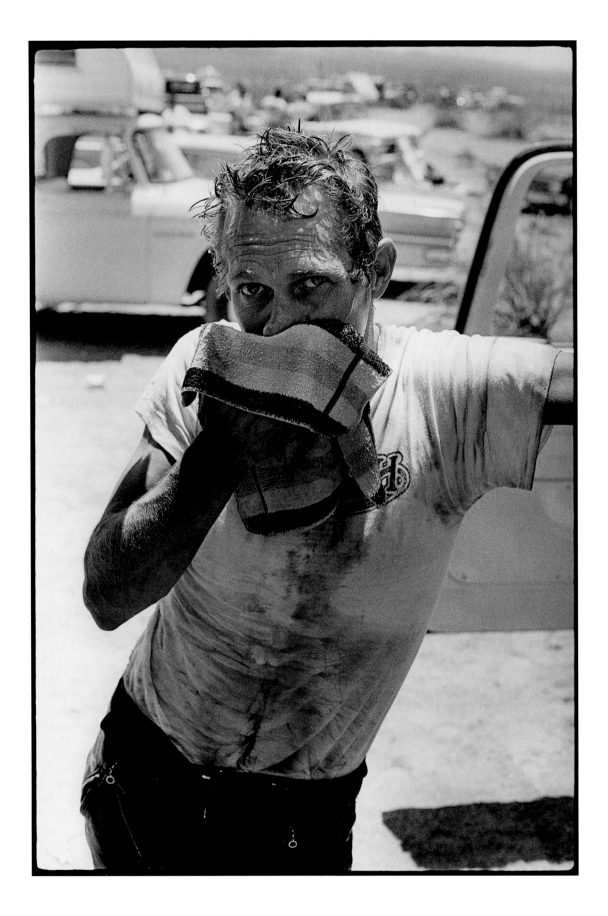

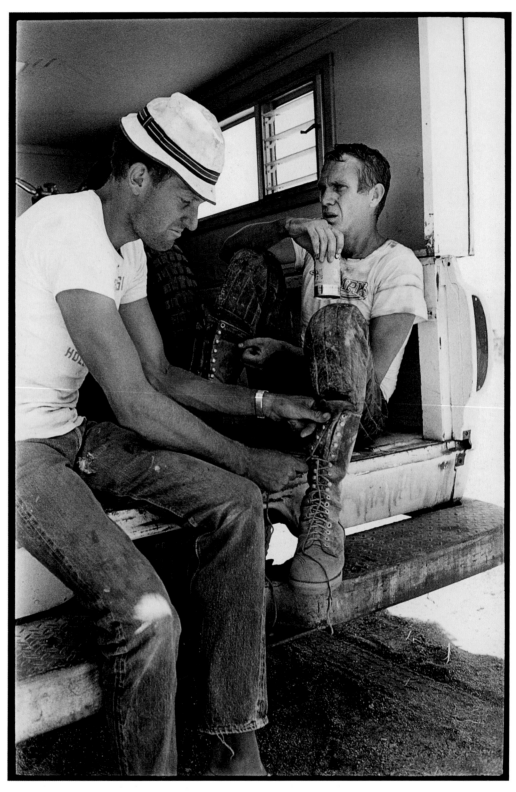

Fellow biker Cliff Coleman carefully unlaces Steve's boots after the grueling race. Mojave Desert, 1963.
Bikerfreund Cliff Coleman schnürt nach dem mörderischen Rennen vorsichtig Steves Stiefel auf. Mojave-Wüste 1963.
Cliff Coleman, motard comme Steve, lui défait soigneusement ses lacets après une course épuisante. Désert Mojave, 1963.

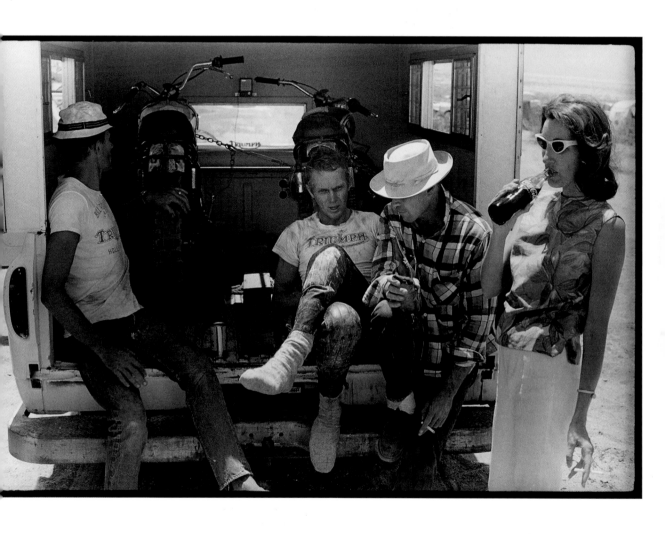

Pages 74–75: Steve and Bud Ekins enjoy cold brews while they rehash the events of the day. Mojave Desert, 1963.

Seite 74–75: Steve und Bud Ekins lassen sich ein kaltes Bier schmecken, während sie noch einmal die Ereignisse des Tages durchgehen. Mojave-Wüste 1963.

Pages 74–75 : Steve et Bud Ekins se désaltèrent tout en se remémorant les temps forts de la journée. Désert Mojave, 1963.

Steve drove me in his Shelby Cobra to his new home, a beautiful, stone country-style mansion on Oakmont Drive in the Brentwood section of Los Angeles. He was very proud of it and said to me, "Clax, who would have thought that this poor, rough street kid could ever achieve this." It was a very emotional moment for us both. Los Angeles, 1963.

Steve fuhr mich in seinem Shelby Cobra zu seinem neuen Zuhause, einer wunderschönen Steinvilla im Landhausstil am Oakmont Drive in Brentwood, Los Angeles. Er war sehr stolz darauf und sagte zu mir: „Clax, wer hätte

gedacht, dass sich das arme, ungehobelte Straßenkind je so etwas leisten könnte." Es war ein sehr bewegender Augenblick für uns beide. Los Angeles 1963.

Un jour, Steve m'a conduit dans sa Shelby Cobra à sa nouvelle demeure, une magnifique maison de campagne en pierre située sur Oakmont Drive, dans le quartier Brentwood de Los Angeles. Il en était très fier et il m'a dit :

« Clax, qui aurait pensé qu'un pauvre gamin de la rue comme moi pourrait un jour avoir ça ? » Ce fut un grand moment d'émotion pour nous deux. Los Angeles, 1963.

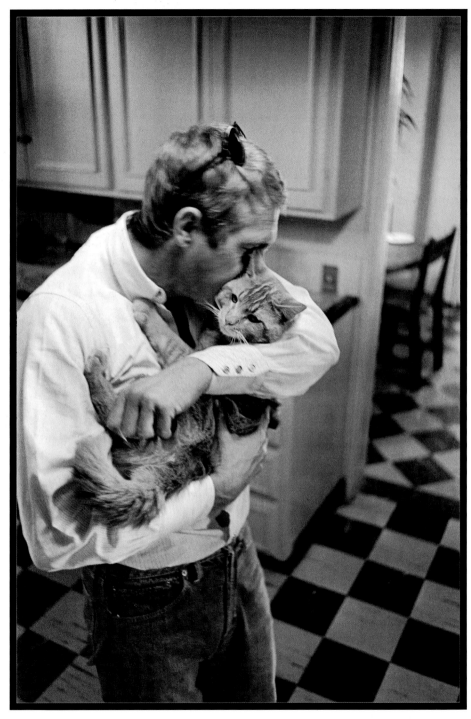

Steve embraces the family pet, Kitty Kat, in the kitchen of his new home. His tenderness to the little pet provided a wonderful contrast to his tough-guy image. Los Angeles, 1963.

Steve schmust mit der Familienkatze Kitty Kat in der Küche seines neuen Hauses. Sein zärtlicher Umgang mit dem kleinen Tier bot einen wunderbaren Kontrast zu seinem Image als rauer Bursche. Los Angeles 1963.

Steve embrasse le chat de la famille, Kitty Kat, dans la cuisine de sa nouvelle demeure. Cette tendresse envers l'animal contraste avec son image de dur. Los Angeles, 1963.

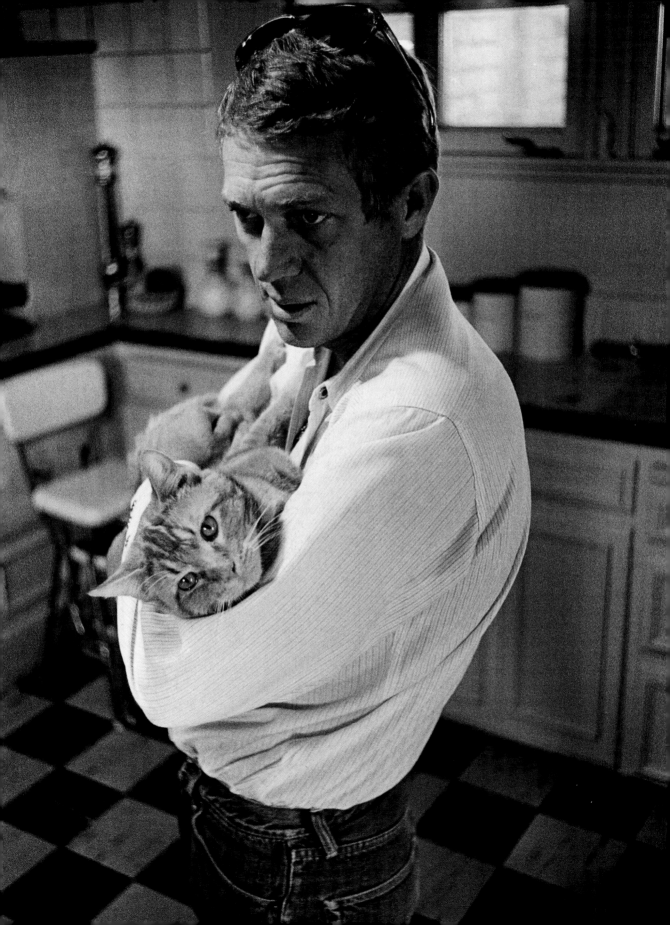

Steve clowns with a rug fashioned from a cougar hide in his den. Los Angeles, 1963.

Steve albert auf seinem Zimmer mit dem aus einem Pumafell gefertigten Bettvorleger herum. Los Angeles 1963.

Dans sa tanière, Steve s'amuse avec une descente de lit fabriquée à partir d'une peau de couguar. Los Angeles, 1963.

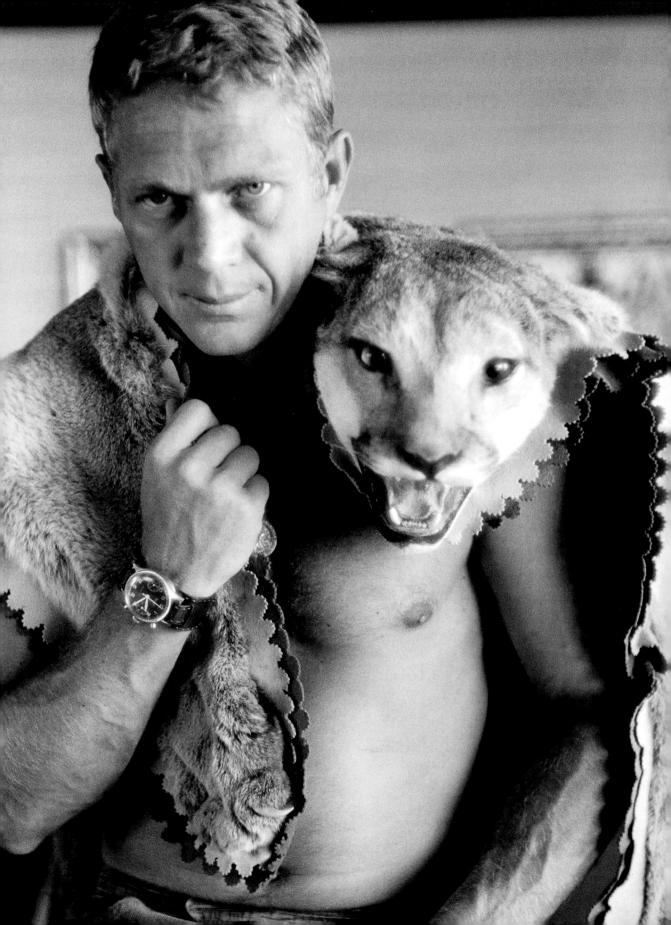

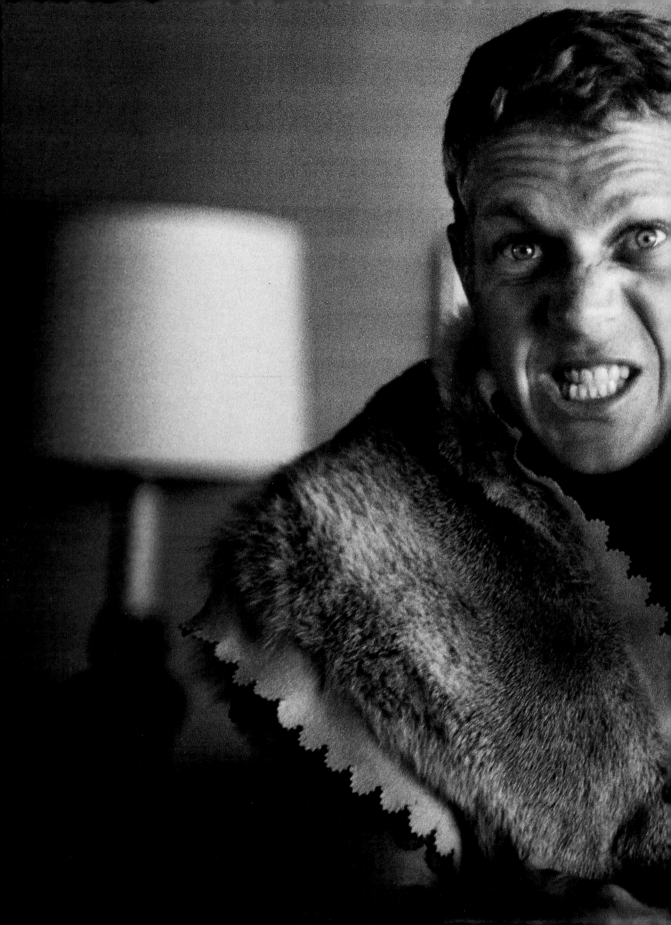

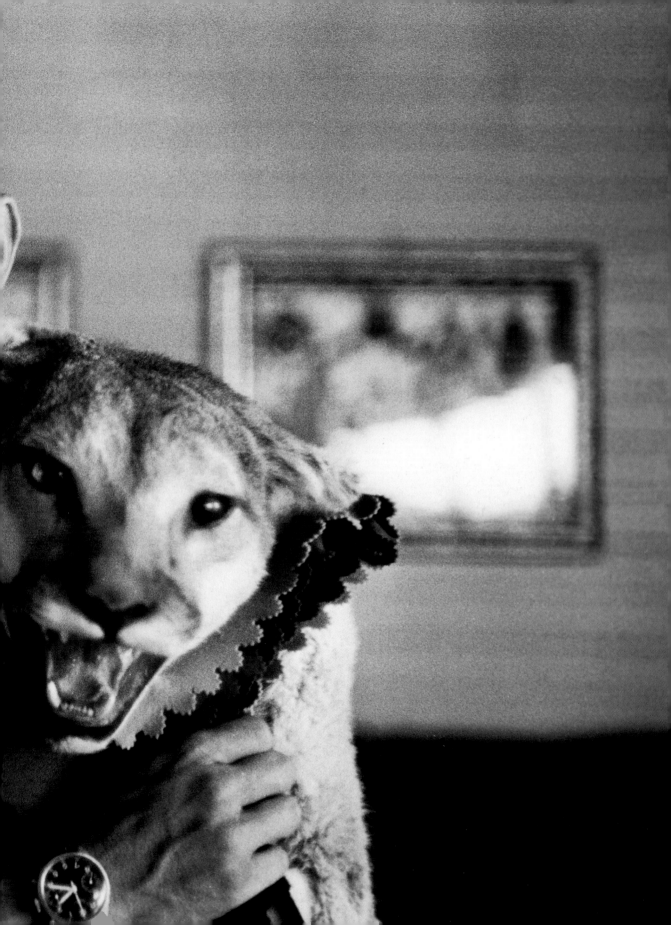

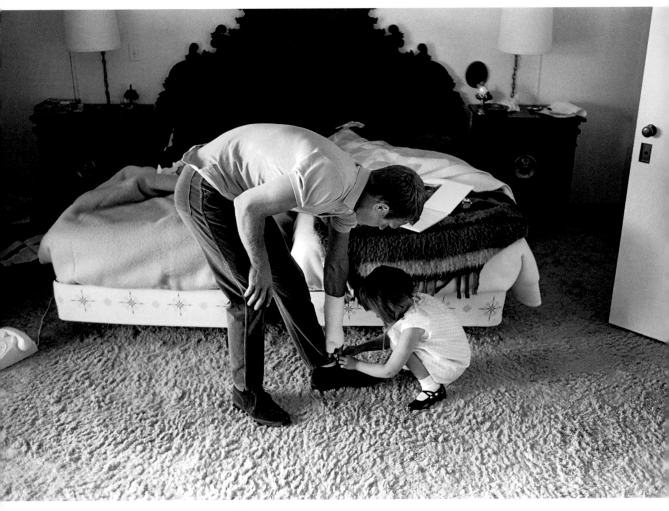

Steve with his daughter Terry. Los Angeles, 1964.
Steve mit seiner Tochter Terry. Los Angeles 1964.
Steve et sa fille Terry. Los Angeles, 1964.

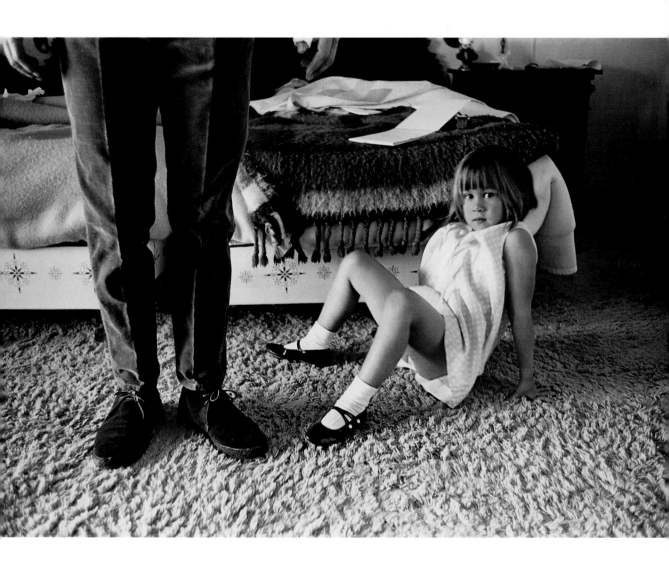

Like his father, Chad displays an early interest in racing at the McQueen house on Solar Drive. Hollywood, 1962.

Genau wie sein Vater zeigt Chad schon früh Interesse an Autorennen vor dem Haus der McQueens am Solar Drive. Hollywood 1962.

Comme son père, Chad montre un intérêt précoce pour la course dans le jardin de la famille McQueen sur Solar Drive. Hollywood, 1962.

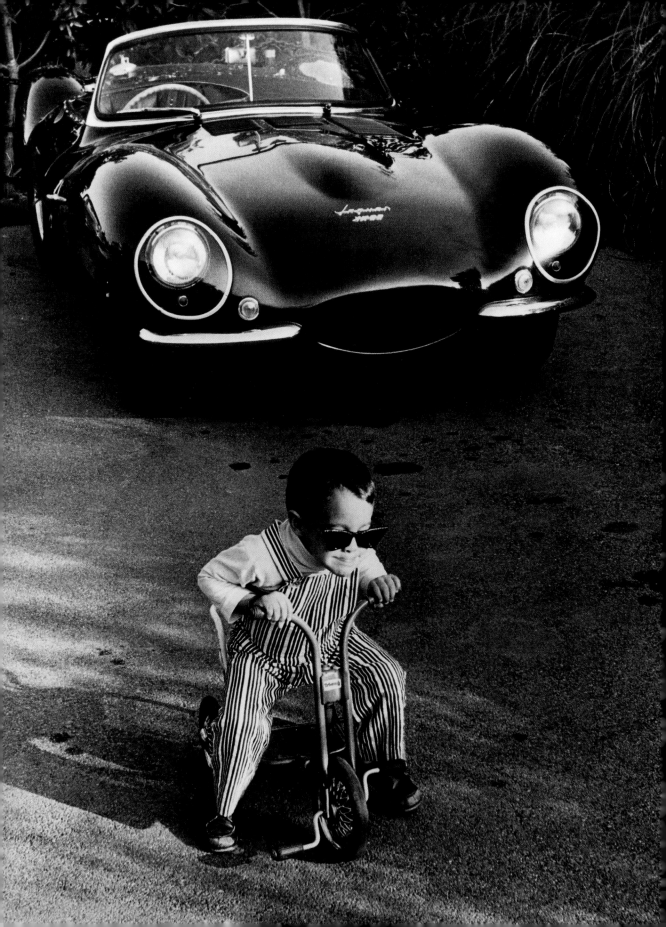

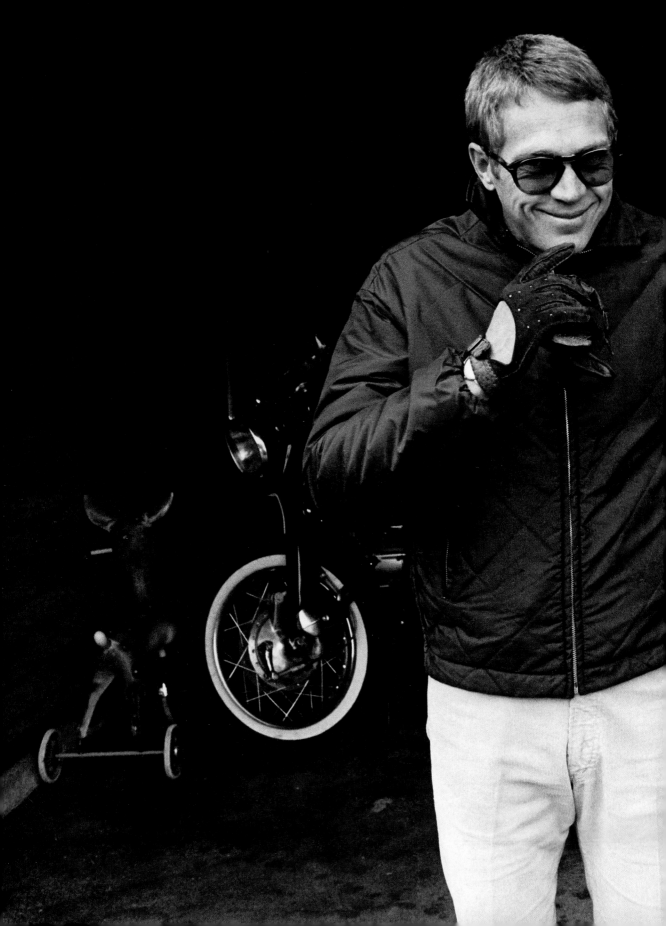

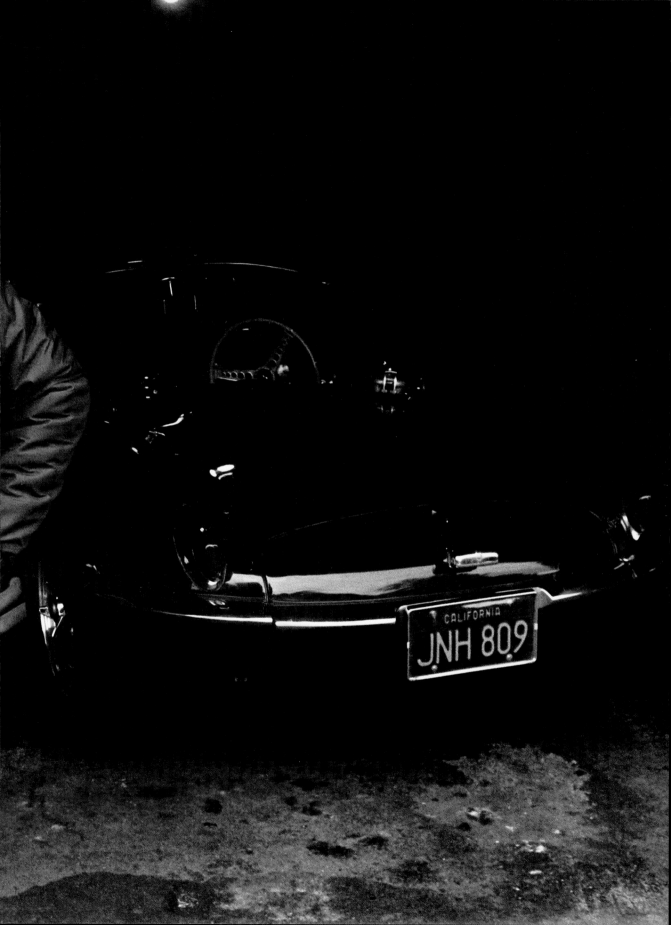

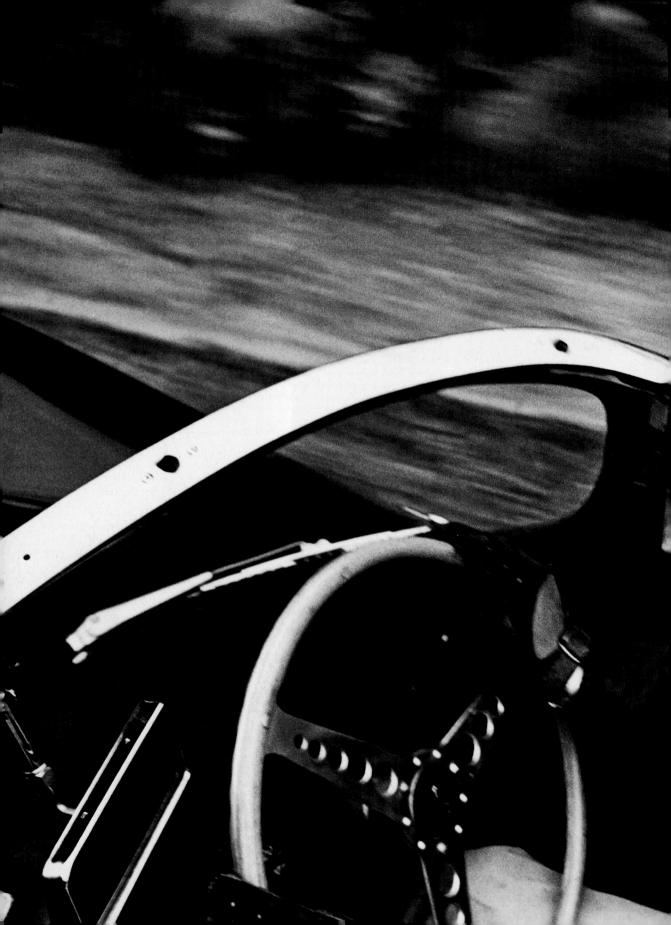

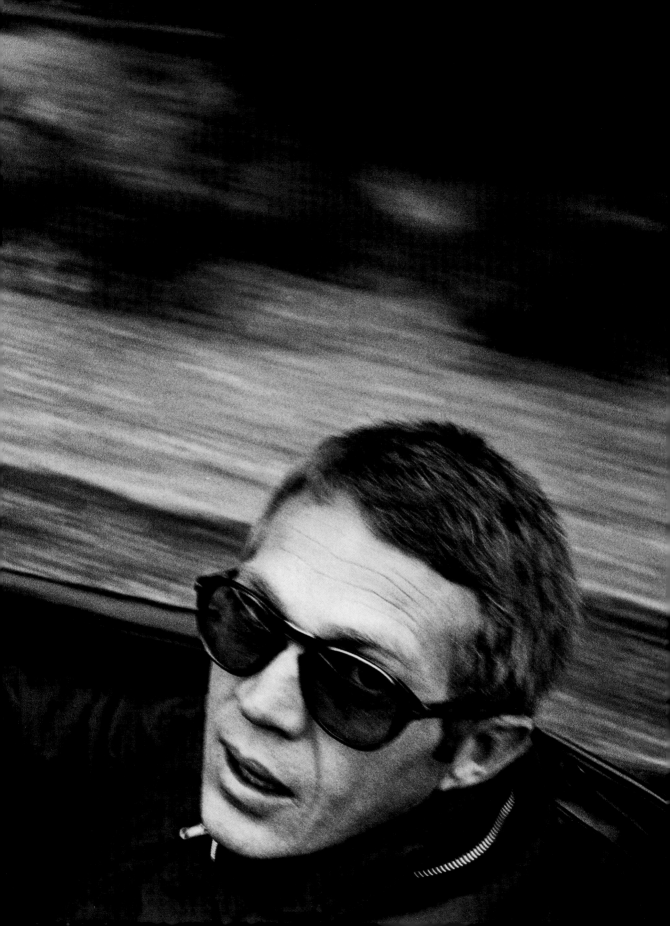

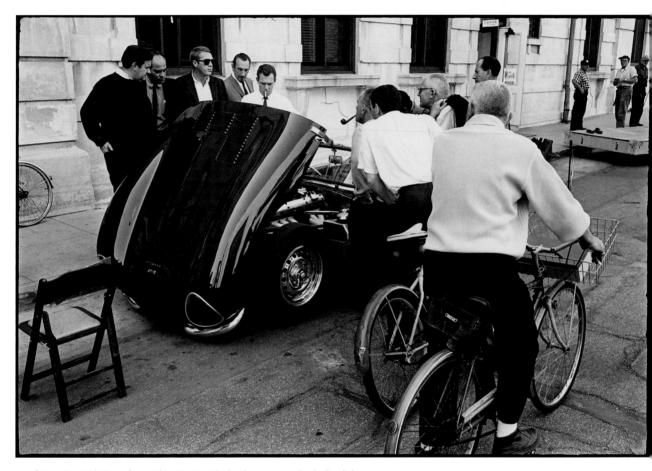

Steve shared his love of cars with almost anybody who was around, whether it be on a studio lot or on location in some small town in Texas. Paramount Studios, Hollywood, 1963.

Steve tat seine Liebe zu Autos so ziemlich jedem in seiner Nähe kund, sei es auf einem Studiogelände oder bei Dreharbeiten in einer Kleinstadt in Texas. Paramount Studios, Hollywood 1963.

En studio ou en extérieur dans une petite ville au fin fond du Texas, Steve partageait sa passion pour les voitures avec pratiquement tout le monde. Studios de la Paramount, Hollywood, 1963.

Pages 92–93: Steve piloting his Jaguar XKSS on Mulholland Drive at a break-neck speed with a rather foolish but eager photographer standing in the passenger seat shooting away. Los Angeles, 1963.

Seite 92–93: Steve steuert seinen Jaguar XKSS in halsbrecherischem Tempo über den Mulholland Drive; neben ihm auf dem Beifahrersitz steht ein ziemlich belämmerter, aber begeisterter Fotograf und knipst, was das Zeug hält. Los Angeles 1963.

Pages 92–93 : Steve au volant de sa Jaguar XKSS sur Mulholland Drive, roulant à toute allure. Un photographe stupide mais désireux de prendre cette photo à tout prix se tient debout sur le siège passager. Los Angeles, 1963.

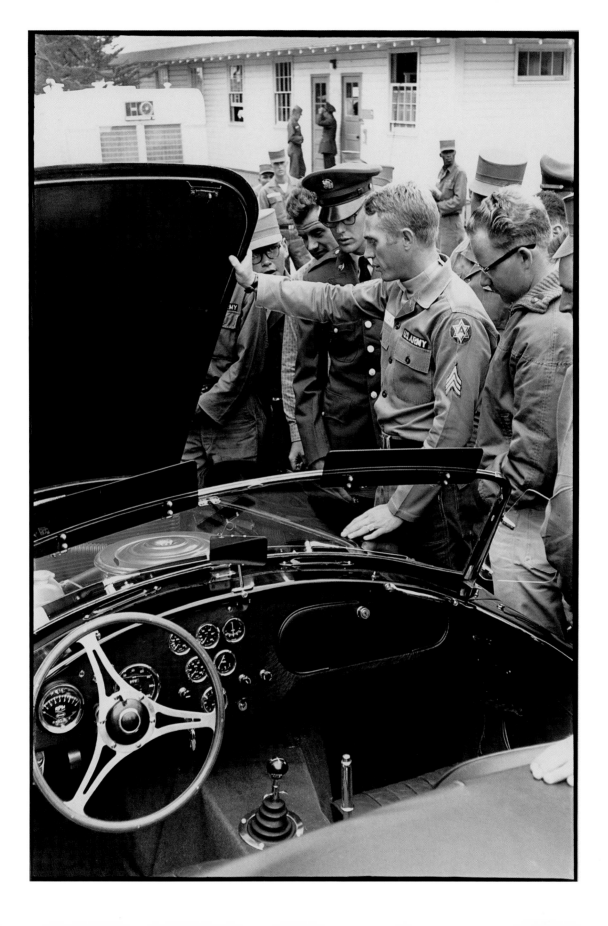

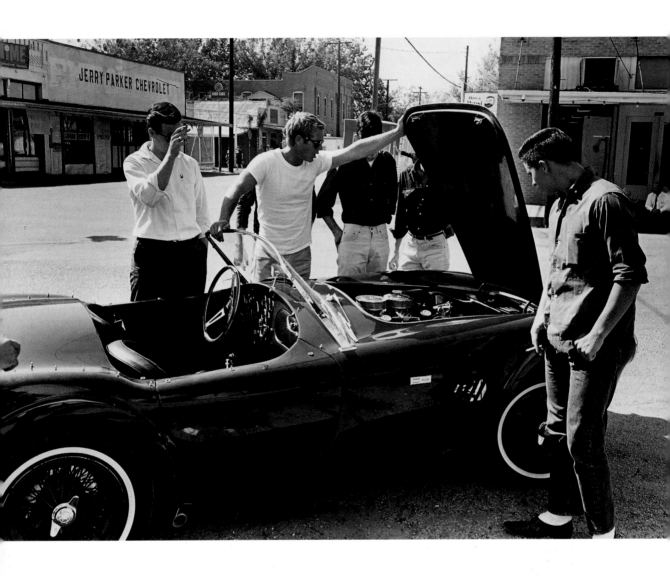

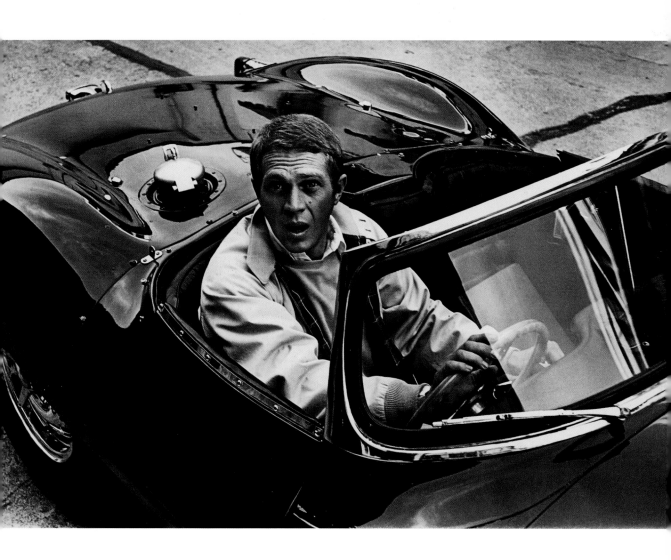

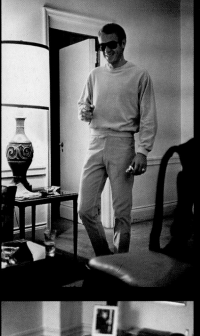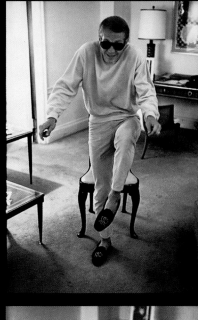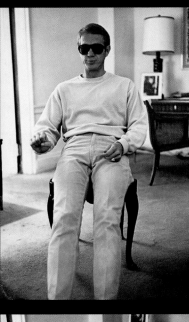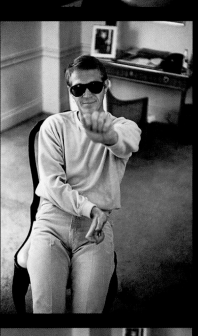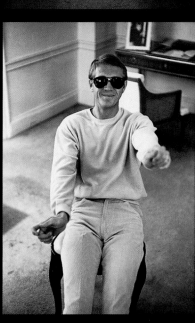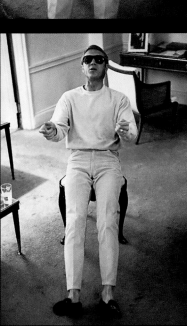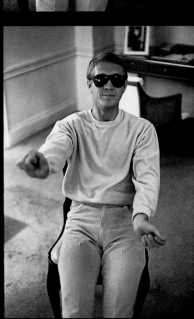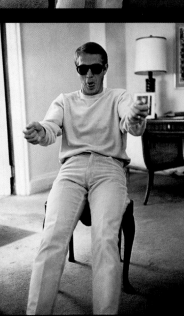

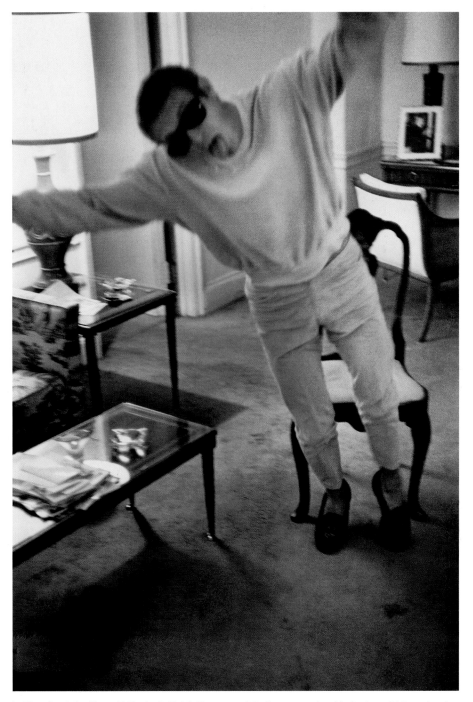

In his suite at the Sherry-Netherlands Hotel, Steve came into the room and suddenly stepped into an imaginary Formula One race car. He started up his "engine" and with roars, squeals, grrrs, and all of the sounds of a racing vehicle, he "raced" down the "track," only to end in a very loud "crash!" New York City, 1962.

Als Steve in seiner Suite im Sherry Netherlands Hotel ins Zimmer kam, verwandelte er sich plötzlich in einen fiktiven Formel-1-Rennwagenfahrer. Er ließ den „Motor" anspringen und schoss mit entsprechendem Dröhnen, Quietschen und Grollen über die „Rennstrecke", bevor das Ganze in einem ohrenbetäubenden Crash endete! New York City 1962.

Steve fait irruption dans sa suite du Sherry Netherlands Hotel et, tout d'un coup, il se met à mimer une course de Formule 1. Il démarre son « moteur » avec force vrombissements, crissements et autres grondements sourds, puis il « s'élance dans la course » pour finir par un retentissant « Badaboum ! » New York, 1962.

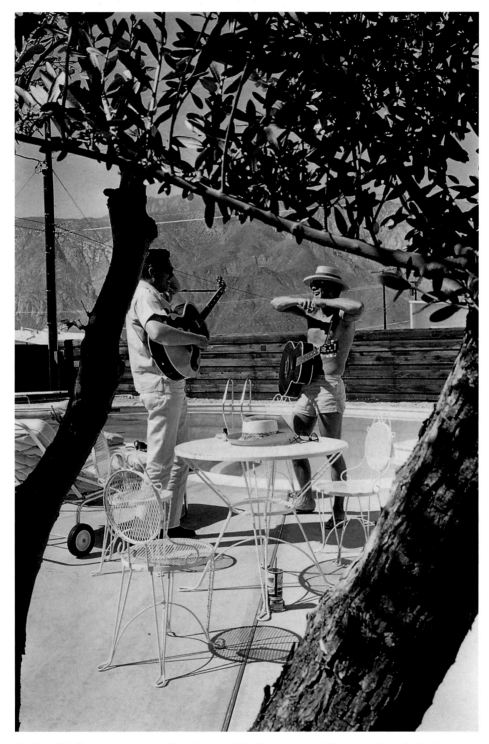

Musician Billy Strange came down to Steve's house in Palm Springs to teach him to play the guitar for his character in *Baby, the Rain Must Fall*. Palm Springs, 1963.

Der Musiker Billy Strange besuchte Steve in seinem Haus in Palm Springs, um ihm für seine Rolle in *Die Lady und der Tramp* das Gitarrespielen beizubringen. Palm Springs 1963.

Le musicien Billy Strange rend visite à Steve dans sa maison de Palm Springs afin de lui apprendre à jouer de la guitare pour son rôle dans *Le Sillage de la violence*. Palm Springs, 1963.

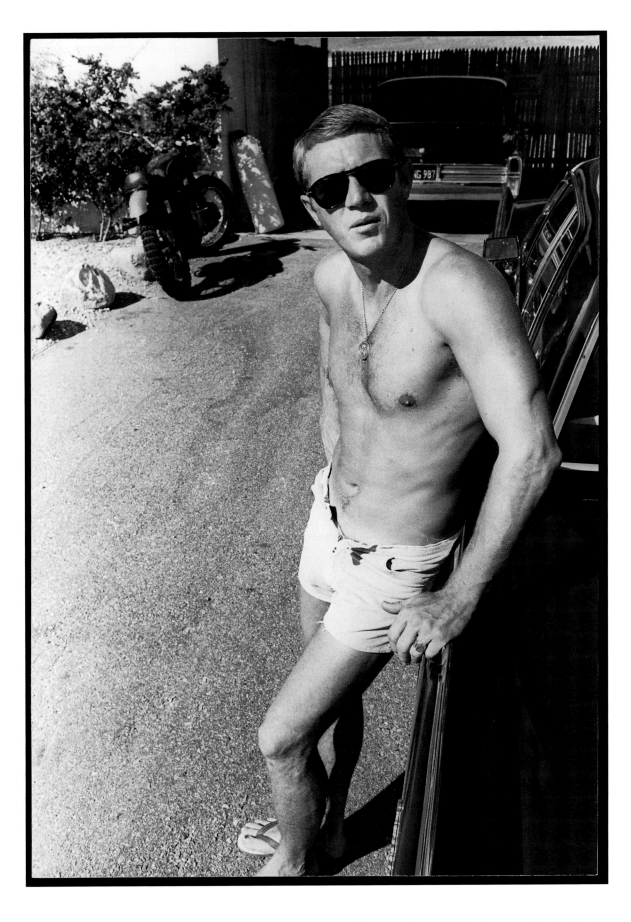

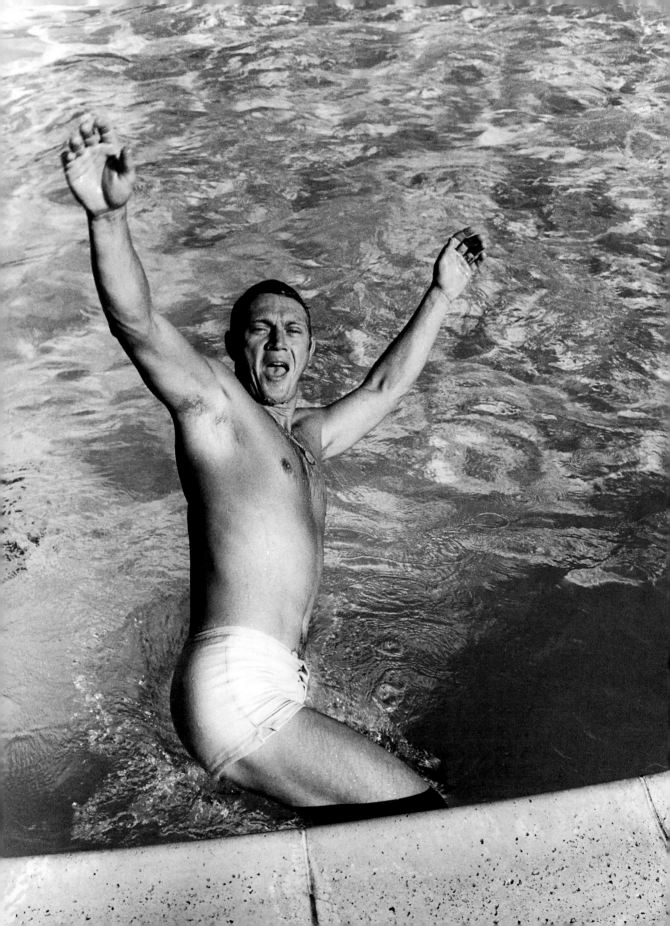

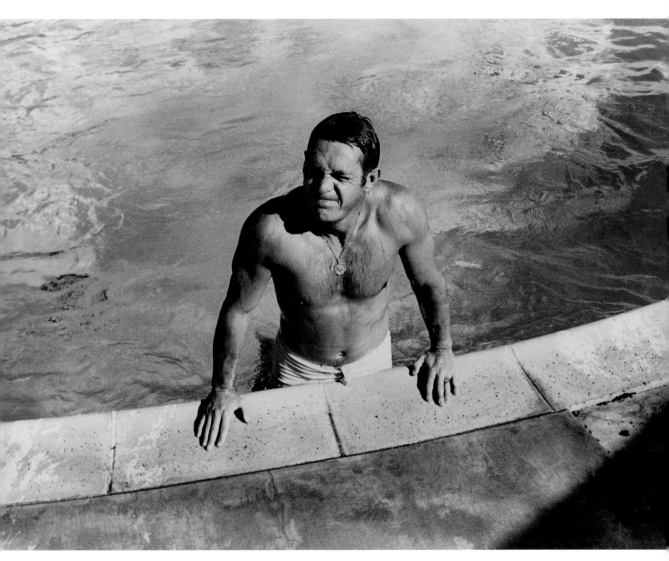

The Palm Springs hideaway, 1963.
Der Zufluchtsort in Palm Springs, 1963.
Steve dans son jardin secret, à Palm Springs, 1963.

On location, in the backwoods of Columbus, Texas. Steve claimed that he had a tin ear and couldn't carry a tune at all. But he had a very good sense of rhythm and was a brilliant mime. He gave a convincing and amusing performance as a musician in the film. Columbus, Texas, 1963.

Bei Dreharbeiten im Hinterland von Columbus, Texas, behauptete Steve, er habe ein schlechtes Gehör und könne keinen Ton halten. Dafür besaß er ein ausgezeichnetes Rhythmusgefühl und war ein brillanter Mime. Im Film gab er eine durchaus überzeugende und lustige Darbietung eines Musikers. Columbus, Texas, 1963.

Tournage en extérieur à Columbus, au fin fond du Texas. Steve a toujours prétendu qu'il n'avait pas l'oreille musicale et qu'il était incapable de jouer juste. Cependant, il avait un grand sens du rythme et c'était un très bon mime. Dans le film, son jeu de musicien a donc été très convaincant et divertissant. Columbus, Texas, 1963.

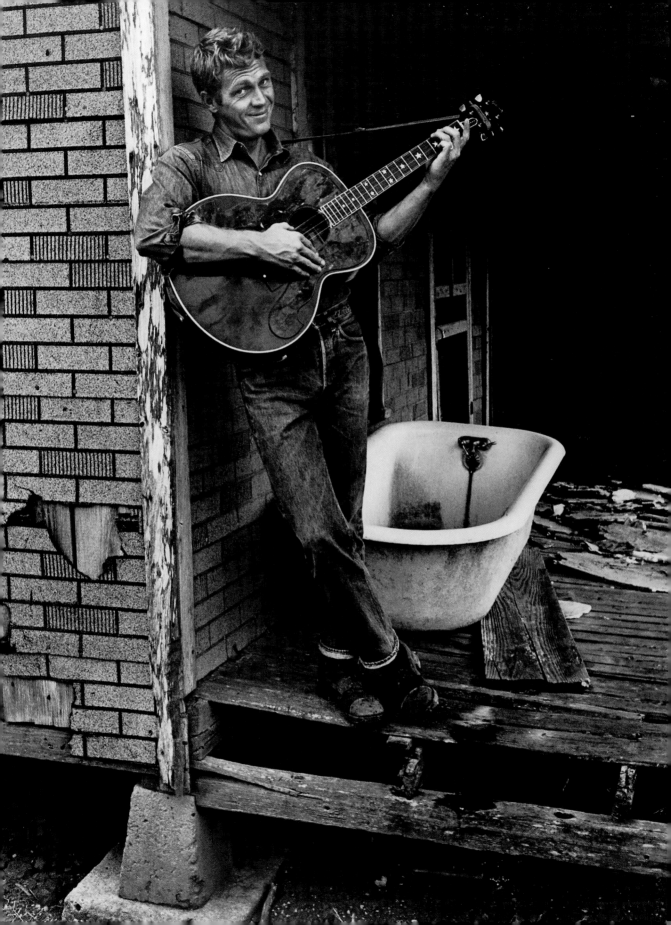

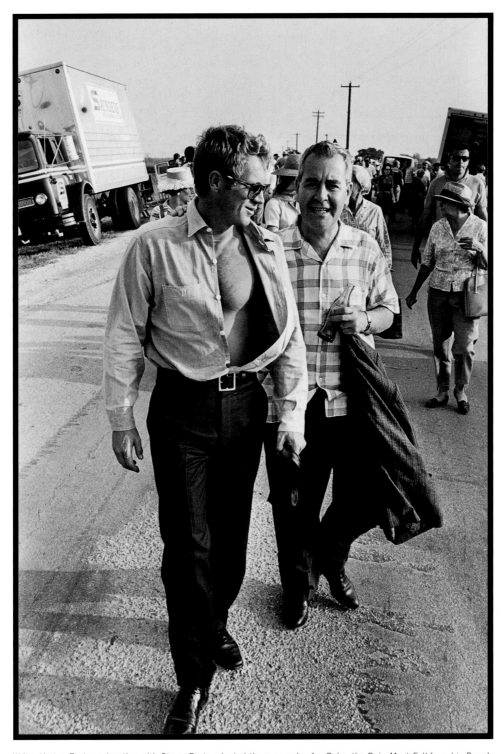

Writer Horton Foote on location with Steve. Foote adapted the screenplay for *Baby, the Rain Must Fall* from his Broadway play *The Traveling Lady*. Wharton, Texas, 1963.

Der Schriftsteller Horton Foote mit Steve am Set. Foote schrieb das Drehbuch zu *Die Lady und der Tramp*, eine Adaption seines Broadwaystücks *The Traveling Lady*. Wharton, Texas, 1963.

Steve en compagnie de l'écrivain Horton Foote sur le lieu de tournage. Foote a adapté le scénario du *Sillage de la violence* à partir de sa pièce jouée à Broadway *The Traveling Lady*. Wharton, Texas, 1963.

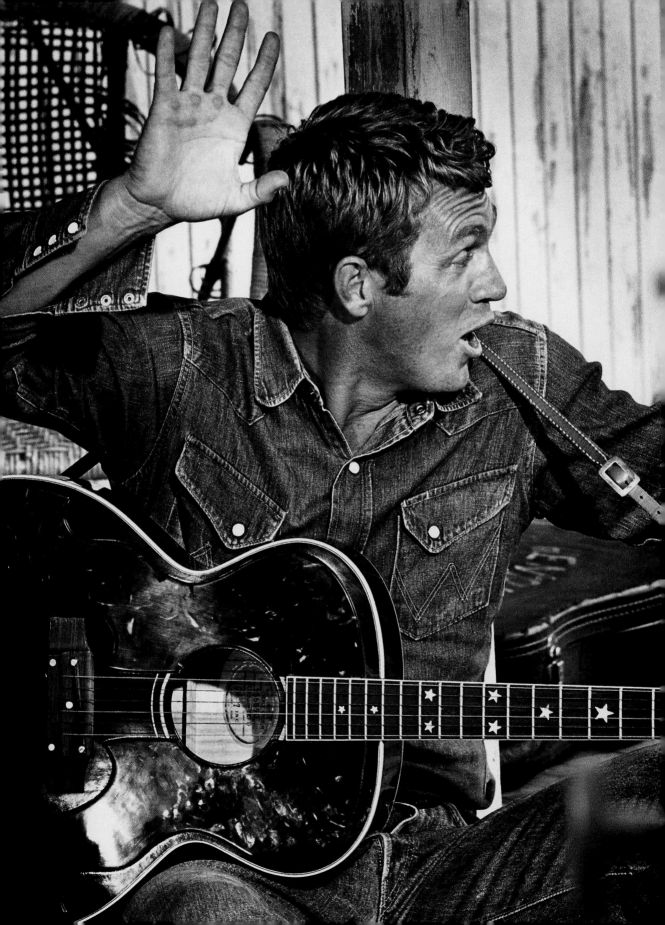

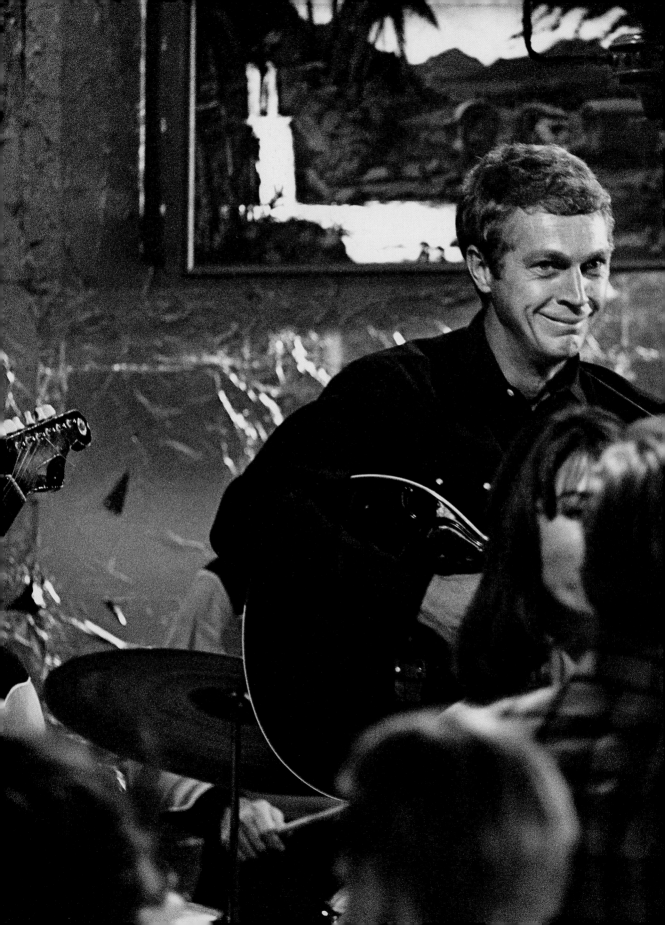

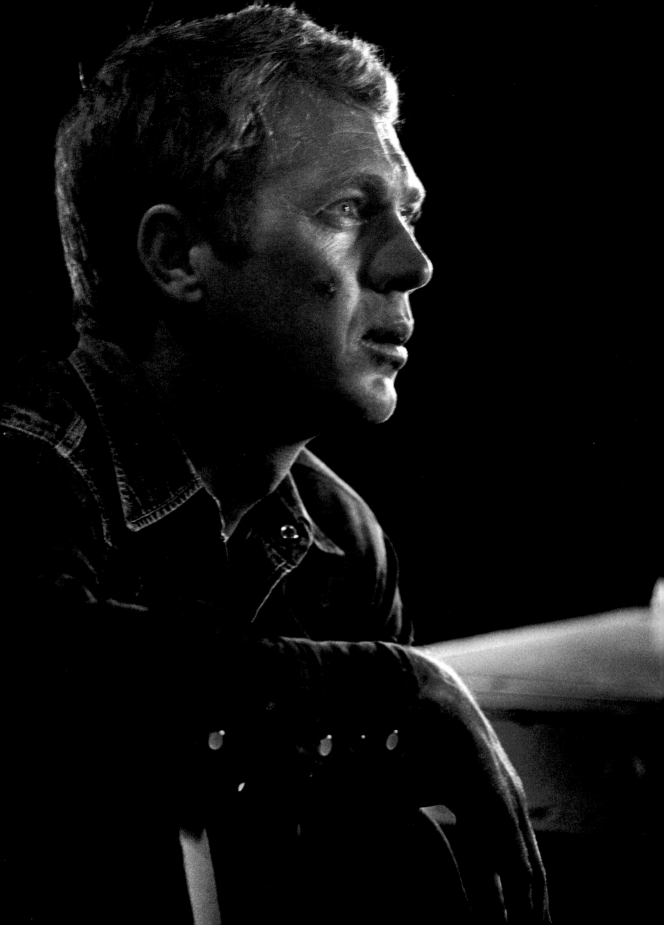

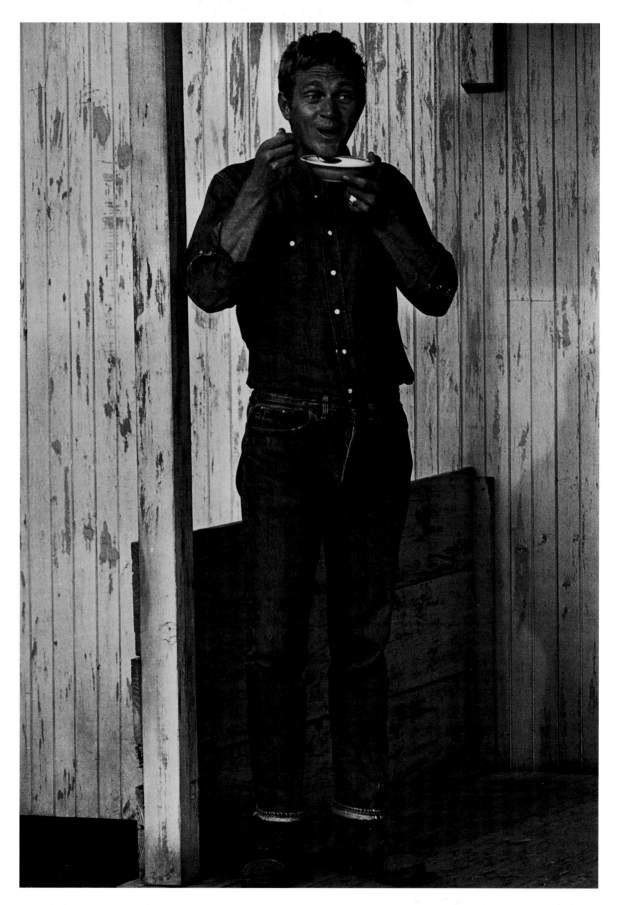

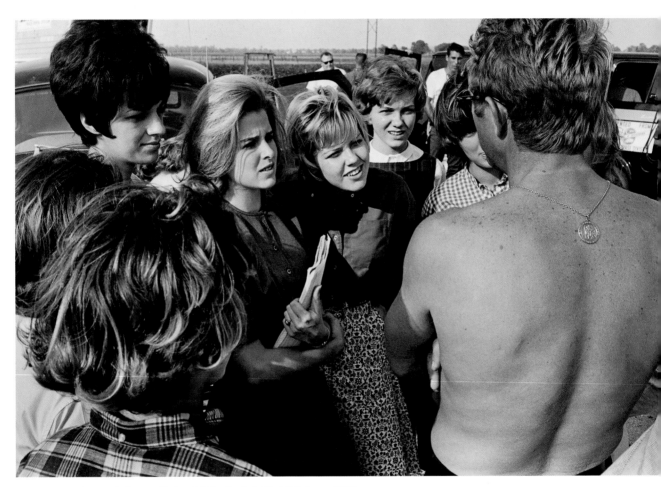

Fans in Wharton during the filming of *Baby, the Rain Must Fall*. Texas, 1963.
Fans in Wharton während der Dreharbeiten zu *Die Lady und der Tramp*. Texas 1963.
Admiratrices à Wharton pendant le tournage du *Sillage de la violence*. Texas, 1963.

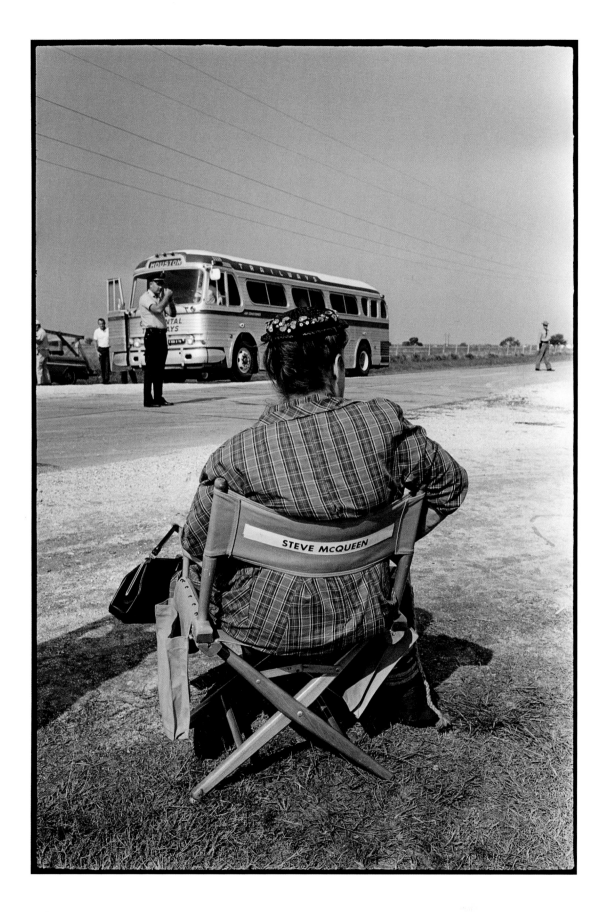

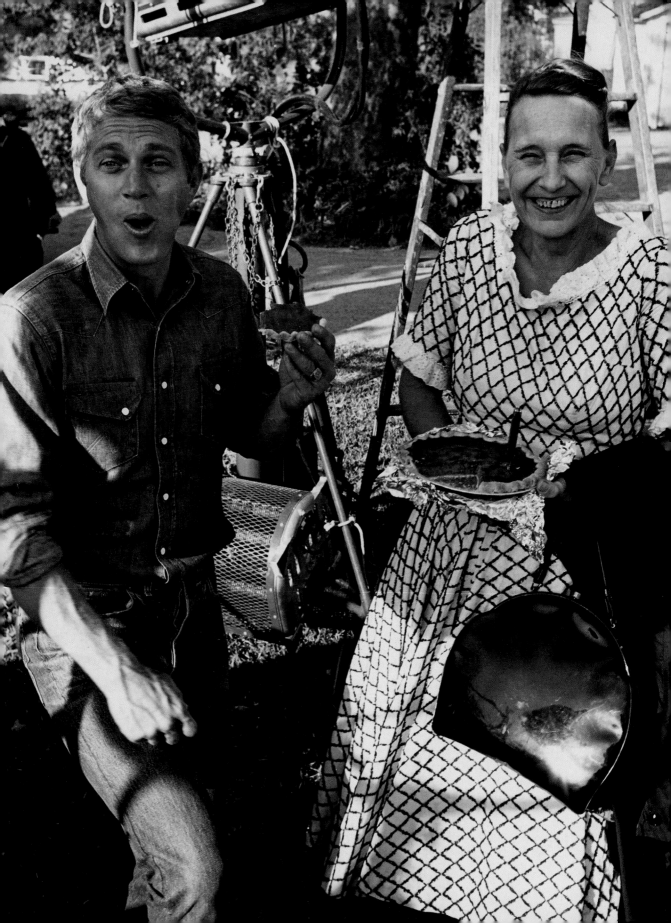

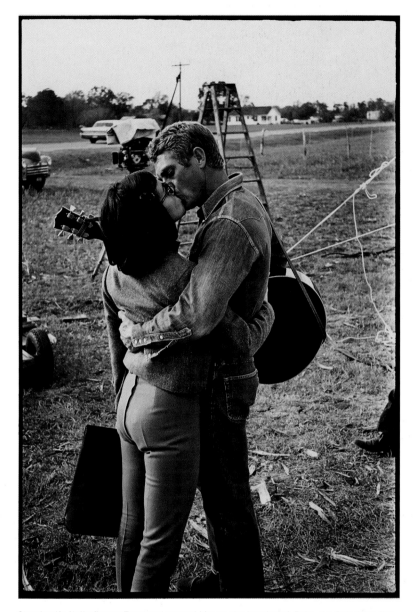

Steve's wife Neile flew to Texas and greeted him on the location of *Baby, the Rain Must Fall*. Texas, 1963.

Steves Ehefrau Neile war nach Texas gekommen, um ihren Mann am Set von *Die Lady und der Tramp* in die Arme zu schließen. Texas 1963.

Neile, l'épouse de Steve, a rejoint son mari au Texas sur le lieu de tournage du *Sillage de la violence*. Texas, 1963

Page 116: A neighborhood lady brought Steve a gift of a homemade sweet potato pie she had just baked. Texas, 1963.

Pages 118–119: Steve and his co-star Lee Remick rehearse while on location for *Baby the Rain Must Fall*. Bay City, Texas, 1963.

Seite 116: Eine Frau aus der Nachbarschaft brachte Steve eine hausgemachte Kartoffeltorte, die sie gerade gebacken hatte. Texas 1963.

Seite 118–119: Steve und seine Filmpartnerin Lee Remick bei einer Probe während der Dreharbeiten zu *Die Lady und der Tramp*. Bay City, Texas, 1963.

Page 116: Une dame des environs offre à Steve une part de tarte aux patates douces qu'elle vient tout juste de cuire. Texas, 1963.

Pages 118–119: Steve et sa partenaire Lee Remick répètent en extérieur pour *Le Sillage de la violence*. Bay City, Texas, 1963.

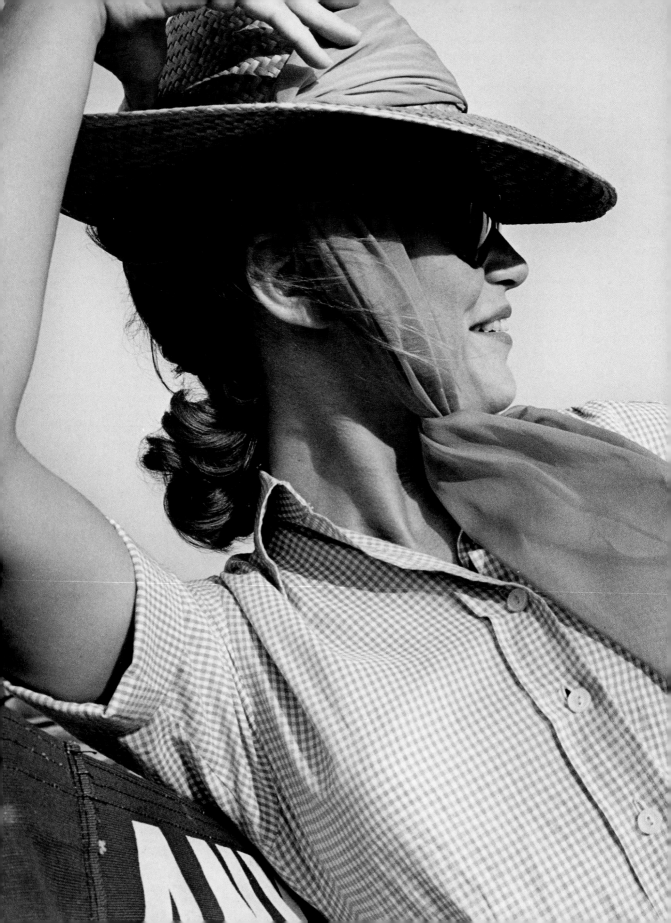

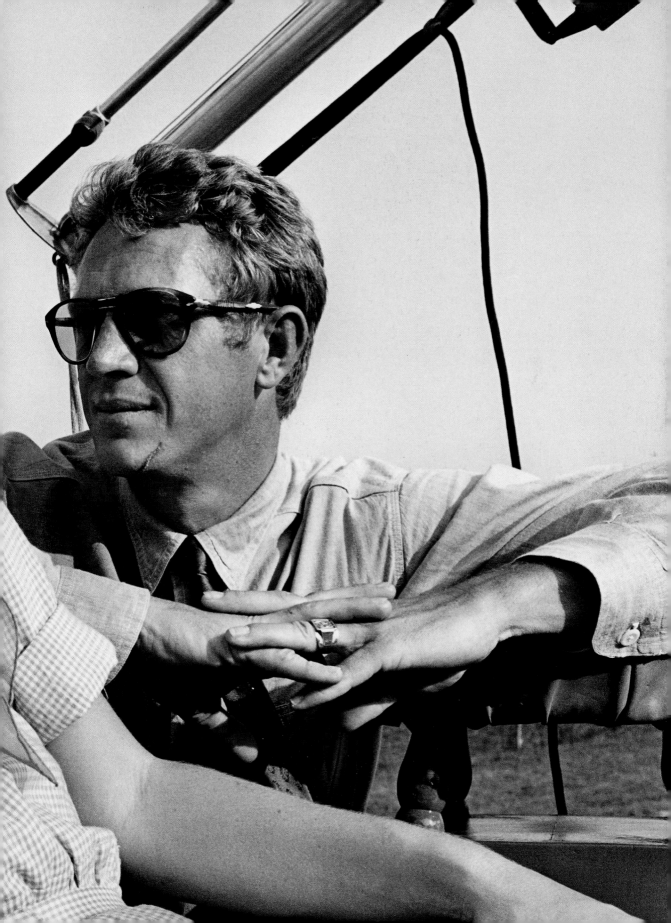

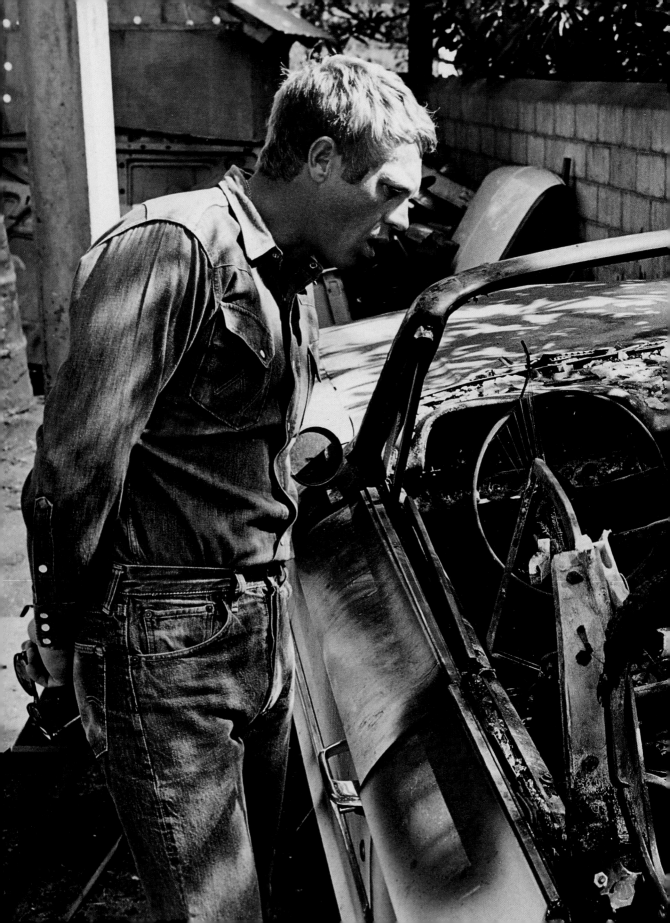

"Did I do that?"
Steve's love for automobiles was well-known. But his abusive behavior
to some of the vehicles he drove was rarely revealed. It was the custom
while on location for a local automobile agency to let the production
company borrow several of their new cars to be used by the movie execu-
tives and, of course, the stars. When Steve wasn't needed on the set, he
would frequently take a car, load it with his buddies, and go for a drive.
He would often go off-road with the new car at top speed and beat the
hell out of it until it would hardly make it back to the set.
One time when I was with him, he drove a brand new Ford convertible, with
only thirty miles on the odometer, at top speed for such a long stretch of
the Texas highway that the engine began to smoke and eventually caught
on fire. He slowed down and shouted to me, "Clax, when I tell you to jump,
jump!" We did jump out of the car just as it burst into flames. Steve sat on
the side of the country road at a safe distance from the burning vehicle
and laughed his head off. I was a bit startled and found the experience
less amusing. The car burned to the ground before the local fire truck
arrived. The next day the local newspaper headlines read, "Movie Star
Steve McQueen Narrowly Escapes Death in Burning Car." Texas, 1963.

„War ich das?"
Steves Leidenschaft für Autos war allgemein bekannt. Aber wie sehr er die
Wagen zum Teil malträtierte, wussten die wenigsten. Es war üblich, dass
eine lokale Autovermietung in der Nähe des Drehorts der Produktionsfirma
mehrere Neufahrzeuge zur Verfügung stellte, die die Produktionsleitung
und natürlich auch die Stars benutzen konnten. Wenn Steve am Set nicht
gebraucht wurde, nahm er sich gern ein Auto, lud seine Kumpels ein und
machte eine Spritztour. Oft jagte er den Neuwagen mit Vollgas quer
durchs Gelände und richtete ihn so übel zu, dass er es kaum noch bis zum
Set zurück schaffte.
Einmal, als ich mit ihm zusammen unterwegs war, prügelte er ein brand-
neues Ford-Cabrio, das erst 30 Meilen auf dem Buckel hatte, so lange mit
Vollgas über den Texas-Highway, bis der Motor anfing zu qualmen und
schließlich Feuer fing. Steve ging vom Gas und rief mir zu: „Clax, wenn
ich dir sage, spring, dann spring!" Wir sprangen genau in dem Moment
raus, als der Wagen in Flammen aufging. Steve saß in sicherer Entfernung
von dem brennenden Wrack am Rand der Landstraße und lachte sich halb-
tot. Ich war ziemlich erschrocken und fand die Sache nicht ganz so lustig.
Noch bevor der Löschzug der Feuerwehr eintraf, brannte der Wagen
vollständig aus. Am nächsten Tag hieß es in den Schlagzeilen der lokalen
Zeitungen: „Filmstar Steve McQueen knapp dem Flammentod im Auto ent-
kommen". Texas 1963.

« C'est moi qui ai fait ça ? »
La passion de Steve pour les voitures était bien connue. Mais son
comportement excessif au volant de certains véhicules a rarement été
évoqué. Pendant les tournages en extérieur, l'usage voulait qu'une agence
de location de voitures de la région permette à toute l'équipe de produc-
tion – et aux vedettes de cinéma, bien évidemment – d'essayer plusieurs
de leurs nouveaux modèles. Quand Steve ne tournait pas sur le plateau, il
avait pour habitude d'emprunter une voiture, de faire monter à bord
quelques-uns de ses amis et de partir faire un tour. Conduisant à toute
allure, il faisait de nombreuses sorties de route pour savoir ce que la
voiture avait dans le ventre, et parfois, c'est à peine s'il parvenait à
rapporter le véhicule sur le lieu du tournage.
Un jour, il m'a emmené avec lui dans une Ford décapotable toute neuve,
avec seulement quelques kilomètres au compteur. Il a conduit à toute
vitesse pendant tellement longtemps sur l'autoroute que le moteur a
commencé à fumer et a fini par s'enflammer. Il a alors ralenti et il m'a
crié : « Clax, quand je te dirai de sauter, saute ! » Nous avons sauté tous
les deux, juste au moment où la voiture s'est embrasée complètement.
Steve s'est assis au bord de la route, à une bonne distance de la voiture
en feu, et il s'est mis à rire comme un fou. J'étais un peu ahuri et j'avais
nettement moins envie de rire que lui. Il ne restait plus que la carcasse de
la voiture quand les pompiers sont arrivés. Le lendemain, le journal local
titrait : « L'acteur Steve McQueen échappe de justesse à la mort dans une
voiture en flammes. » Texas, 1963.

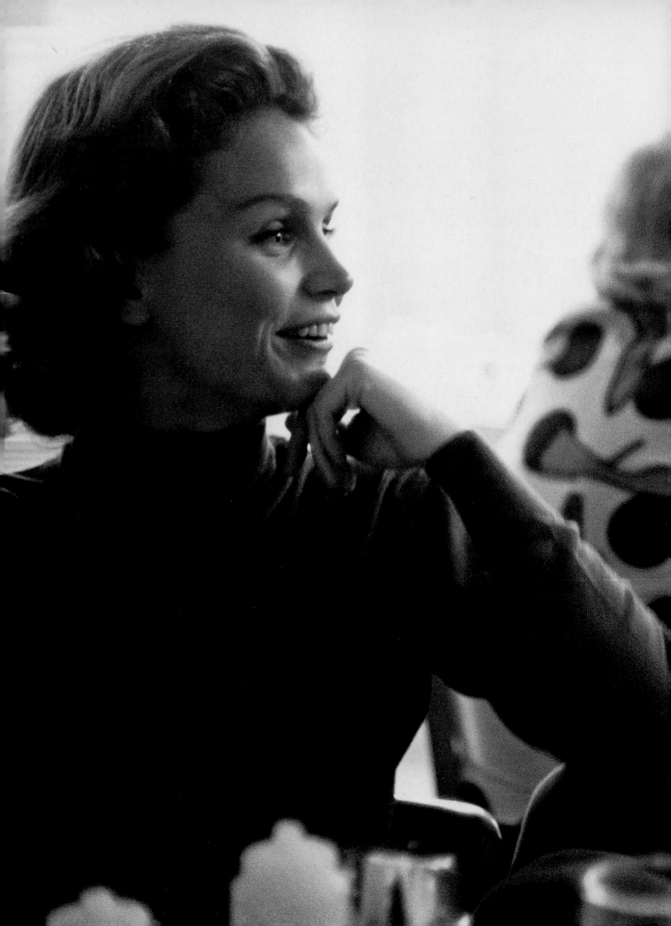

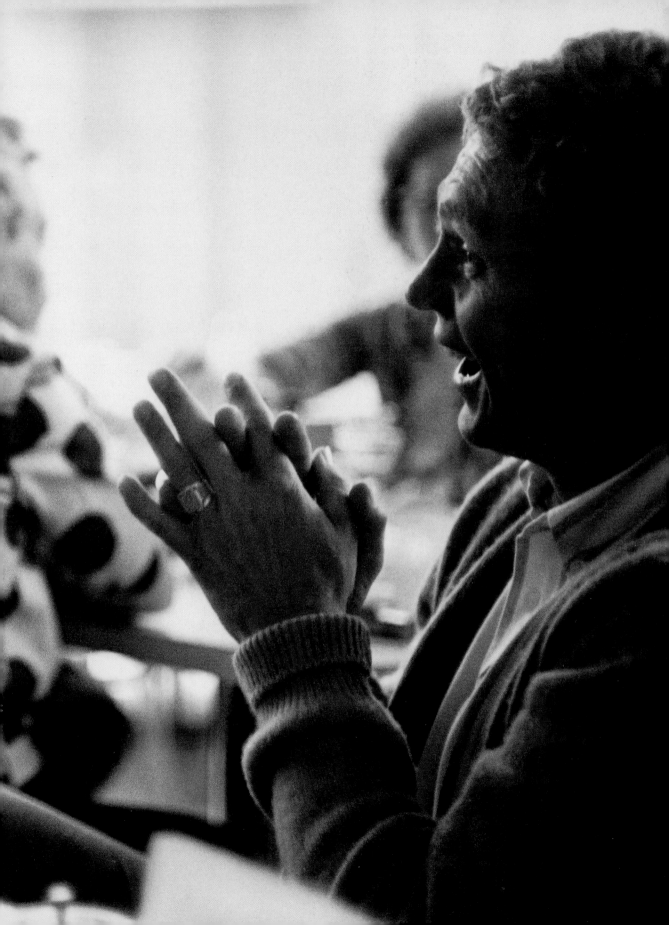

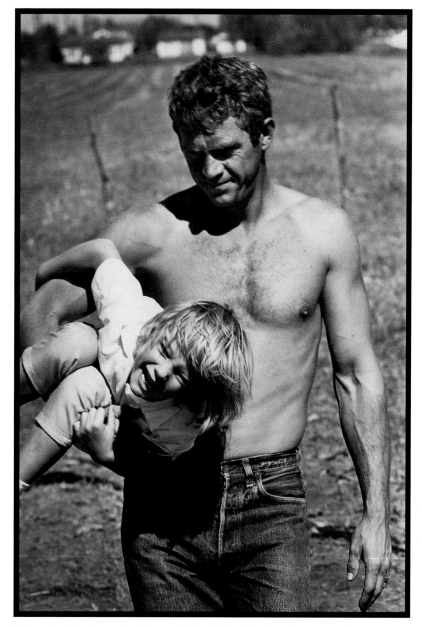

While on location, Steve missed his own children. He had fun with the young actress who played Lee Remick's daughter in the film. Texas, 1963.

Während der Dreharbeiten vermisste Steve seine Kinder. Er hatte viel Spaß mit dem kleinen Mädchen, das in dem Film die Tochter von Lee Remick spielte. Texas 1963.

Quand Steve tournait en extérieur, ses enfants lui manquaient. Il s'est beaucoup amusé avec la jeune actrice qui jouait le rôle de la fille de Lee Remick dans *Le Sillage de la violence*. Texas, 1963.

Pages 122–123: On location in Texas, Lee Remick and Steve have a little fun during a lunch break. I think every one of Steve's leading ladies was smitten with him and he usually treated them with respect.
Texas, 1963.

Seite 122–123: Während einer Mittagspause bei den Dreharbeiten in Texas flirten Lee Remick und Steve ein bisschen miteinander. Ich glaube, jede von Steves Filmpartnerinnen war von ihm hingerissen, und für gewöhnlich behandelte er sie mit Respekt. Texas 1963.

Pages 122–123 : Pendant le tournage au Texas, Lee Remick et Steve plaisantent au cours d'un déjeuner. Je crois que les partenaires de Steve à l'écran ont toutes succombé à son charme et, en règle générale, il les traitait avec beaucoup de respect. Texas, 1963.

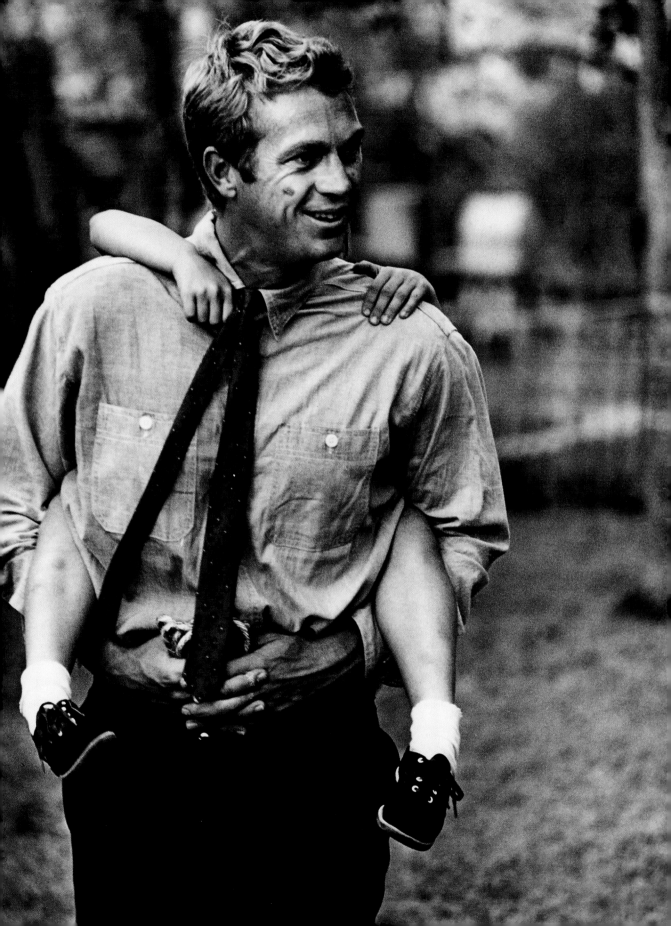

While on location in Bay City, Texas, Lee Remick and Steve visit the local five-and-dime store. When Steve got off the "horse" he said, "I never could trust a horse." Texas, 1963.

Bei den Dreharbeiten im texanischen Bay City besuchen Lee Remick und Steve das ortsansässige Billigkaufhaus. Als Steve von dem „Pferd" stieg, sagte er: „Ich habe noch nie einem Pferd trauen können." Texas 1963.

Pendant le tournage à Bay City, au Texas, Lee Remick et Steve visitent un bazar de la région. Quand Steve est « descendu de cheval », il a lancé : « Je n'ai jamais pu faire confiance à un cheval. » Texas, 1963.

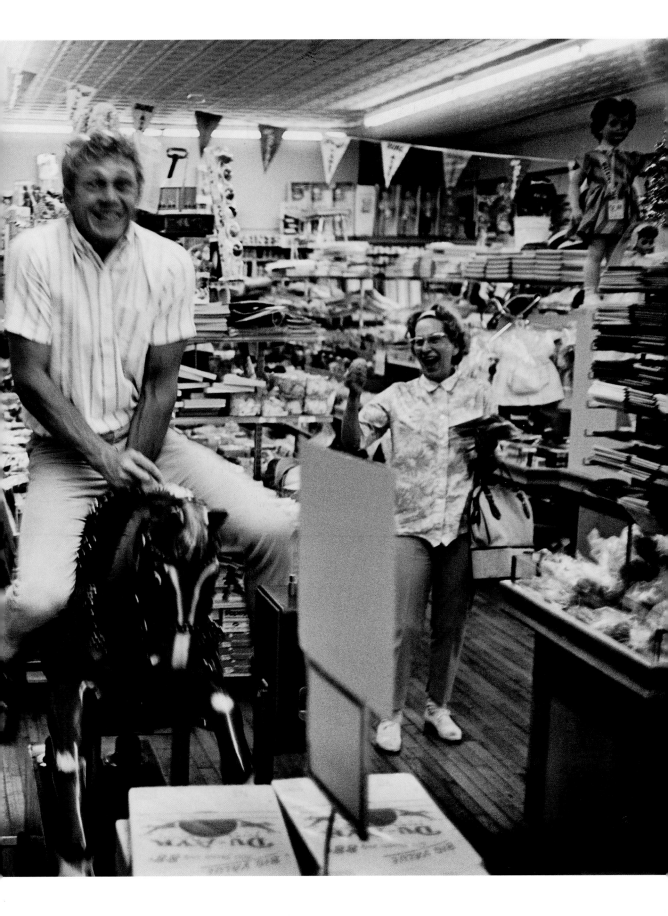

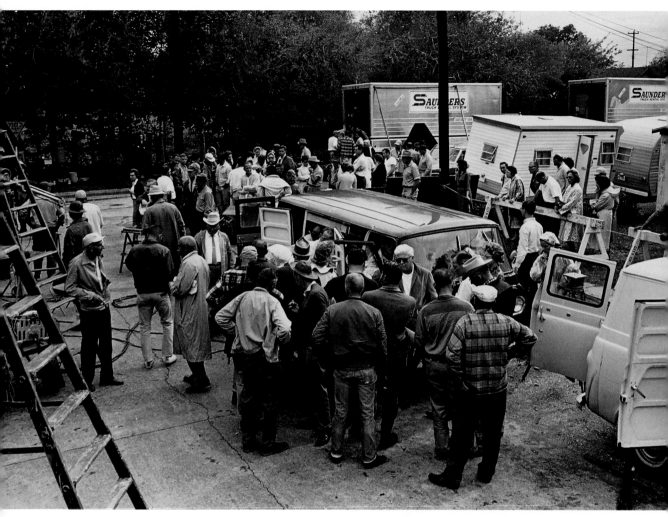

November 23, 1963. While shooting on location in Columbus, Texas, the local police car radio suddenly blasted out a loud, distorted announcement disturbing the quiet scene being filmed on the veranda of a small house. The sound of the police radio carried news of another shooting—this time in Dallas. "The President has been shot!" shouted one of the state troopers. The entire cast and crew gathered around the radio. Everyone was stunned, of course. A pall was cast over the entire group. Lunch break was called, but very few of us could eat.

Steve took the news of the assassination of President Kennedy especially hard. He was very quiet for the rest of our stay in Texas. The producer, Alan Pakula, decided to fold up the set, leave Texas and head back to Hollywood where they would have to recreate the set on the sound stage. Peggy and Neile met Steve and me at Los Angeles airport, and we parted ways with sadness.

Bei Dreharbeiten in Columbus, Texas, am 23. November 1963: Plötzlich dröhnte aus dem Radio des lokalen Polizeiwagens eine verzerrte Meldung und störte die ruhige Szene, die auf der Veranda eines kleinen Hauses gedreht wurde. „Der Präsident ist erschossen worden!", rief einer der Polizisten. Die gesamte Besetzung und das Filmteam drängten sich um das Radio. Natürlich waren alle wie betäubt. Ein Leichentuch legte sich über unsere Gruppe. Die Mittagspause wurde eingeläutet, aber kaum einer konnte etwas essen.

Steve traf die Nachricht von Präsident Kennedys Ermordung besonders hart. Die restliche Zeit unseres Aufenthalts in Texas war er sehr still. Der Produzent Alan Pakula beschloss, das Set abzubauen, von Texas nach Hollywood zurückzufahren und das Szenenbild im Tonstudio wieder aufzubauen. Neile und Peggy holten Steve und mich am Flughafen von Los Angeles ab und wir trennten uns in tiefer Trauer.

En plein tournage à Columbus, au Texas, le 23 novembre 1963. La scène filmée dans la véranda d'une petite maison est soudainement interrompue par la radio qui hurle à l'intérieur de la voiture de police. « Le Président a été abattu ! », s'écrie l'un des officiers. Tout le monde se rassemble autour de la voiture. Nous sommes tous abasourdis, évidemment. Un voile sombre vient de s'abattre sur toute l'équipe. C'est l'heure du déjeuner, mais peu d'entre nous parviennent à avaler quelque chose.

Steve a vraiment eu du mal à accepter la nouvelle de l'assassinat du président Kennedy. Il est resté silencieux jusqu'à la fin du tournage au Texas. Le producteur Alan Pakula a finalement décidé de démonter le plateau, de quitter le Texas et de rentrer à Hollywood pour recréer les décors en studio. Neile et Peggy nous ont rejoints, Steve et moi, à l'aéroport de Los Angeles, et nous nous sommes quittés avec tristesse.

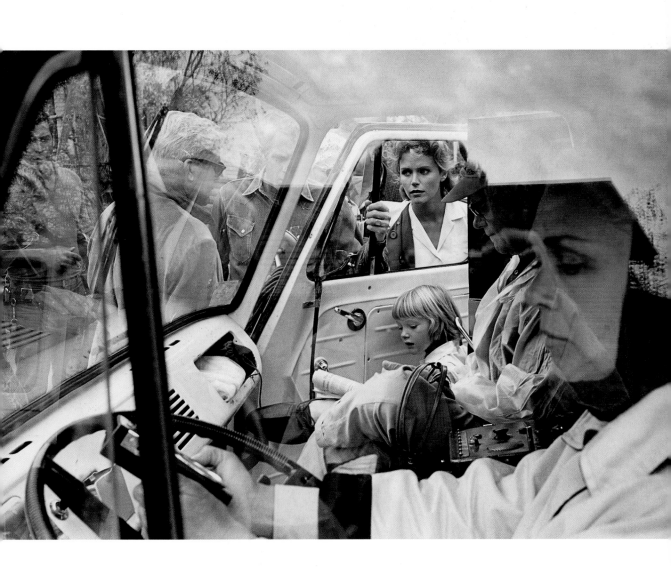

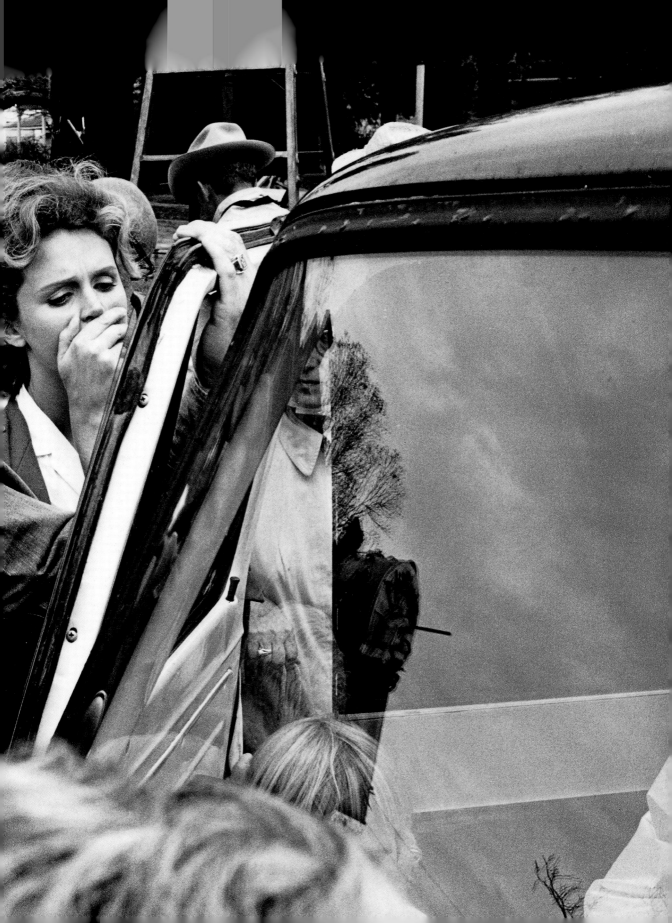

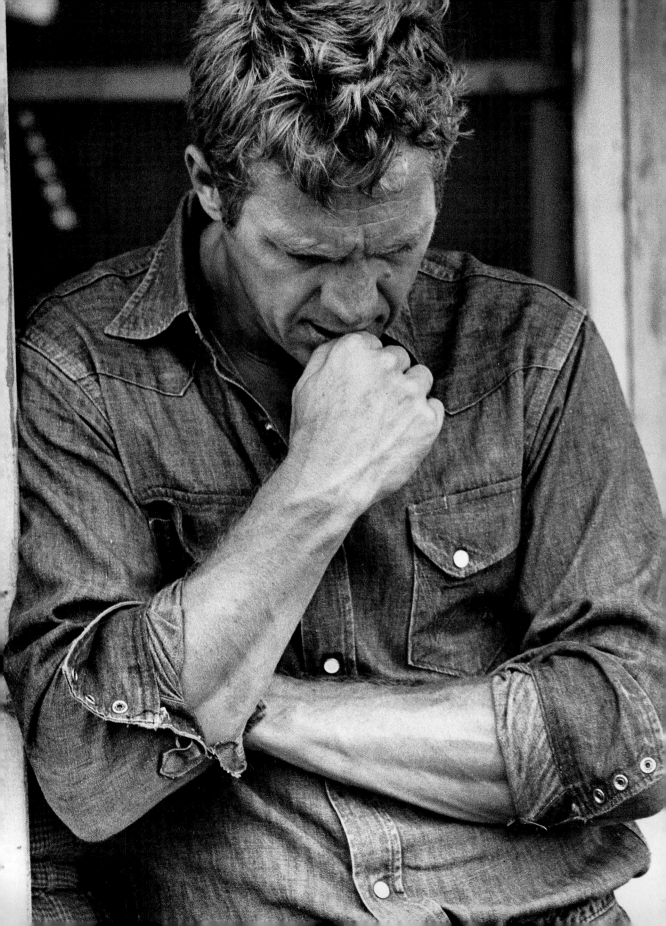

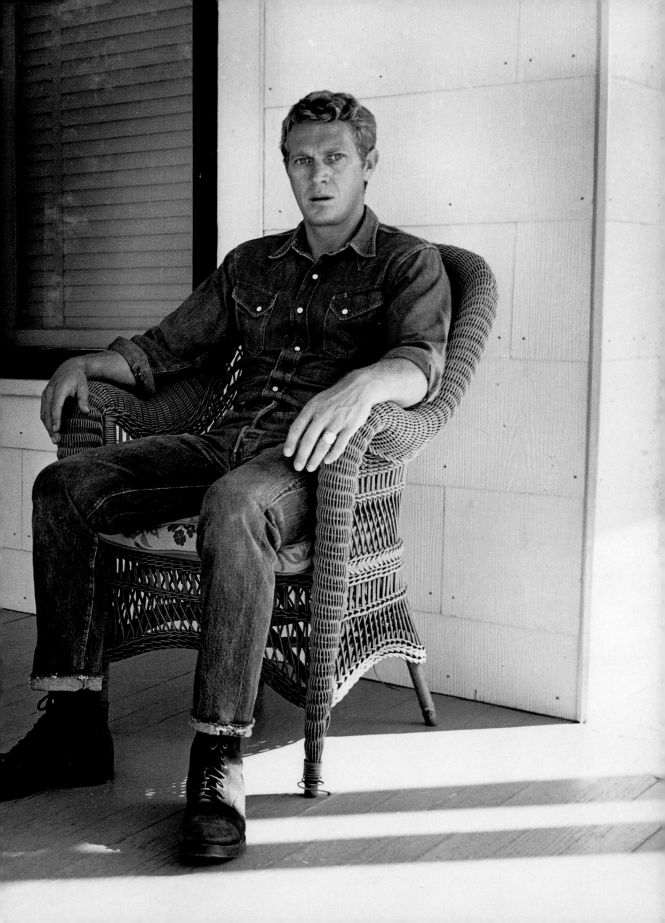

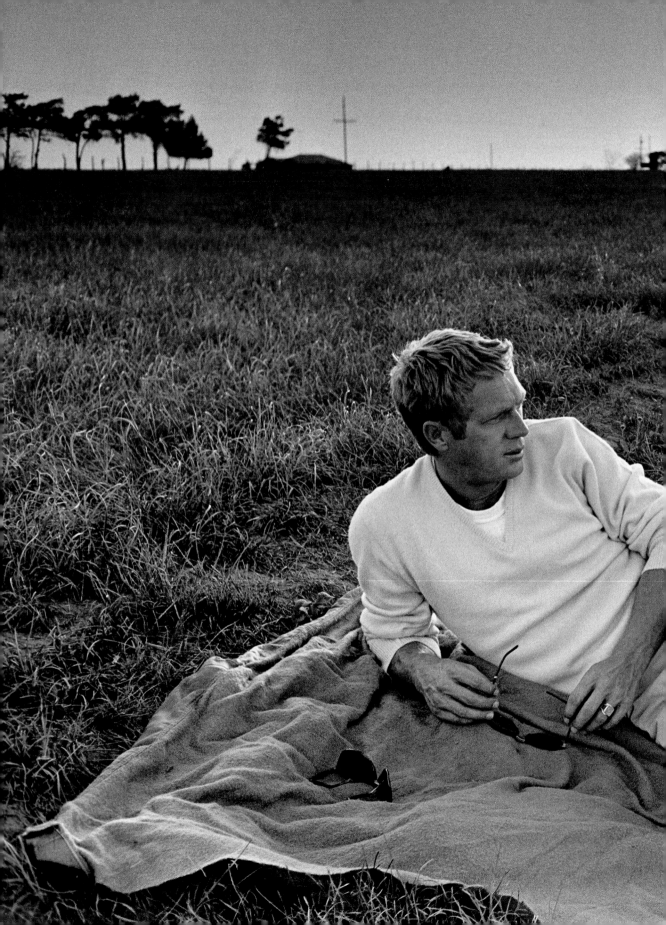

Steve claimed that he was dyslexic and had trouble reading scripts. But here he read and learned the script with the same voracity that he consumed his donuts and coffee. Monterey, California, 1963.

Steve behauptete, er sei Legastheniker und habe Schwierigkeiten, Drehbücher zu lesen. Hier las und lernte er das Skript so gierig wie er die Donuts und den Kaffee verschlang. Monterey, Kalifornien, 1963.

Steve a toujours prétendu qu'il était dyslexique et qu'il avait des difficultés à lire les scénarios. Ici, cependant, il lit et apprend par cœur le scénario avec la même voracité qu'il engloutit son café et ses beignets. Monterey, Californie, 1963.

Pages 140–141: Steve and co-star Jackie Gleason rehearse their lines on the set of *Soldier in the Rain*. In real life, Gleason was a rather elegant man, and he commented to me once that he thought "Steve's dining habits were barbaric." Fort Ord, California, 1963.

Seite 140–141: Steve und Schauspielerkollege Jackie Gleason bei einer Probe am Set von *Soldier in the Rain*. Im wirklichen Leben war Gleason ein ziemlich eleganter Herr und bemerkte mir gegenüber einmal, er fände Steves Essgewohnheiten „barbarisch". Fort Ord, Kalifornien, 1963.

Pages 140–141 : Steve et son partenaire Jackie Gleason sur le tournage de *La Dernière Bagarre*. Jackie Gleason qui était un homme plutôt élégant dans la vie réelle, m'a confié qu'il trouvait que la façon de se conduire à table de Steve était « barbare ». Fort Ort, Californie, 1963.

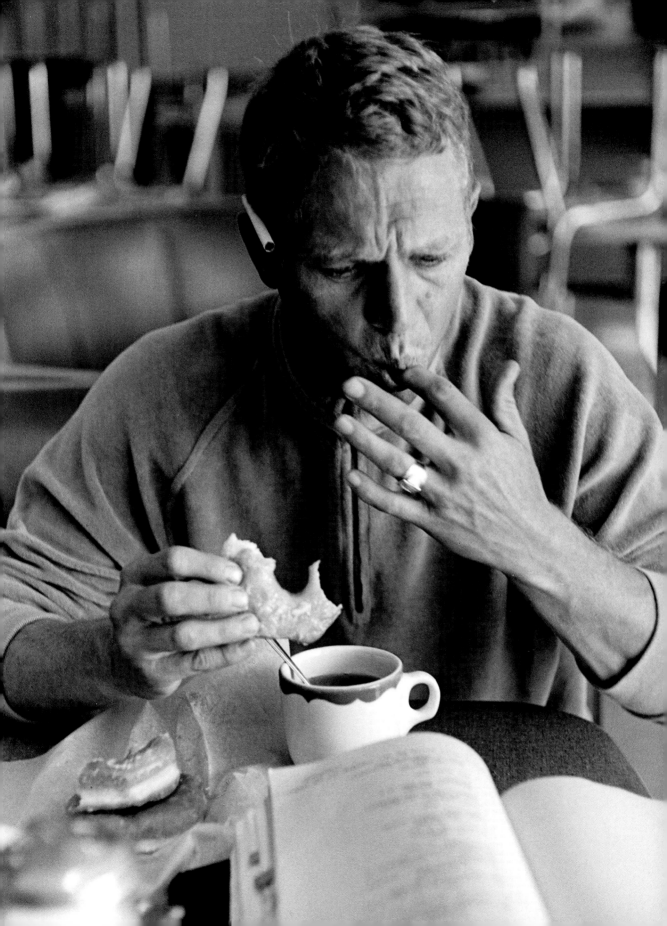

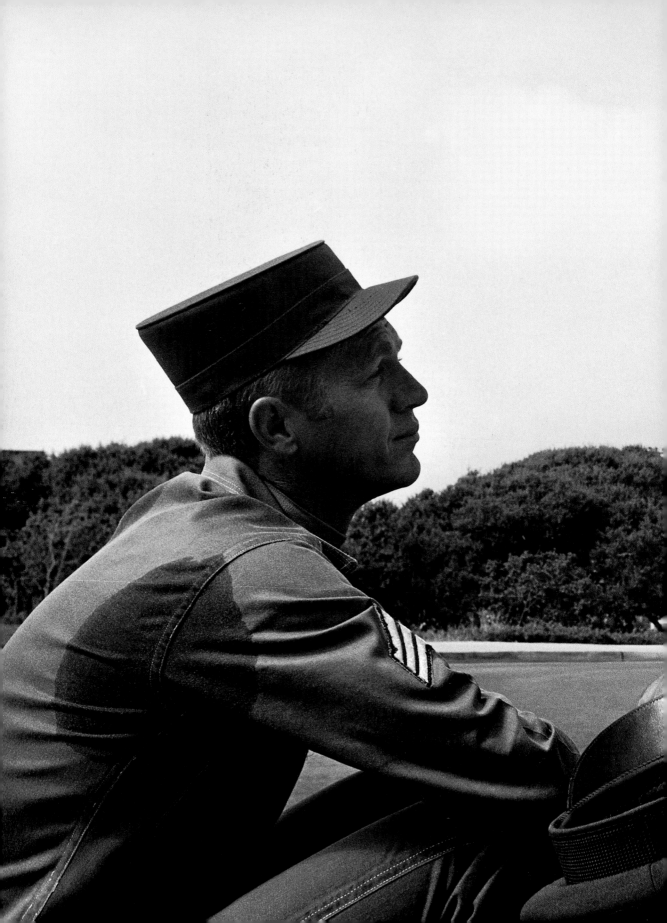

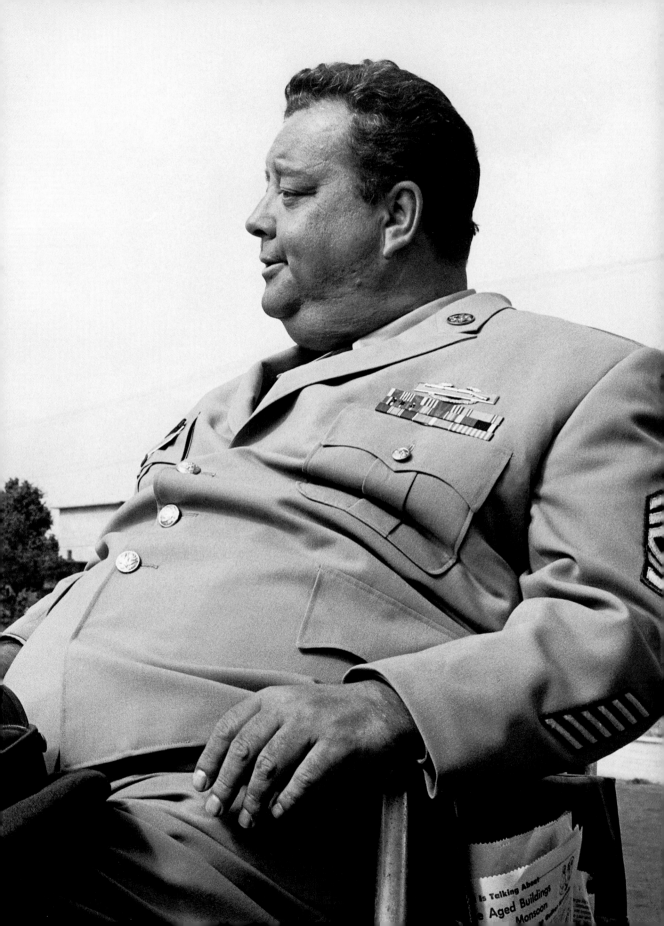

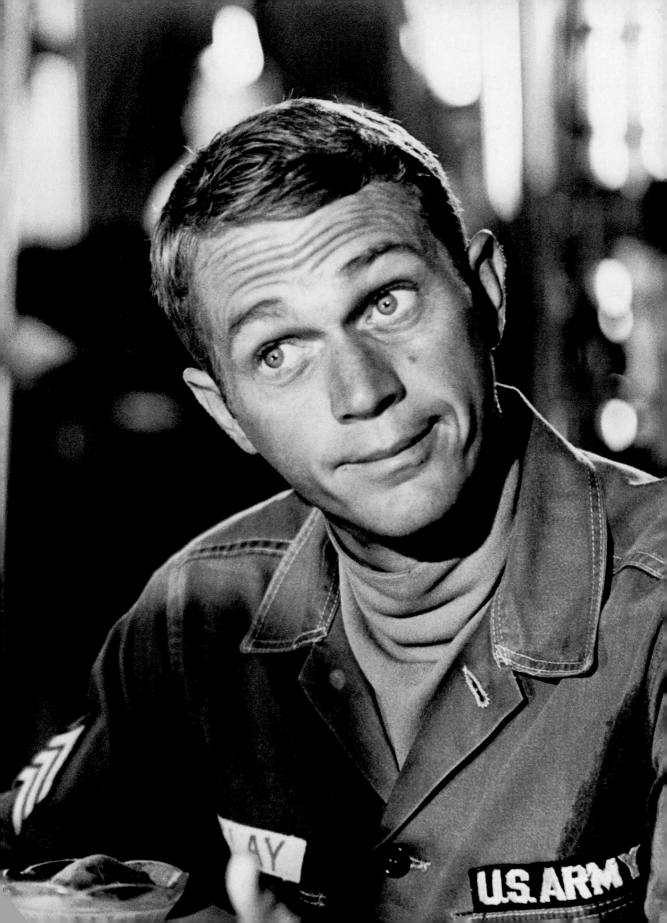

*Cosmopolitan* magazine assigned me to shoot a story on fashion designer Rudi Gernreich. I asked Steve if he would model with Peggy, who was Rudi's favorite model and muse. Steve agreed and enjoyed the experience. This picture was shot with his Ferrari in front of Steve's house. Los Angeles, 1964.

Das *Cosmopolitan Magazine* erteilte mir den Auftrag, eine Fotostory über den Modedesigner Rudi Gernreich zu schießen. Ich fragte Steve, ob er zusammen mit Peggy – Rudis Lieblingsmodel und Muse – Modell stehen würde. Steve war einverstanden und fand Vergnügen an der Aufgabe. Das Foto zeigt die beiden mit seinem Ferrari vor Steves Haus. Los Angeles 1964.

Le magazine *Cosmopolitan* m'avait chargé de faire un reportage sur le créateur de mode Rudi Gernreich. J'ai demandé à Steve s'il voulait poser avec Peggy, le mannequin préféré et la muse de Gernreich. Steve a accepté et il a beaucoup apprécié l'expérience. Ce cliché a été pris devant la maison de Steve, avec sa Ferrari. Los Angeles, 1964.

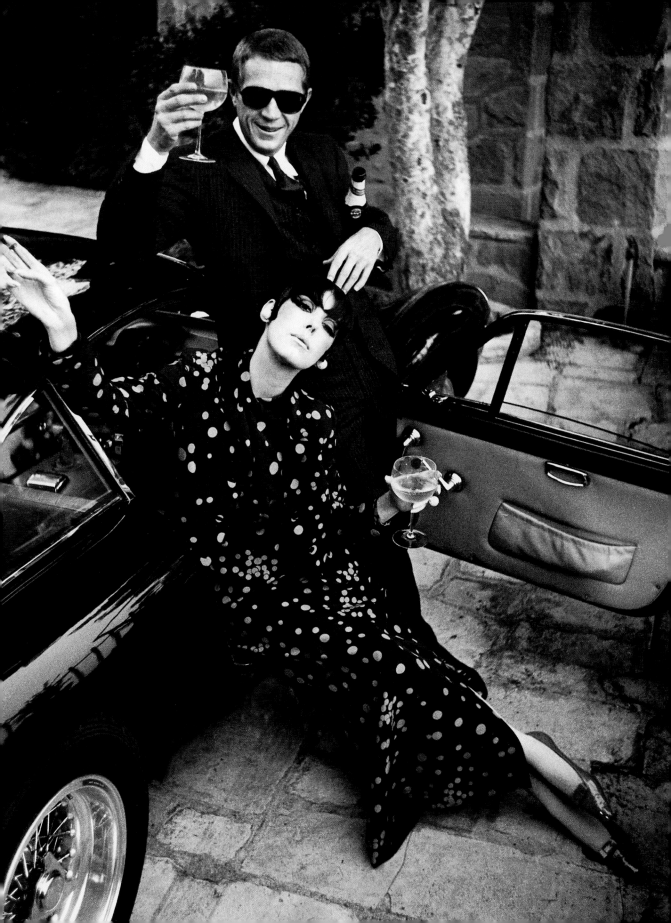

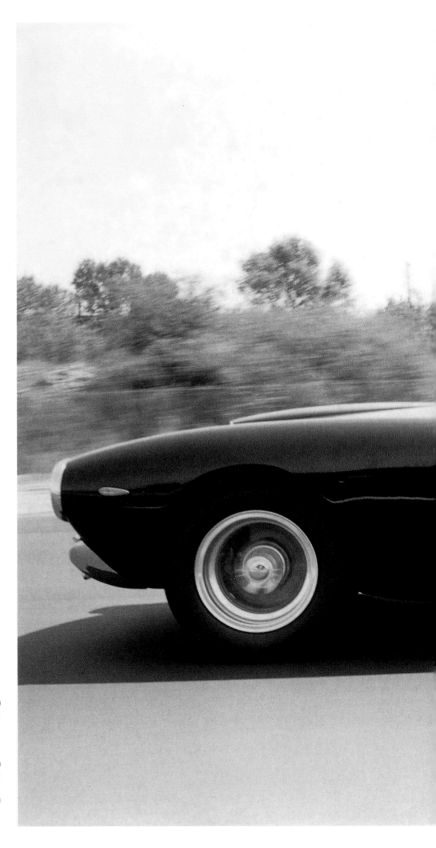

After Steve finished *The Cincinnati Kid*, he and Neile asked Peggy and me if we would like to take a motoring trip with them. Neile had just given Steve a new Ferrari ('63 250 GT Lusso Berlinetta) and I had just bought a Porsche 356 SC. We went up the California coast on Highway 1, into San Francisco, over to Reno and Lake Tahoe, then down into Death Valley and back to Los Angeles. It was a leisurely trip in spite of the times that Steve would pass my little Porsche at about 130 mph. California, 1964.

Nachdem Steve *Cincinnati Kid* beendet hatte, fragten er und Neile Peggy und mich, ob wir Lust hätten, mit ihnen eine Spritztour zu machen. Neile hatte Steve einen neuen Ferrari (1963 250 GT Lusso Berlinetta) geschenkt und ich hatte mir gerade einen Porsche 356 SC gekauft. Wir fuhren auf dem Highway 1 die kalifornische Küste hinauf, rein nach San Francisco, rüber nach Reno und Lake Tahoe, dann hinunter ins Death Valley und zurück nach Los Angeles. Es war ein gemütlicher Trip trotz der Schreckmomente, wenn Steve meinen kleinen Porsche mit rund 200 Sachen überholte. Kalifornien 1964.

Après le tournage du *Kid de Cincinnati*, Steve et Neile m'ont demandé si Peggy et moi souhaitions les accompagner pour une virée en voiture. Neile venait tout juste d'offrir à Steve une nouvelle Ferrari (une 250 GT Lusso Berlinetta de 1963) et je venais de m'acheter une Porsche 356 SC. Nous avons pris la Highway 1 qui longe la côte californienne, nous nous sommes rendus à San Francisco, puis à Reno et au lac Tahoe ; enfin nous avons regagné Los Angeles par la Vallée de la Mort. Un bien agréable voyage, malgré le mauvais moment quand Steve a doublé ma petite Porsche à plus de 200 km/h ... Californie, 1964.

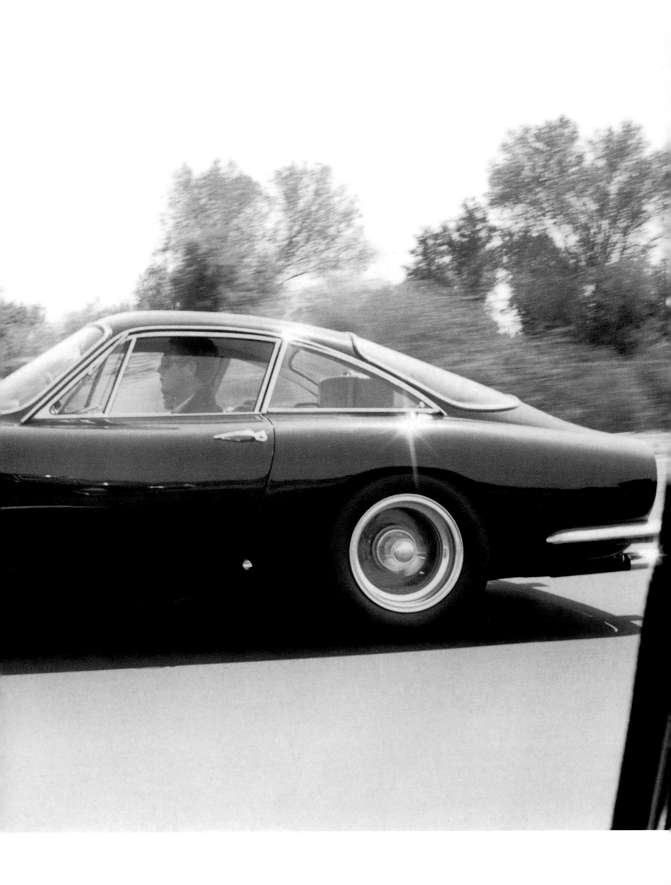

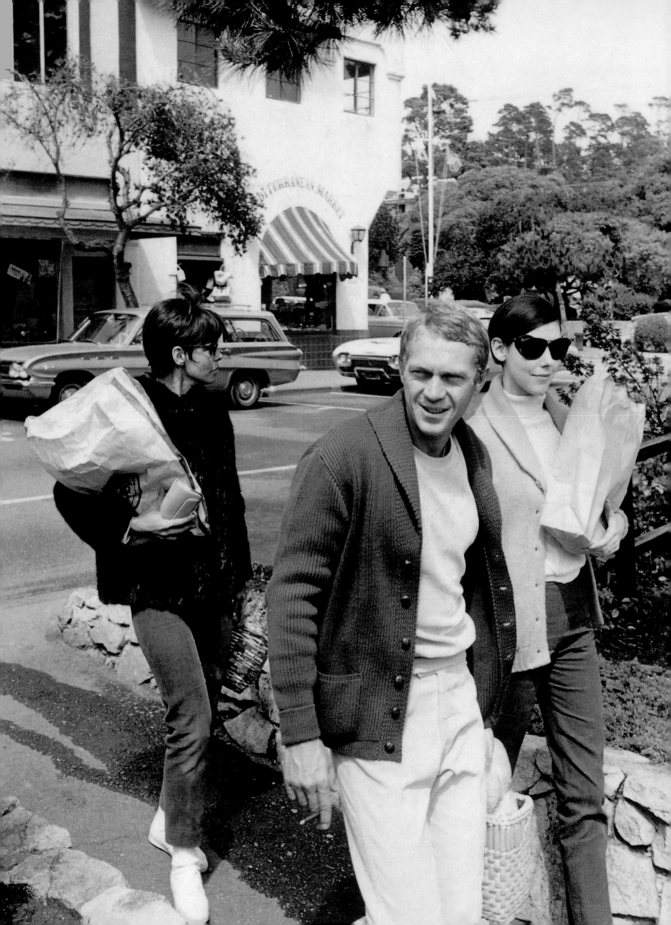

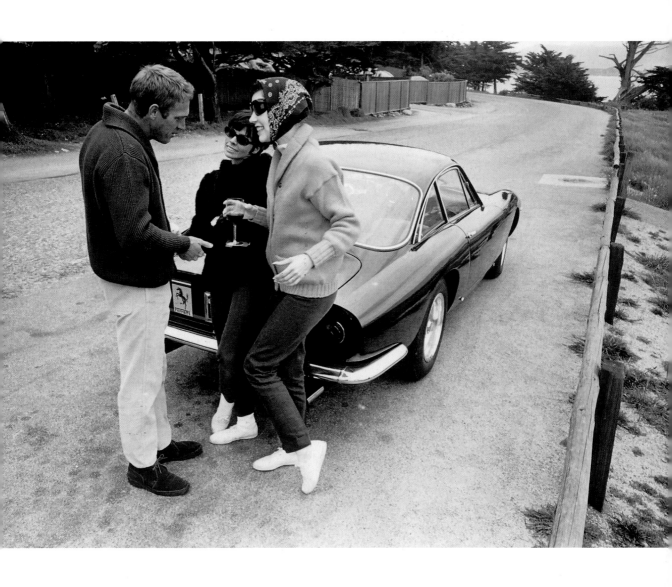

Peggy, Neile, and Steve shop in Carmel for food for our picnic. Carmel, California, 1964.
Peggy, Neile und Steve kaufen in Carmel Essen für unser Picknick ein. Carmel, Kalifornien, 1964.
Peggy, Neile et Steve font les courses à Carmel pour notre pique-nique du midi. Carmel, Californie, 1964.

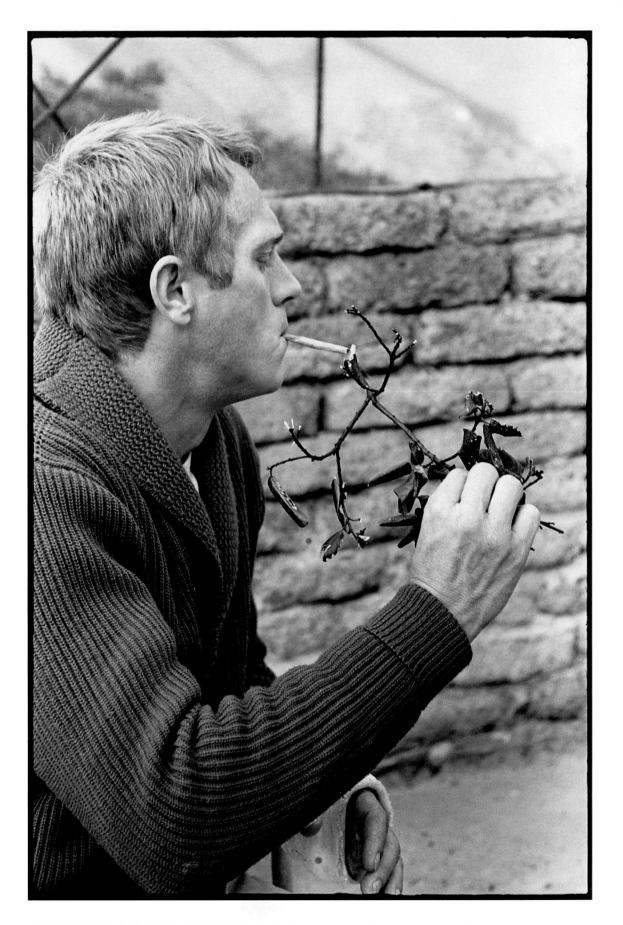

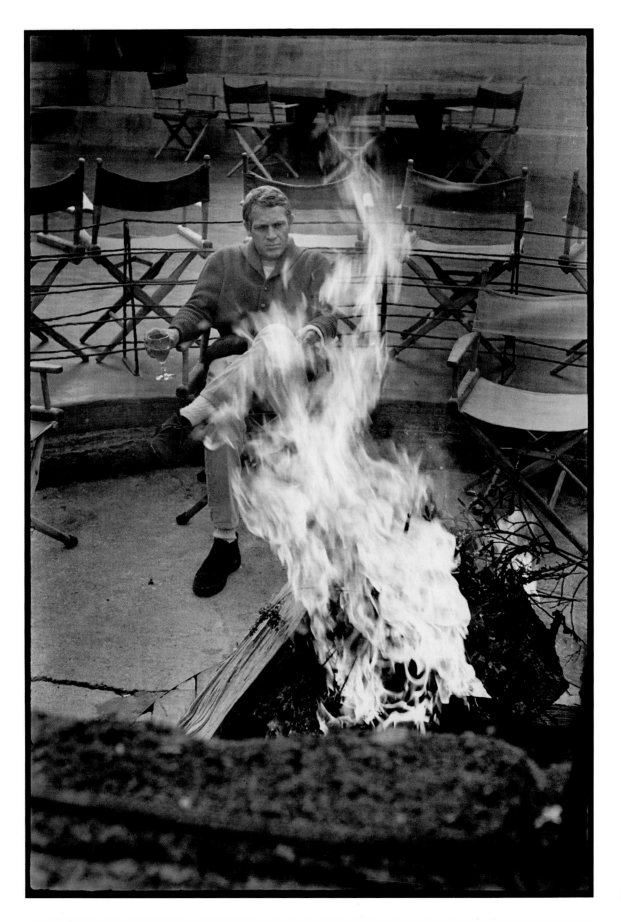

Page 150: Steve lights his "cigarette" with a twig of dried mistletoe at the Nepenthe Restaurant in Big Sur. Steve was a tremendous "head." He would smoke pot day and night and on any occasion. I was always amazed that he could concentrate while acting in a scene having just inhaled a joint or two in his dressing room. I said to him once, "Man, I don't know how you do it. I can't possibly indulge in grass while I'm photographing. I'd get hung up on everything around me. I prefer it after work to relax, listen to music and introspect. Enjoy colors, sounds, and tastes." Steve replied, "Clax, I like to push it as far as it will go. It keeps me on the edge. It's sort of a challenge. That feeling that I almost can't make it, but then I do. Know what I mean? I think it helps my concentration."

Then I began noticing something about him. As I learned his expressions and acting habits, it got so that I could tell when he was stoned and when he was not. I would watch his face on the big screen, and I knew immediately. It became my own private little game. Big Sur, California, 1964.

Seite 150: Steve zündet sich im Restaurant Nepenthe in Big Sur seine „Zigarette" an einem getrockneten Mistelzweig an. Steve liebte Marihuana. Er kiffte rund um die Uhr. Ich wunderte mich oft, wie er sich auf eine Szene konzentrieren konnte, nachdem er in der Garderobe gerade ein oder zwei Joints durchgezogen hatte. Einmal sagte ich zu ihm: „Mann, wie machst du das nur? Wenn ich stoned bin, kann ich nicht fotografieren. Alles um mich herum würde mich ablenken. Ich rauche lieber einen nach der Arbeit, zur Entspannung. Ich höre Musik, denke nach, genieße Farben, Töne, Geschmäcke." Darauf Steve: „Clax, ich treibe es gern auf die Spitze. Ich bewege mich immer nahe am Abgrund. Es ist eine Art Herausforderung. Das Gefühl, dass ich es nicht schaffe, und dann gelingt es mir doch. Verstehst du? Es hilft mir, mich zu konzentrieren."

Von dem Tag an sah ich ihn mit anderen Augen. Ich erkannte an seinem Gesichtsausdruck, an der Art wie er spielte, ob er stoned war oder nicht. Ich sah sein Gesicht auf der Leinwand und wusste es sofort. Ich machte mein eigenes kleines Spiel daraus. Big Sur, Kalifornien, 1964.

Page 150 : Steve allume sa « cigarette » avec une branche de gui au Nepenthe Restaurant, à Big Sur. Steve était un vrai « pompier ». Il fumait de la marijuana jour et nuit, et en toute occasion. J'ai toujours été impressionné par sa capacité à se concentrer sur une scène même après avoir fumé un joint ou deux dans sa loge. Un jour, je lui ai dit : « Mon vieux, je ne sais pas comment tu fais. Je ne vois vraiment pas comment je pourrais fumer de l'herbe tout en prenant des photos. Je crois que je resterais scotché devant tout ce qui m'entoure. Je préfère en profiter après le travail pour me détendre, j'écoute de la musique et je fais mon introspection. Je savoure les couleurs, les sons et les goûts. » Steve m'a répondu : « Clax, moi, j'aime repousser les limites. C'est ce qui me fait avancer. C'est comme un défi. J'adore avoir l'impression que je ne vais pas pouvoir y arriver, et finalement, j'y arrive. Tu vois ce que je veux dire ? Je crois que ça m'aide à me concentrer. »

Puis, j'ai commencé à remarquer quelques détails à son sujet. J'ai appris à connaître ses expressions et son jeu d'acteur. À la fin, je pouvais dire quand Steve était défoncé et quand il ne l'était pas : je voyais son visage apparaître sur le grand écran et je savais immédiatement. C'était devenu comme un jeu pour moi. Big Sur, Californie, 1964.

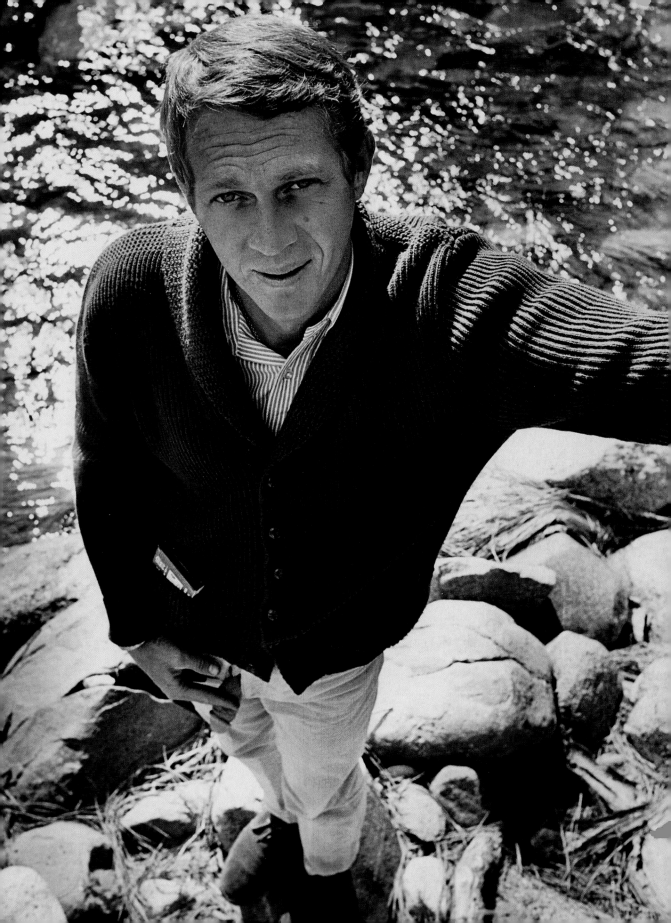

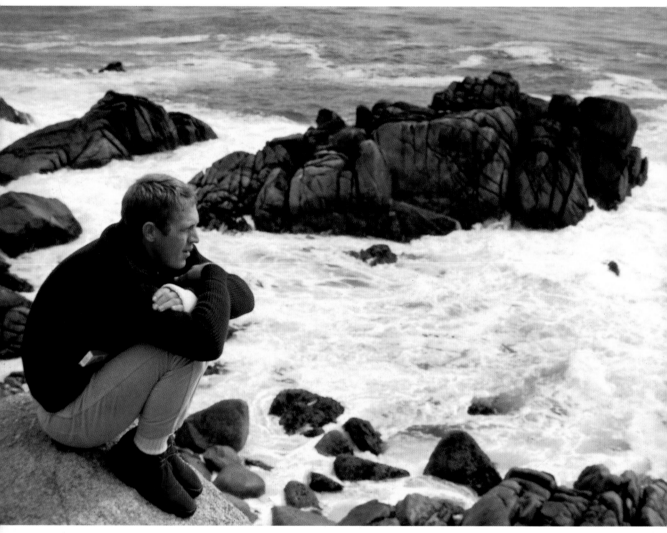

On the California Coast. Steve had broken his wrist in a motorcycle accident, but for insurance reasons he told the studio that he slipped on some grease in the back of his truck. He was not allowed to ride motorcycles when under contract to a studio. Carmel, California, 1964.

An der kalifornischen Küste. Steve hatte sich bei einem Motorradunfall das Handgelenk gebrochen, aber aus versicherungstechnischen Gründen erzählte er dem Studio, er sei im öligen Laderaum seines Trucks ausgerutscht. Er durfte nicht Motorrad fahren, solange er bei einem Studio unter Vertrag stand. Carmel, Kalifornien, 1964.

Sur la côte californienne. Steve s'était cassé le poignet dans un accident de moto, mais pour des raisons d'assurance, il a dit au studio qu'il avait glissé sur une flaque d'huile à l'arrière de son camion. Quand il était sous contrat avec un studio, il n'avait pas le droit de piloter une moto. Carmel, Californie, 1964.

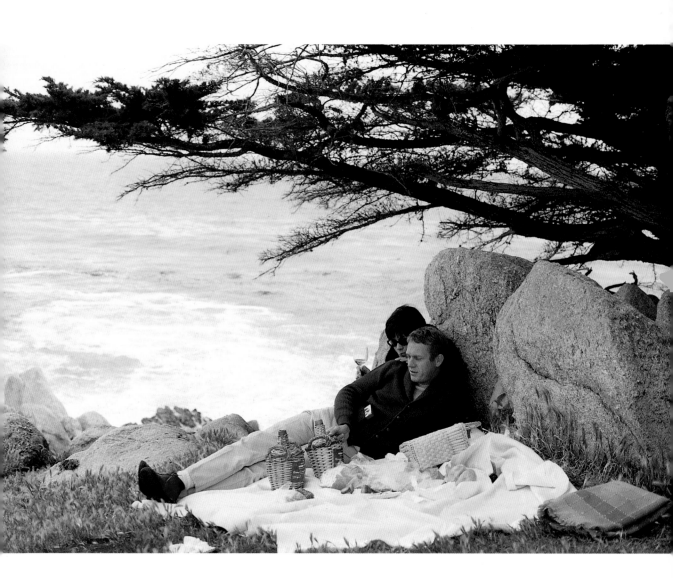

Peggy, Neile, Steve, and I have fun on Broadway in North Beach. San Francisco, 1964.

Peggy, Neile, Steve und ich machen Faxen am Broadway in North Beach. San Francisco 1964.

Peggy, Neile, Steve et moi dans Broadway, à North Beach. San Francisco, 1964.

Page 158–159: On a terrace of the Mark Hopkins Hotel, Steve is in the midst of telling an adventuresome tale to Peggy. I think Neile had heard it before. San Francisco, 1964.

Seite 158–159: Auf einer Terrasse des Mark Hopkins Hotels ist Steve gerade dabei, Peggy eine abenteuerliche Geschichte zu erzählen. Ich glaube, Neile kannte sie bereits. San Francisco 1964.

Pages 158–159: Sur la terrasse du Mark Hopkins Hotel, Steve est en train de raconter une histoire pleine de péripéties à Peggy. Je crois que Neile l'avait déjà entendue avant. San Francisco. 1964

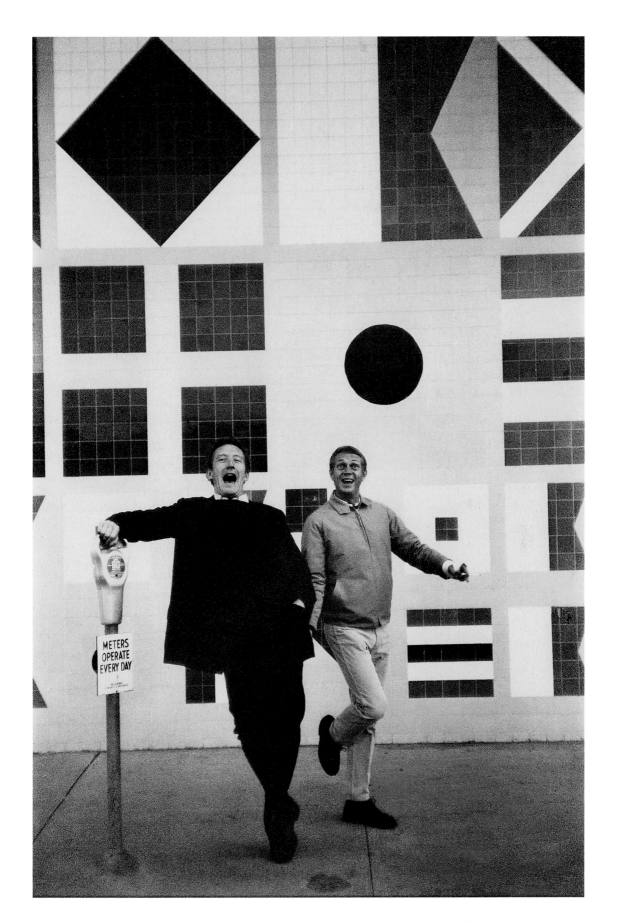

METERS
OPERATE
EVERY DAY

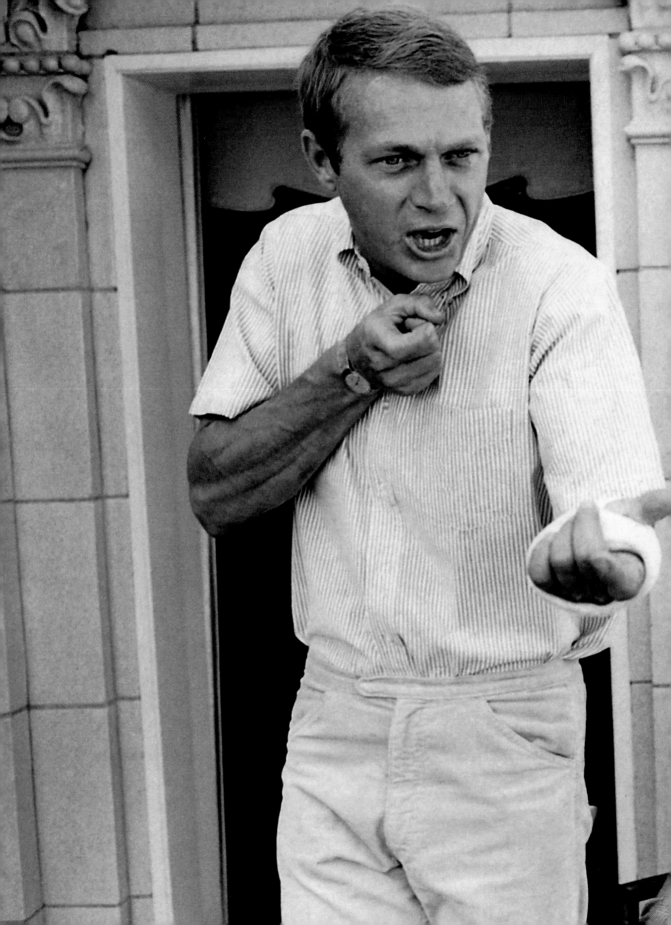

Steve on his Triumph near Mulholland Drive. Hollywood Hills, 1963.
Steve auf seiner Triumph in der Nähe des Mulholland Drive. Hollywood Hills 1963.
Steve sur sa Triumph, près de Mulholland Drive. Hollywood Hills, 1963.

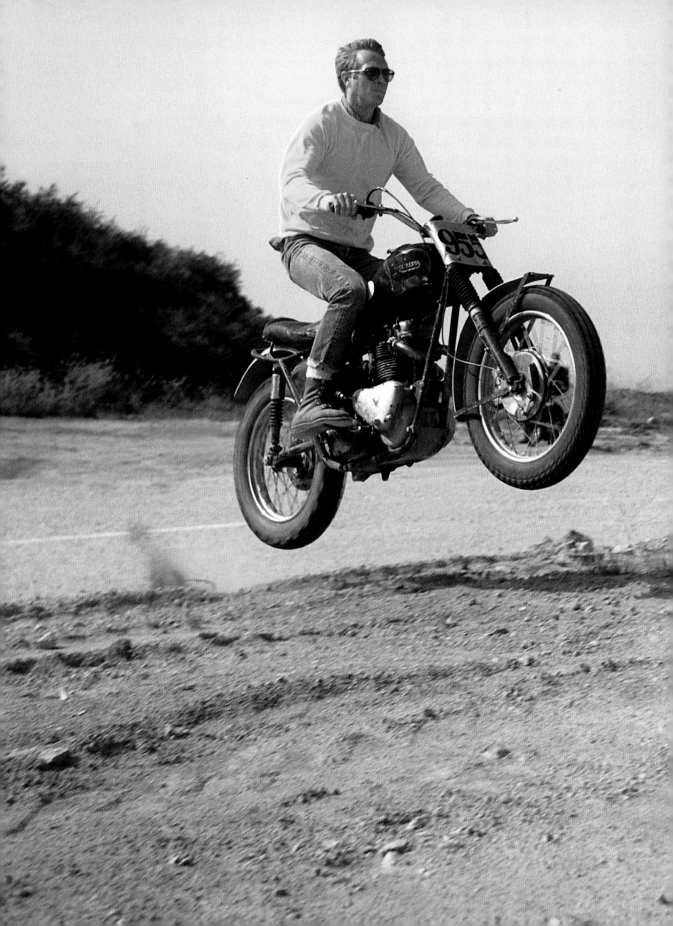

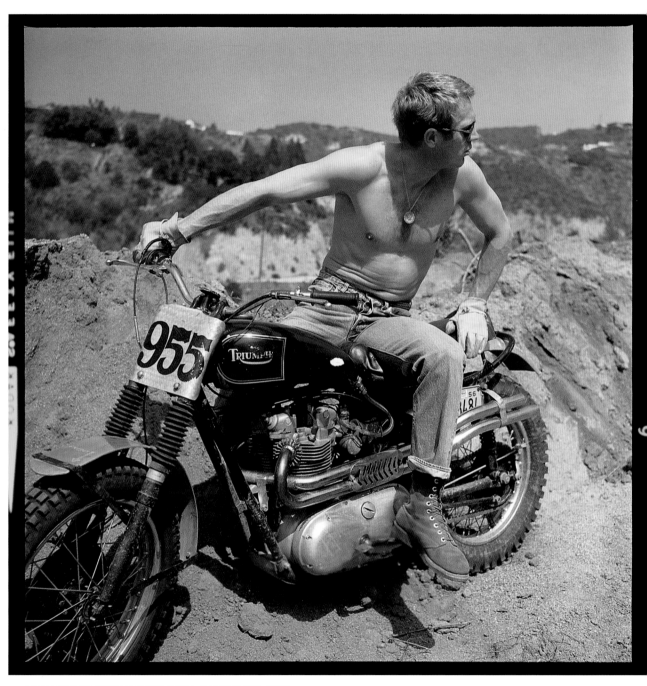

Steve astride his '63 Triumph TR6 650 cc. Hollywood Hills, 1963.
Steve rittlings auf seiner 1963 Triumph TR6 650 cm³. Hollywood Hills 1963.
Steve sur sa Triumph TR6 650 cm³ de 1963. Hollywood Hills, 1963.

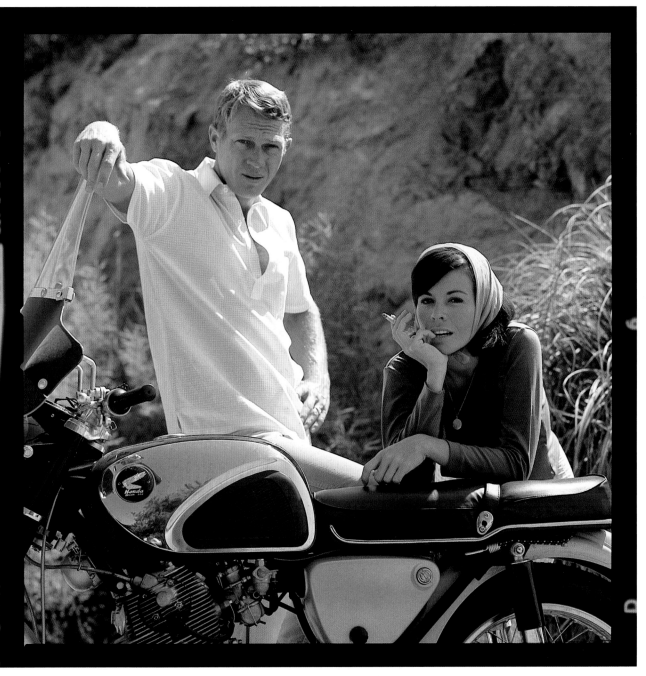

Steve and Neile in the driveway of their house on Solar Drive. Hollywood Hills, 1962.
Steve und Neile in der Einfahrt ihres Hauses am Solar Drive. Hollywood Hills 1962.
Steve et Neile dans l'allée conduisant à leur maison de Solar Drive. Hollywood Hills, 1962.

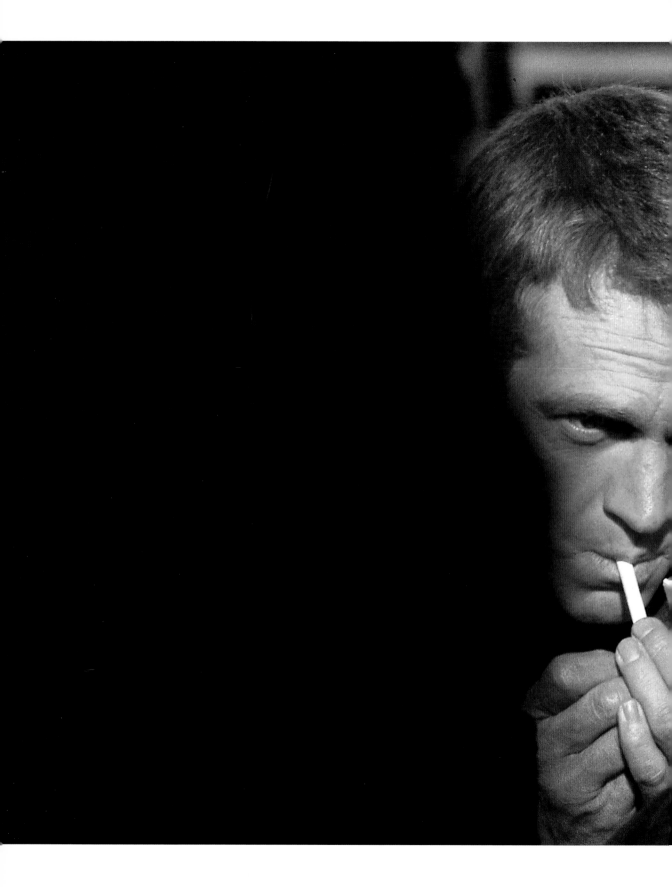

Steve with director Norman Jewison on the
set of *The Cincinnati Kid* at MGM Studios.
Culver City, 1964.

Steve mit Regisseur Norman Jewison am
Set von *Cincinnati Kid* in den MGM Studios.
Culver City 1964.

Steve en compagnie du réalisateur Norman
Jewison, sur le tournage du *Kid de Cincinnati*
dans les studios de la MGM. Culver City, 1964.

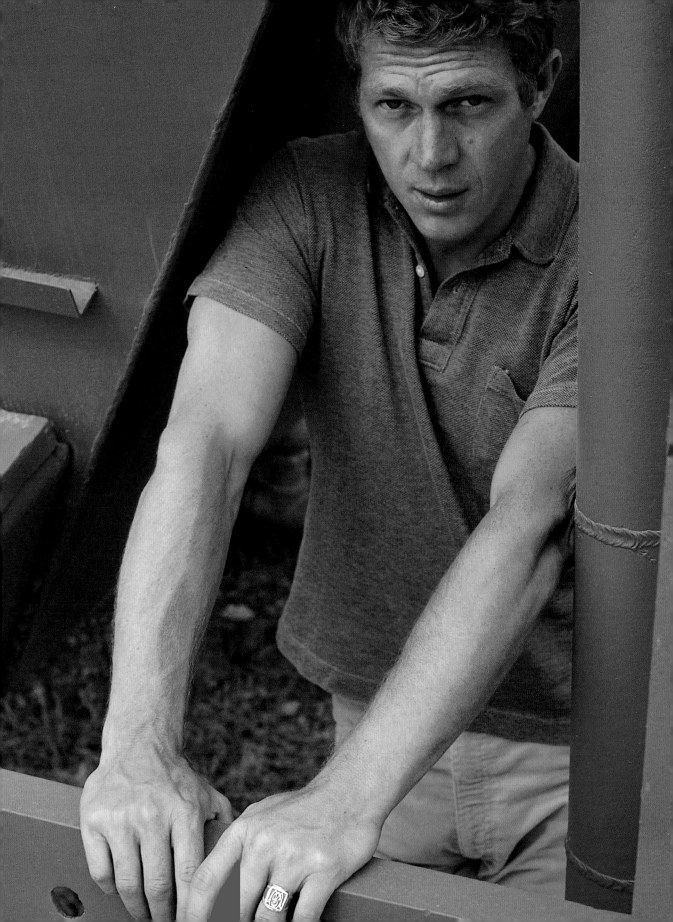

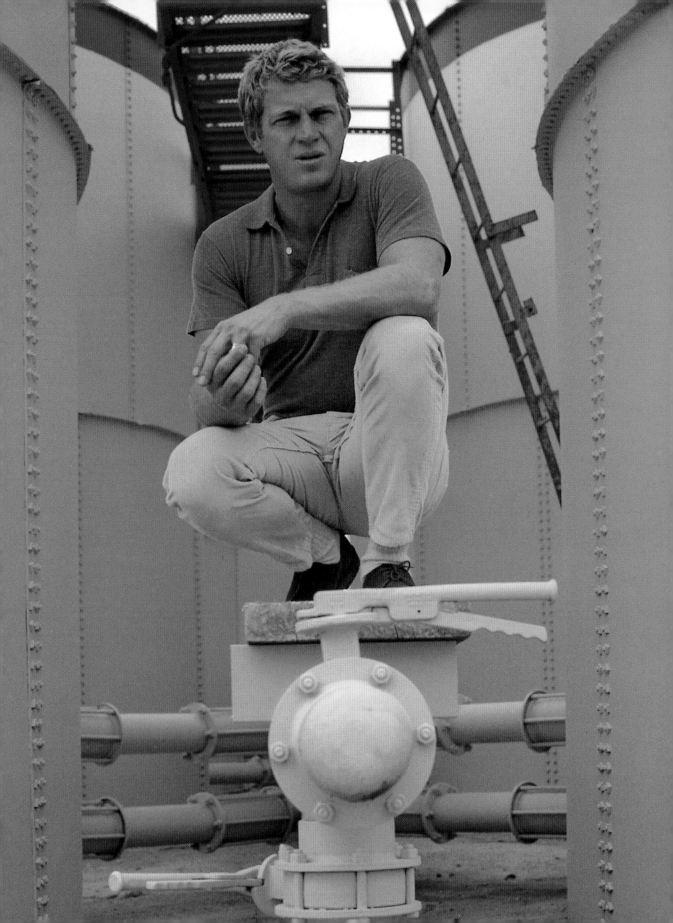

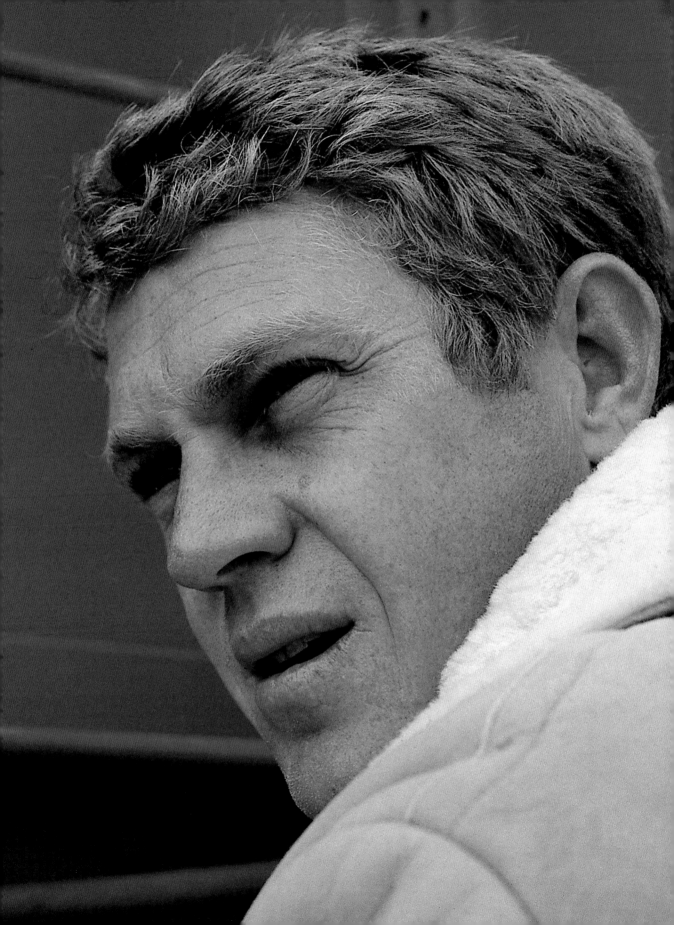

Steve believed in staying in shape, and he worked out regularly at a studio gym. When on location, he had it in his contract for the production company to provide him with a moveable gym. Paramount Studios, Hollywood, 1963.

Steve legte Wert auf körperliche Fitness und trainierte regelmäßig im Fitnessraum des Studios. Die Produktionsfirma musste ihm vertraglich zusichern, bei Dreharbeiten immer die nötigen Sportgeräte bereitzustellen. Paramount Studios, Hollywood 1963.

Steve prenait soin de sa forme en s'entraînant régulièrement dans une salle de gym. Pour les tournages en extérieur, il exigeait toujours dans ses contrats que la production mette à sa disposition des appareils de gymnastique. Studios de la Paramount, Hollywood, 1963.

Pages 176–179: With *Cincinnati Kid* co-star Tuesday Weld.
Seite 176–179: Mit Tuesday Weld, seiner Filmpartnerin aus *Cincinnati Kid*.
Pages 176–179 : Steve en compagnie de sa partenaire du *Kid de Cincinnati*, Tuesday Weld.

Pages 180–181: Steve and MGM wanted portraits taken for publicity and Steve insisted that I be hired to shoot him. Whatever Steve wanted, he got. Culver City, 1964.

Seite 180–181: MGM brauchte Werbefotos von Steve und er bestand darauf, dass ich sie machen sollte. Und wenn Steve etwas wollte, bekam er es auch. Culver City 1964.

Pages 180–181 : Steve et la MGM voulaient une série de photos publicitaires. Il a insisté pour que je réalise ces clichés. Quand Steve demandait quelque chose, il l'obtenait toujours. Culver City, 1964.

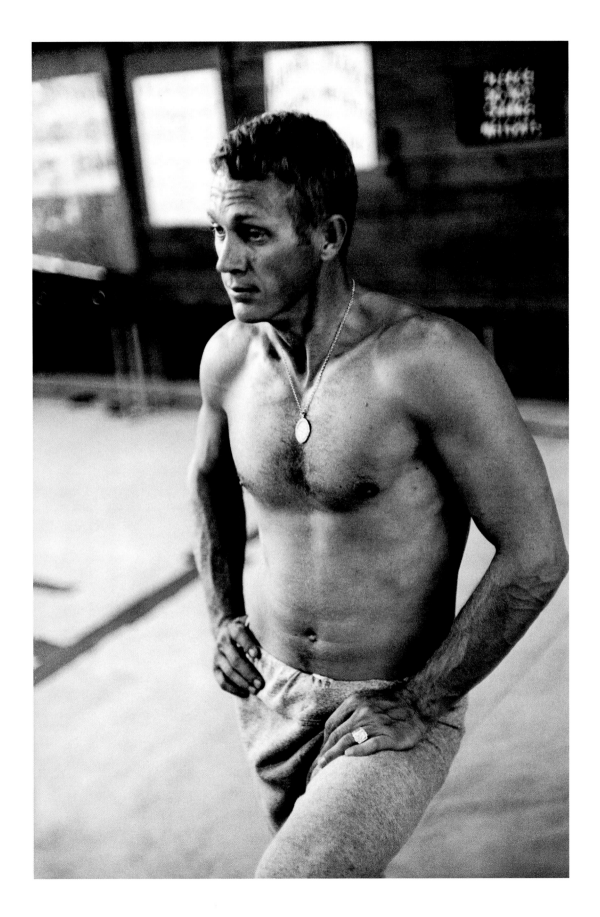

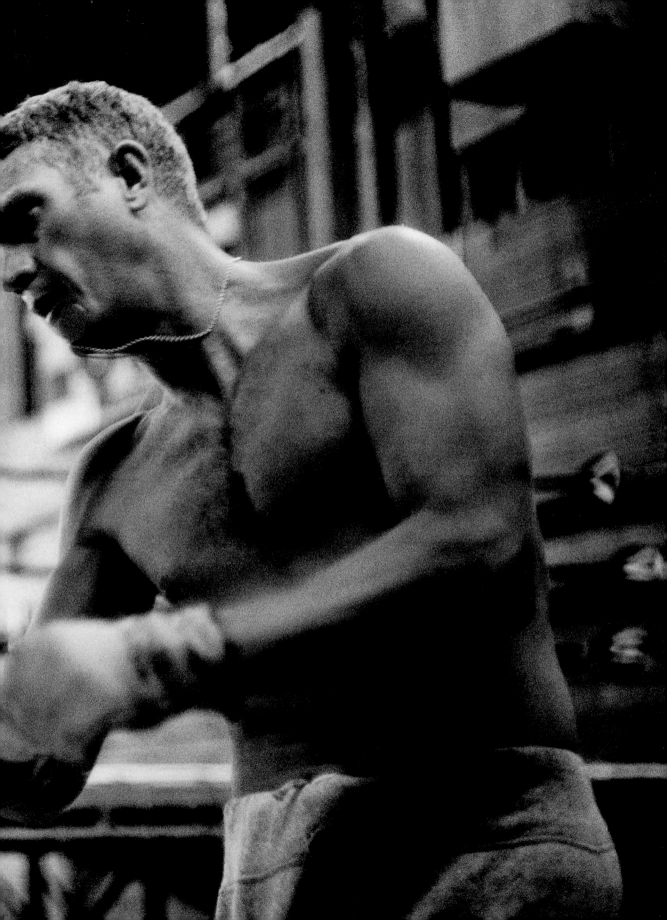

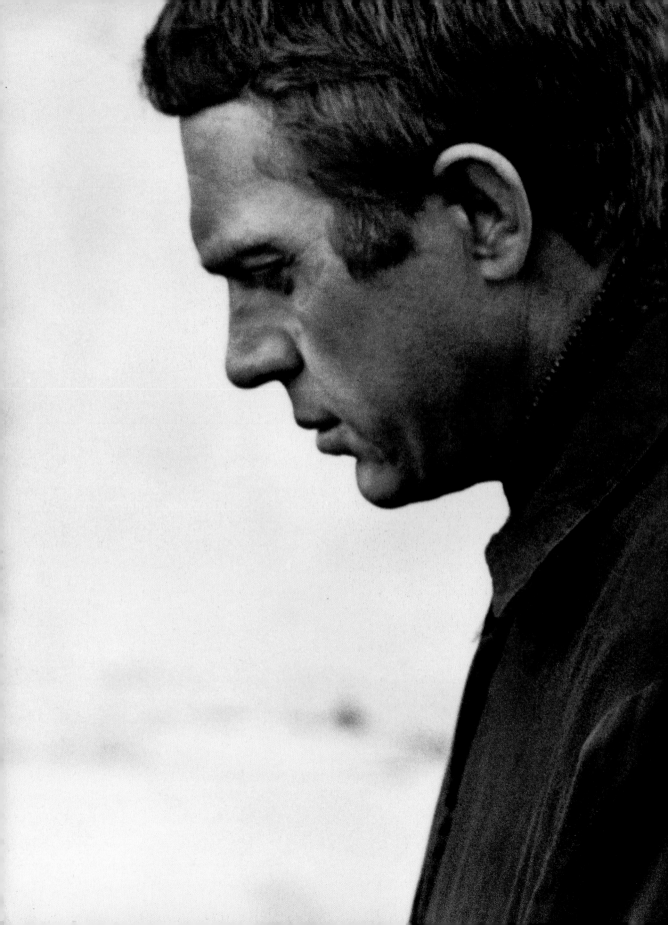

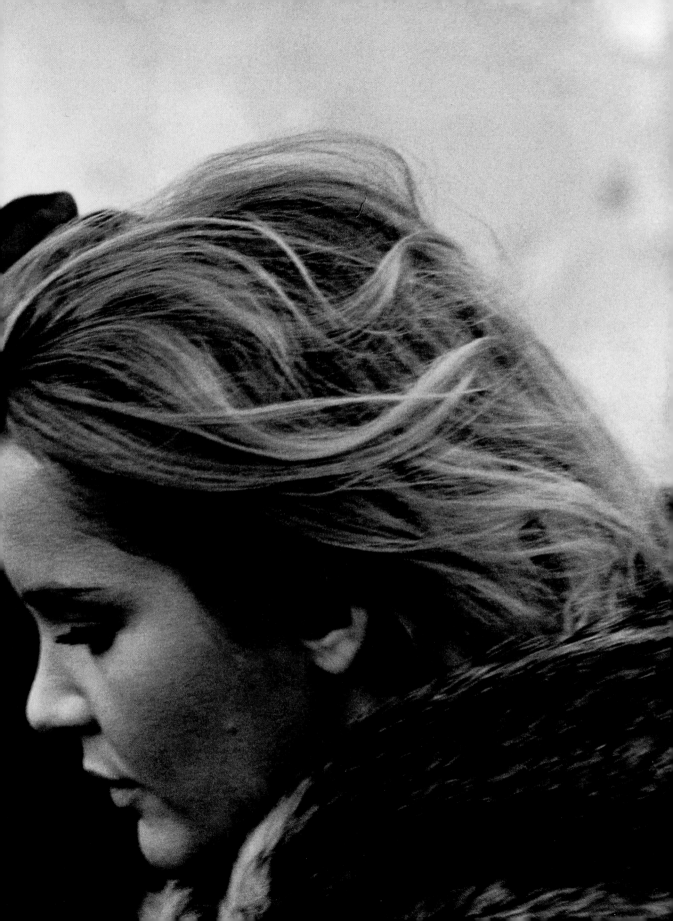

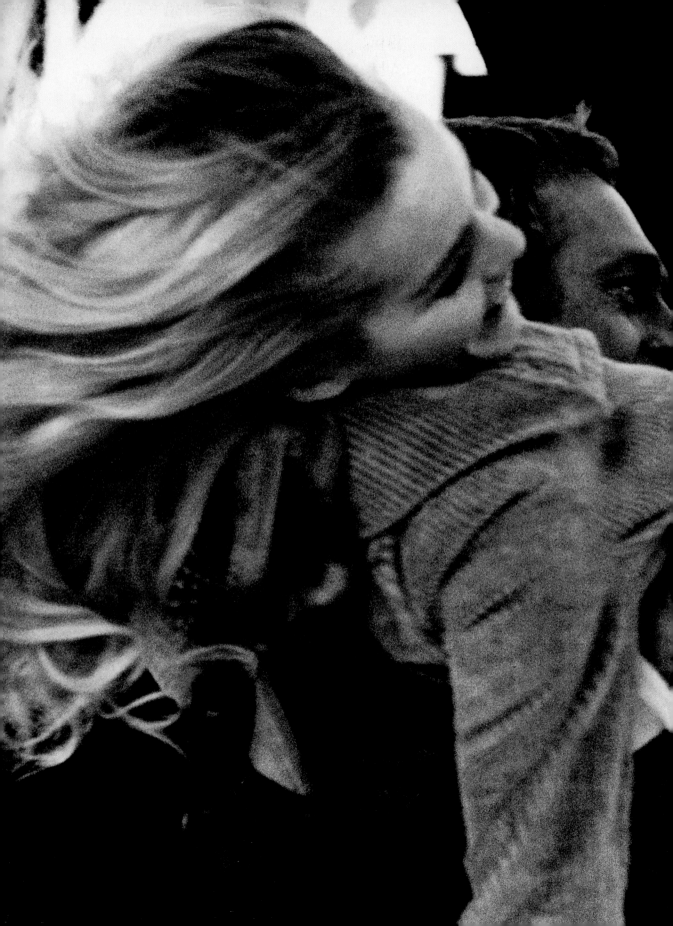

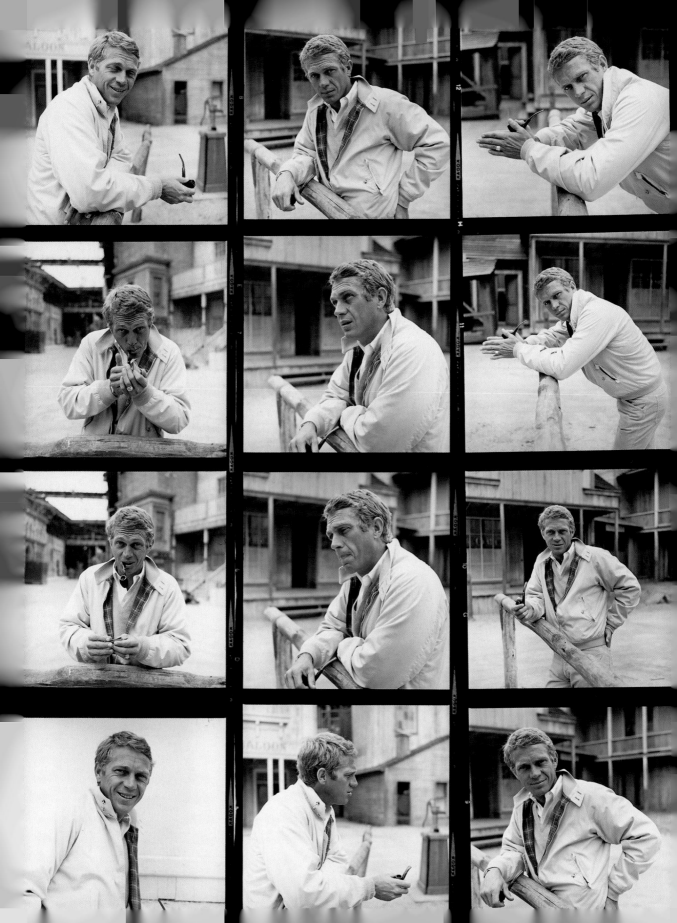

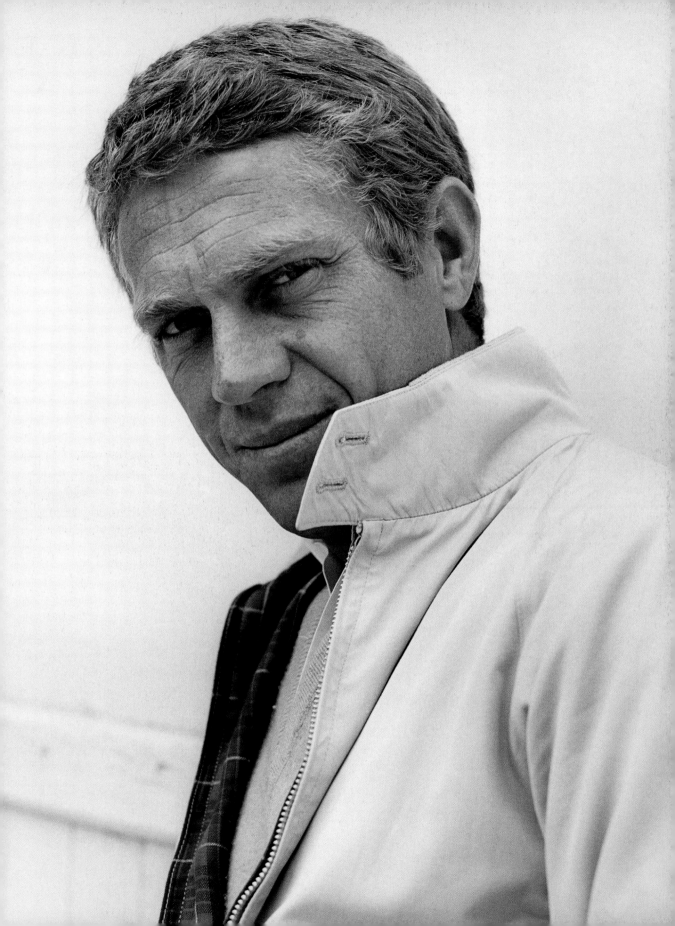

# AFTERWORD

Steve McQueen, March 24, 1930 – November 7, 1980

As I look over these wonderful photographs of Dad, which were taken when I was very young, perhaps three or four years old, I realize how little he had changed through the years. Although the pictures were taken during the beginning of his career, they capture his dynamic, rebellious behavior, his humor, and most of all, his sensitivity. Every expression I've seen before. They bring back an awful lot of great memories.

It's obvious that Dad trusted William Claxton very much. "Clax," as Dad called him, has told me that he was constantly fascinated with his tough guy, often secretive and daredevil qualities; but most of all, he admired his cool and hip personality.

Clax and Dad both loved fast cars and took many trips together. Their relationship was unique and trusting. Otherwise, these moments could not have been recorded on film for all of us to enjoy. This book captures his friend, my Dad, in close-up.

Wenn ich diese wunderbaren Fotos von Dad betrachte, die alle aufgenommen wurden, als ich noch sehr klein war, drei oder vier Jahre alt, wird mir bewusst, wie wenig er sich über die Jahre verändert hatte. Obgleich die Bilder aus der Anfangszeit seiner Karriere stammen, spiegeln sie bereits sein dynamisches, rebellisches Wesen, seinen Humor und vor allem seine Empfindsamkeit. Ich kenne jede einzelne Pose, jeden Gesichtsausdruck. Sie rufen zahllose kostbare Erinnerungen wach.

Es ist offensichtlich, dass Dad William Claxton vertraute. „Clax", wie er ihn nannte, erzählte mir, wie sehr ihn die Verschlossenheit und Verwegenheit dieses harten Burschen faszinierte. Am meisten jedoch bewunderte er seine gelassene und unkonventionelle Art.

Clax und Dad teilten ihre Leidenschaft für schnelle Autos und unternahmen so manche gemeinsame Spritztour. Ihre Beziehung war einzigartig und von Vertrauen geprägt. Andernfalls hätte Claxton diese Momente nie mit der Kamera einfangen können, wären diese Fotos, die uns alle erfreuen, nicht entstanden. Mit diesem Buch gelingt ihm eine Nahaufnahme seines Freundes, meines Vaters.

Quand je regarde ces superbes photos de mon père, qui ont été prises quand j'étais très jeune (je devais avoir trois ou quatre ans à l'époque), je me rends compte qu'il n'a pratiquement pas changé au fil des ans. Réalisés au début de sa carrière, ces clichés ont saisi son comportement dynamique et rebelle, son humour, et surtout, sa sensibilité. Toutes ces expressions me sont si familières. Ils me rappellent un nombre incroyable de merveilleux souvenirs.

De toute évidence, mon père avait une confiance absolue en William Claxton. « Clax », comme il l'appelait, m'a confié qu'il avait toujours été fasciné par ce risque-tout souvent cachottier aux allures de dur ; mais, par-dessus tout, il admirait sa personnalité relax et branchée.

Clax et mon père avaient tous les deux une passion pour les voitures et ils ont beaucoup voyagé ensemble. Ils ont su nouer une complicité exceptionnelle. S'il n'en avait pas été ainsi, ces moments, qui font notre plus grand bonheur aujourd'hui, n'auraient jamais pu être fixés sur la pellicule. Cet ouvrage est un gros plan sur mon père, le fidèle ami de Clax.

Chad McQueen, Malibu, 2004

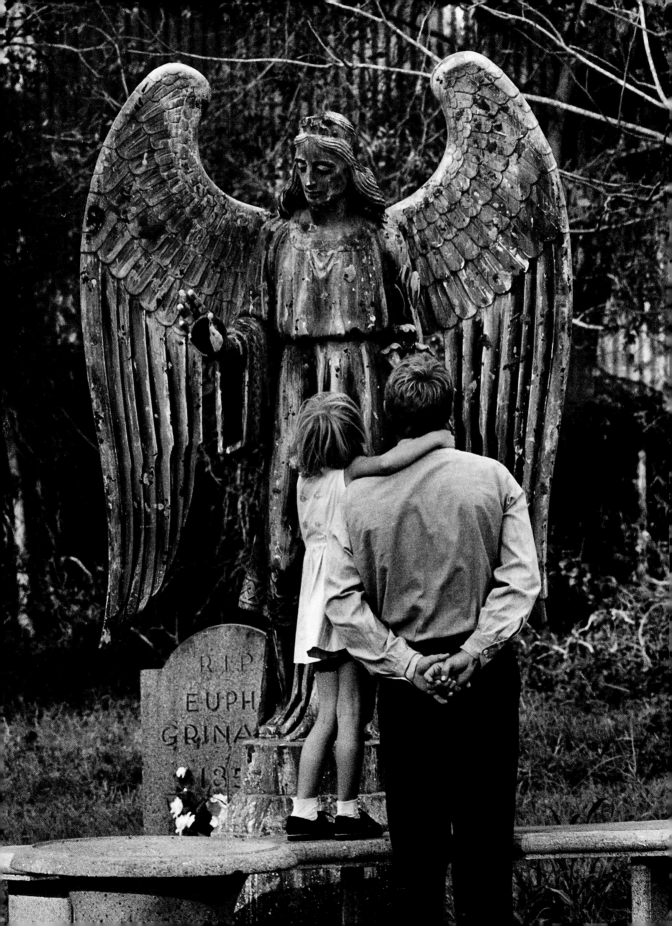

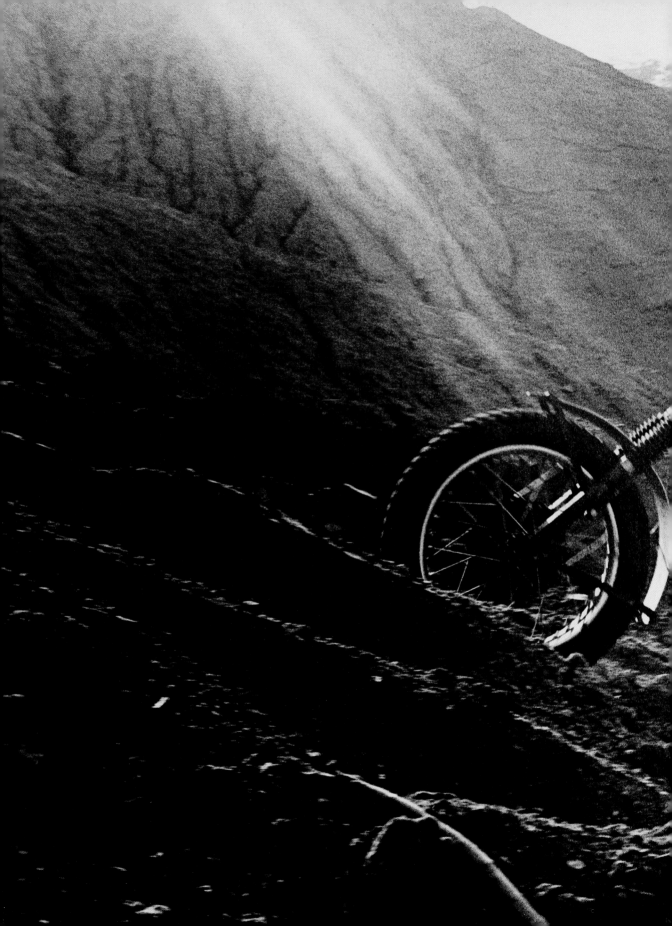

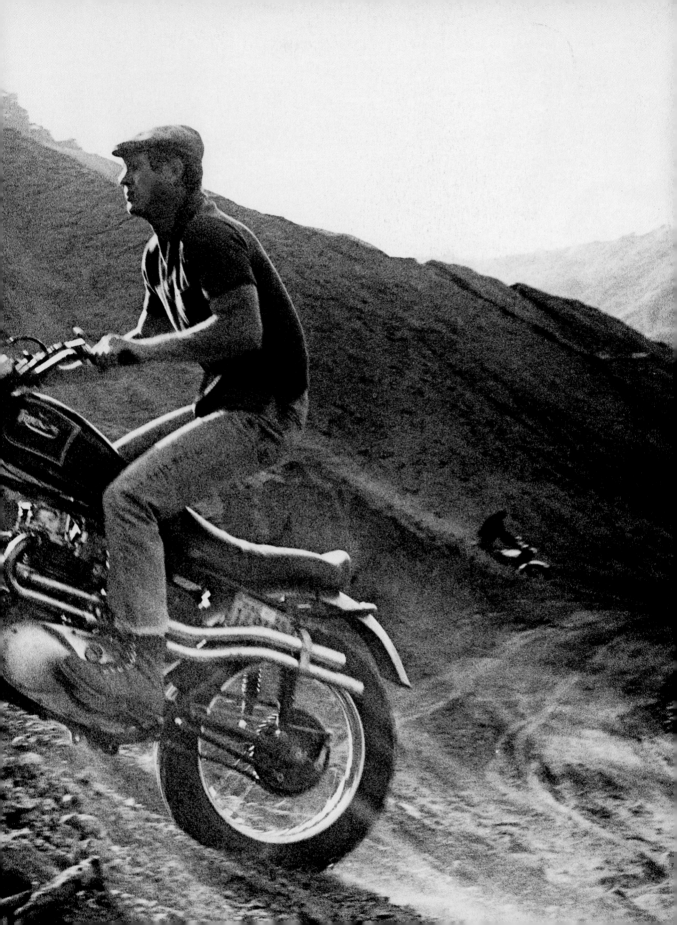

# WILLIAM CLAXTON

Born and raised in Southern California, William Claxton holds a special place in the history of American photography. Since his earliest pictures in the 1950s, he has been creating photographs that have garnered attention for their intimate yet soulful feel.

Always noted for his sensitive and poetic style, Claxton has long been considered the preeminent photographer of jazz music. His jazz imagery has graced the covers of countless albums and magazines for over five decades.

In 1952, while a student at U.C.L.A., Claxton began to photograph a young and unknown trumpet player named Chet Baker. The resulting collection of images from these sessions has become known throughout the world of jazz music. Covering the trumpeter's meteoric rise to fame and his equally dramatic demise, the Claxton images of Baker are largely credited as defining both his initial fame and legacy.

Since his early career – shooting for *LIFE*, *Paris Match*, and *Vogue*, among other magazines – Claxton has worked with and become friends with many Hollywood luminaries. His very personal pictures of Frank Sinatra, Marlene Dietrich, Steve McQueen, and Judy Garland have made lasting impressions of the intimate moments coaxed from such traditionally private personalities. Well-known in the recording world, Claxton is one of the founding members of N.A.R.A.S. – the *Grammy Awards*. In 2003, he was awarded the distinguished *Lucie* by the International Photography Awards.

In the 1960s, Claxton collaborated with his wife, the noted fashion model Peggy Moffitt, to create a stunning collection of iconic fashion images featuring the revolutionary designs of Rudi Gernreich. A Claxton-directed film from this era, *Basic Black*, is considered by many to be the first "fashion video" and is now part of the collection of the Museum of Modern Art in New York. To this day, the Claxton/Moffitt/Gernreich images from this era continue to be hailed as masterful examples of modern style.

As the author of thirteen books and subject of dozens of exhibitions, William Claxton enjoys a worldwide audience for his work. The critically acclaimed title *Jazz Life* is the subject of a major, limited reissue for TASCHEN that will appear in late 2004. Claxton lives in Beverly Hills with his wife and partner Peggy Moffitt. Their son, Christopher, manages their photographic archives.

Steve Crist, Los Angeles, 2004

William Claxton and Steve McQueen on a raoad trip. Carmel, 1964.
William Claxton und Steve McQueen auf einer Spritztour. Carmel, 1964.
William Claxton et Steve McQueen lors d'une virée en voiture. Carmel, 1964.

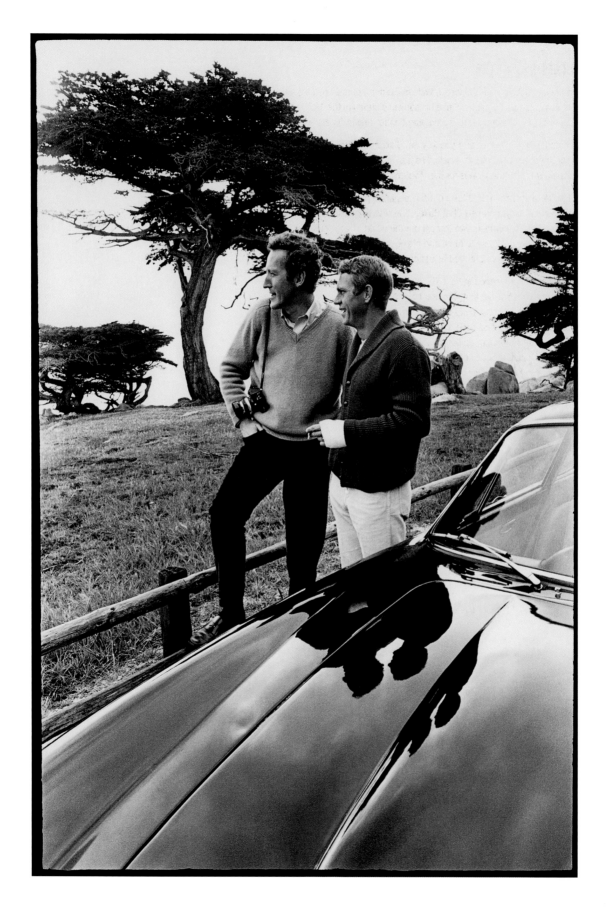

# WILLIAM CLAXTON

William Claxton, geboren und aufgewachsen in Südkalifornien, nimmt einen beson-
deren Platz in der Geschichte der amerikanischen Fotografie ein. Seit den fünfziger
Jahren stoßen seine Arbeiten wegen ihrer intimen und beseelten Atmosphäre auf
reges Interesse.

Claxton wurde bekannt für seinen einfühlsamen und poetischen Stil und galt lange
Zeit als *der* Fotograf für Jazzmusik. Mehr als fünf Jahrzehnte lang zierten seine Bilder
die Cover zahlloser Jazz-Alben und Zeitschriften.

1952 machte Claxton als Student der UCLA die ersten Aufnahmen von einem jungen
unbekannten Trompeter namens Chet Baker. Die damals entstandene Fotoserie wurde
weltberühmt. Nach dem kometenhaften Aufstieg Bakers und seinem ebenso drama-
tischen Fall ist es das Verdienst William Claxtons, sowohl den anfänglichen Ruhm als
auch das Erbe des Trompeters mit seinen Fotos dokumentiert zu haben.

Seit den Anfängen seiner Karriere – er fotografierte unter anderem für die Magazine
*LIFE, Paris Match* und *Vogue* – hat Claxton mit vielen Filmstars zusammen gearbeitet
und dabei manche Freundschaft geschlossen. Seine sehr persönlichen Bilder von
Frank Sinatra, Marlene Dietrich, Steve McQueen und Judy Garland sind bleibende
Eindrücke intimer Momente aus dem Privatleben dieser Persönlichkeiten. Über sei-
ne Beziehungen zur Musikbranche wurde Claxton Gründungsmitglied der National
Academy of Recording Arts & Sciences, die alljährlich die Grammys verleiht. 2003
erhielt er bei den International Photography Awards den begehrten „Lucie".

In den sechziger Jahren schuf Claxton mit seiner Frau, dem bekannten Model Peggy
Moffitt, eine fantastische Sammlung von Modefotos mit dem revolutionären Design
von Rudi Gernreich. In dieser Zeit entstand unter Claxtons Regie auch der Film
*Basic Black*, der allgemein als erstes „Modevideo" bezeichnet wird und heute zur
Sammlung des Museum of Modern Art in New York gehört. Bis in unsere Tage
werden die Claxton/Moffitt/Gernreich-Bilder als meisterhafte Beispiele des Modern
Style gepriesen.

Claxton hat 13 Bücher herausgegeben und seine Fotos wurden in zahlreichen Aus-
stellungen auf der ganzen Welt gezeigt. Der von den Kritikern hoch gelobte Bildband
*Jazz Life* wird bei TASCHEN in limitierter Edition neu aufgelegt und erscheint Ende
2004. Claxton lebt mit seiner Frau Peggy Moffitt in Beverly Hills. Ihr gemeinsamer
Sohn Christopher verwaltet das Fotoarchiv des Künstlerpaars.

**Steve Crist, Los Angeles, 2004**

# WILLIAM CLAXTON

Né et élevé dans le sud de la Californie, William Claxton occupe une place particulière dans l'histoire de la photographie américaine. Depuis ses premiers clichés au début des années 1950, il a réalisé des photographies qui ne cessent d'attirer l'attention à la fois par leur caractère intime et leur expressivité.

Toujours remarqué pour son style poétique et sensible, William Claxton a longtemps été considéré comme le photographe par excellence de l'univers du jazz. Ses clichés ont fait la couverture d'innombrables albums et magazines pendant plus de cinquante ans.

En 1952, alors qu'il étudie à l'université de Californie de Los Angeles, William Claxton commence à photographier un jeune trompettiste inconnu du nom de Chet Baker. La série de clichés qui en résulte est aujourd'hui connue dans tout le monde du jazz. Depuis l'ascension fulgurante du trompettiste vers la célébrité jusqu'à son déclin tout aussi brutal, les photographies de Chet Baker signées William Claxton sont largement reconnues comme reflétant à la fois la célébrité des premières heures et l'empreinte posthume du musicien.

Dès le début de sa carrière (il collabore notamment aux magazines *Life*, *Paris Match* et *Vogue*), William Claxton travaille et se lie d'amitié avec de nombreuses stars hollywoodiennes. Ses clichés très personnels de Frank Sinatra, Marlene Dietrich, Steve McQueen et Judy Garland sont la marque durable des moments intimes volés à ces célébrités d'ordinaire si inaccessibles. Bien connu dans le monde du disque, William Claxton est l'un des membres fondateurs de la National Academy of Recording Arts & Sciences qui organise chaque année la cérémonie des Grammy Awards. En 2003, il a reçu un Lucie Award lors des International Photography Awards.

Dans les années 1960, William Claxton collabore avec son épouse, le célèbre mannequin Peggy Moffitt, pour constituer une impressionnante collection de photographies de mode ayant pour thème les créations révolutionnaires de Rudi Gernreich. Il réalise même un film, *Basic Black*, qui, pour beaucoup, représente le premier « film de mode » et qui fait désormais partie de la collection du Museum of Modern Art de New York. Jusqu'à aujourd'hui, les images de Claxton/Moffitt/Gernreich datant de cette époque sont considérées comme des exemples magistraux de la photographie moderne.

Auteur de treize ouvrages et sujet de nombreuses expositions, William Claxton séduit un large public dans le monde entier. L'ouvrage salué par la critique *Jazz Life* fait l'objet d'une importante réédition limitée pour Taschen qui paraîtra fin 2004. William Claxton vit à Beverly Hills avec son épouse et partenaire Peggy Moffitt. Leur fils Christopher s'occupe de la gestion du fonds photographique.

Steve Crist, Los Angeles, 2004

# STEVE McQUEEN

| | | |
|---|---|---|
| 1956 | *Wanted: Dead or Alive* | Josh Randall |
| 1956 | *Somebody Up There Likes Me* | Fidel |
| 1957 | *The Defender* | Defendant Gordon |
| 1958 | *The Blob* | Teenager Steve Andrews |
| 1958 | *Never Love a Stranger* | Martin Cabell |
| 1959 | *Never So Few* | Corporal Bill Ringa |
| 1960 | *The Magnificent Seven* | Hired gunman Vin |
| 1960 | *The Great St. Louis Bank Robbery* | Bandit George Howler |
| 1961 | *The Honeymoon Machine* | Lieutenant Fergie Howard |
| 1962 | *The War Lover* | Captain Buzz Rickson |
| 1962 | *Hell Is for Heroes* | Private John Reese |
| 1963 | *Love with the Proper Stranger*[1] | Musician Rocky Papasano |
| 1963 | *Soldier in the Rain* | Sergeant Eustis Clay |
| 1963 | *The Great Escape*[2] | P. O. W. Captain Virgil Hilts |
| 1965 | *The Cincinnati Kid* | Poker player Eric Stoner |
| 1965 | *Baby, the Rain Must Fall* | Parole contender Henry Thomas |
| 1966 | *The Sand Pebbles*[3] | Cynical sailor Jake Holman |
| 1966 | *Nevada Smith* | Vengeful son Nevada Smith |
| 1968 | *Bullitt* | Detective Lieutenant Frank Bullitt |
| 1968 | *The Thomas Crown Affair* | Millionaire Thomas Crown |
| 1969 | *The Reivers*[4] | Mentor Boon Hogganbeck |
| 1971 | *Le Mans* | Grand Prix driver Michael Delany, Co-Producer |
| 1971 | *On Any Sunday* | Himself |
| 1972 | *The Getaway* | Convict Carter "Doc" McCoy |
| 1972 | *Junior Bonner* | Rodeo driver Junior Bonner |
| 1973 | *Papillon*[5] | Convict Henri "Papillon" Charriere |
| 1974 | *The Towering Inferno* | Chief Michael O'Hallorhan |
| 1976 | *Dixie Dynamite* | Uncredited stuntman |
| 1978 | *An Enemy of the People* | Doctor Thomas Stockmann, Co-Producer |
| 1980 | *The Hunter* | Bounty hunter "Papa" Thornson |
| 1980 | *Tom Horn* | Ex-army scout Tom Horn, Co-Director |

[1] *Golden Globe Nomination, Best Actor – Drama*
[2] *Golden Globe Nomination, Best Actor – Musical/Comedy*
[3] *Academy Award Nomination, Best Actor; Golden Globe Nomination, Best Actor – Drama*
[4] *Golden Globe Nomination, Best Actor – Drama*
[5] *Best Actor, Moscow International Film Festival*

# WILLIAM CLAXTON Bibliography

*Photographic Memory*
(129 plates, anecdotes and captions) powerHouse Books, New York, 2002

*Steve McQueen*
(120 plates & anecdotes) Arena Editions, Santa Fe, 2000

*Jazz Seen*
TASCHEN GmbH, Cologne, 1999

*Laugh: Portraits of Comedians*
William Morrow, New York, 1999

*The Rudi Gernreich Book*
(with Peggy Moffitt) TASCHEN GmbH, Cologne, 1999
(First Edition: Rizzoli, New York, 1991)

*Jazz: William Claxton*
Chronicle Books, San Francisco, 1996

*Claxography, The Art of Jazz Photography*
Nieswand Verlag GmbH, Kiel, 1995

*Young Chet, A Photographic Memory of Legendary Jazzman Chet Baker.*
Schirmer/Mosel, Munich-Paris, 1993

*Jazz West Coast, The Art of the Record Cover*
(with Hitoshi Namekata) Bijitsu Shupan Shaw, Tokyo, 1993

*California Cool, Album Cover Art*
(with Marsh/ Callingham) Chronicle Books, San Francisco, 1992

*The Year of Tibet, A Portfolio of Platinum Prints*
(with other photographers) Produced by Richard Gere, 1990

*Pictures of Peace*
(with other photographers) Edited by Kim Caputo. Knopf, New York, 1991

*Jazz: William Claxton*
Twelvetrees Press, Santa Fe, 1987 (First edition: case-bound, limited edition)

*Jazz: A Photo History*
(with other photographers) Edited by Joachim E. Berendt. Wolfgang Krüger Verlag
GmbH, Frankfurt am Main, 1978

*Journal of The Loved One*
(with Terry Southern) Random House, New York, 1965

*The Mary and Vincent Price Cookbook*
(with their personal art collection) with Vincent Price. Abrams Art Books,
New York, 1964

*Jazz Life*
(with Joachim E. Berendt) Burda Verlag GmbH, Munich, 1962

*I Like What I Know*
(with Vincent Price) Doubleday, New York, 1962

*Jazz West Coast: A Portfolio of Photographs*
Linear Publications, Hollywood, 1955

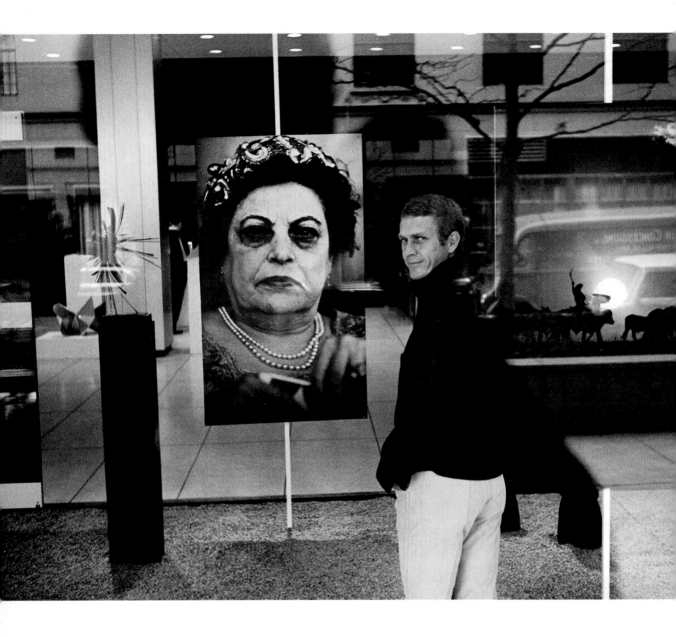

Editor: Steve Crist, Los Angeles
Photography Editor: Peggy Moffitt, Los Angeles
Design: Carrie Worthen and Ben Pope, thirdthing.com
Editorial coordination: Sonja Altmeppen, Cologne
German translation: Alexandra Bootz and Andrea Honecker, Cologne
French translation: mot.tiff, Paris
Production: Horst Neuzner, Cologne

Printed in Italy
ISBN: 3–8228–3117–4